MW00560446

Cuba

Published by the National Geographic Society
1145 17th Street N.W.
Washington, D.C. 20036

Copyright © 1999 National Geographic Society
Photographs © 1999 David Alan Harvey/Magnum

All rights reserved. Without limiting the rights under copyright reserved above,
no part of this publication may be reproduced, stored in or introduced into a
retrieval system, or transmitted, in any form, or by any means (electronic,
mechanical, photocopying, recording, or otherwise) without the written
permission of both the copyright owner and the above publisher of this book.

First printing, October 1999

Library of Congress Cataloging-in-Publication Data

Harvey, David Alan.
 Cuba / photographs by David Alan Harvey ; essays by Elizabeth Newhouse.
 p. cm.
 ISBN 0-7922-7501-2
 1. Cuba--Pictorial works. 2. Cuba--Description and travel.
 3. Cuba--Social life and customs--1959- I. Newhouse, Elizabeth.
 II. Title.
 F1765.3.H37 1999
 972.91--dc21 99-32488
 CIP

Printed in Italy

Cuba

Photographs by David Alan Harvey
Essays by Elizabeth Newhouse

NATIONAL GEOGRAPHIC
WASHINGTON D.C.

Contents

Foreword *David Alan Harvey* 16

Introduction *Elizabeth Newhouse* 20

Six Landings 22

Illusion and Reality 40

The Portfolios

 Havana 56

 Old Havana 110

 The Countryside 130

 Trinidad 154

 The East End 178

Awaiting an Outcome 206

Acknowledgments 214

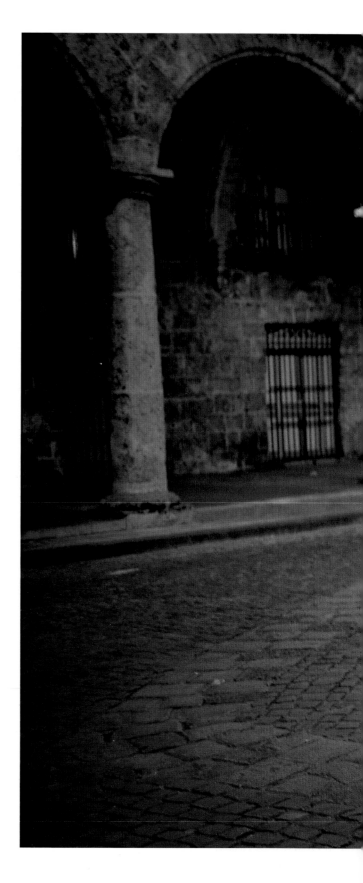

Plaza de la Catedral, Old Havana

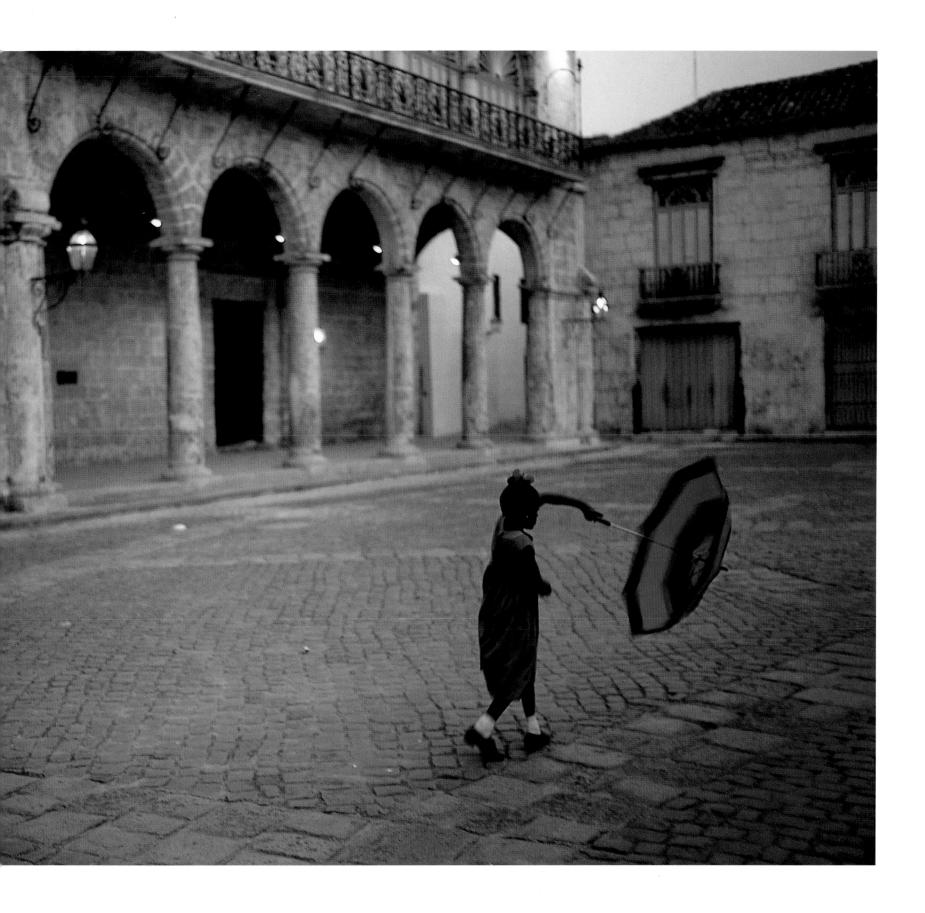

Crowding into a door jamb, friends and family share beer and conversation in the late afternoon sun on a square in Trinidad. The city near Cuba's south coast traces its history to pre-Columbian Indian settlements. Later it became a center for African slave trade, with a thriving sugar industry lasting into the late 1800s.

"People ask me what the Cubans do for fun," says Harvey. "And hanging out, like these folks, is basically what they do. It's an incredibly social society. Cubans seem perfectly happy to just be together."

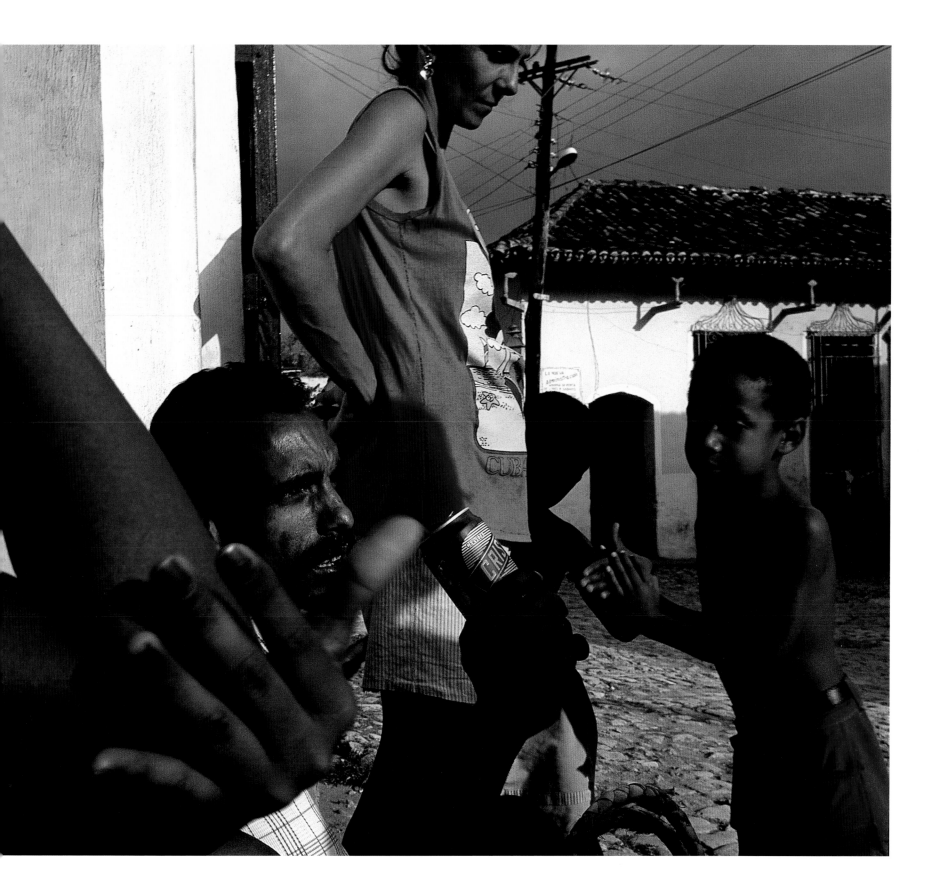

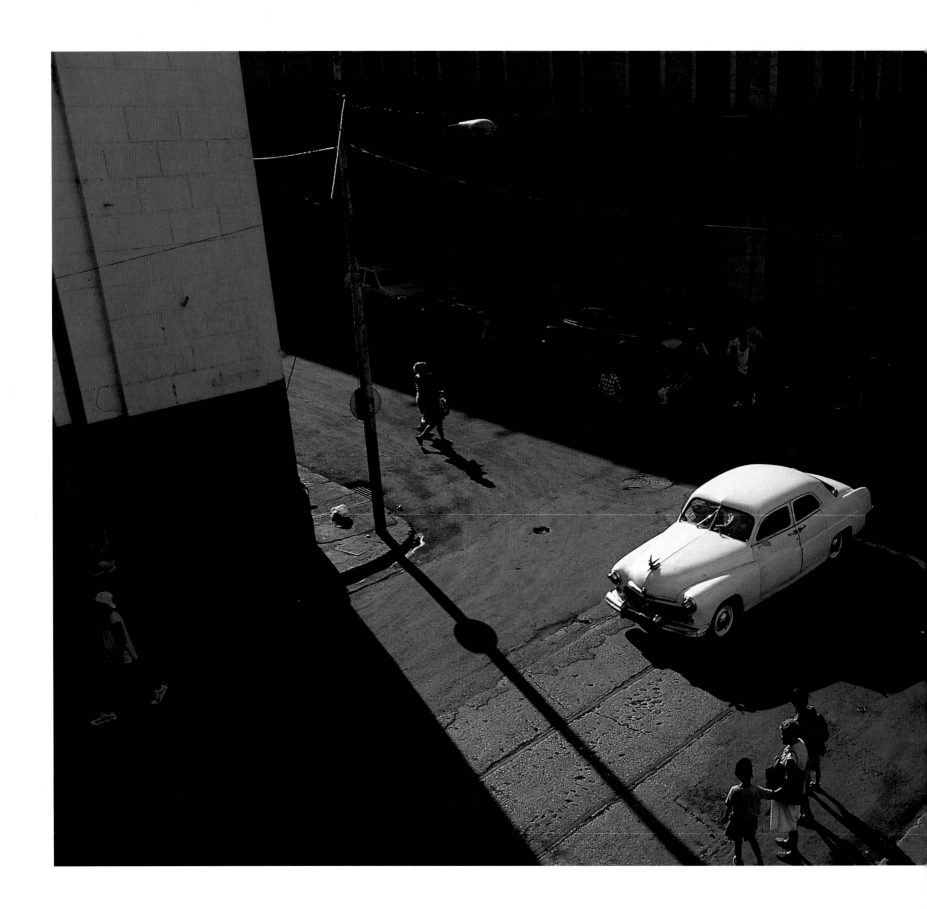

A ghost of prosperity past rolls through downtown Havana. The streets of Cuba are at times a living classic car show, lined with pre-Castro relics of the 1940s and 50s. Some have their original engines, others make do with Russian-made replacements. Virtually all are lovingly maintained, perhaps with an eye on the day when open commerce will make them valuable on the open market.

Since long before the revolution, Havana's Tropicana nightclub has dazzled with its glittery floor show. Gone are the colorful managers who catered to U.S. high rollers during the 1950s; now the place is run by bureaucrats. But the two-hour show still gives its jazzed-up take on Cuban cultural history with a mix of African, Spanish, and native Indian influences.

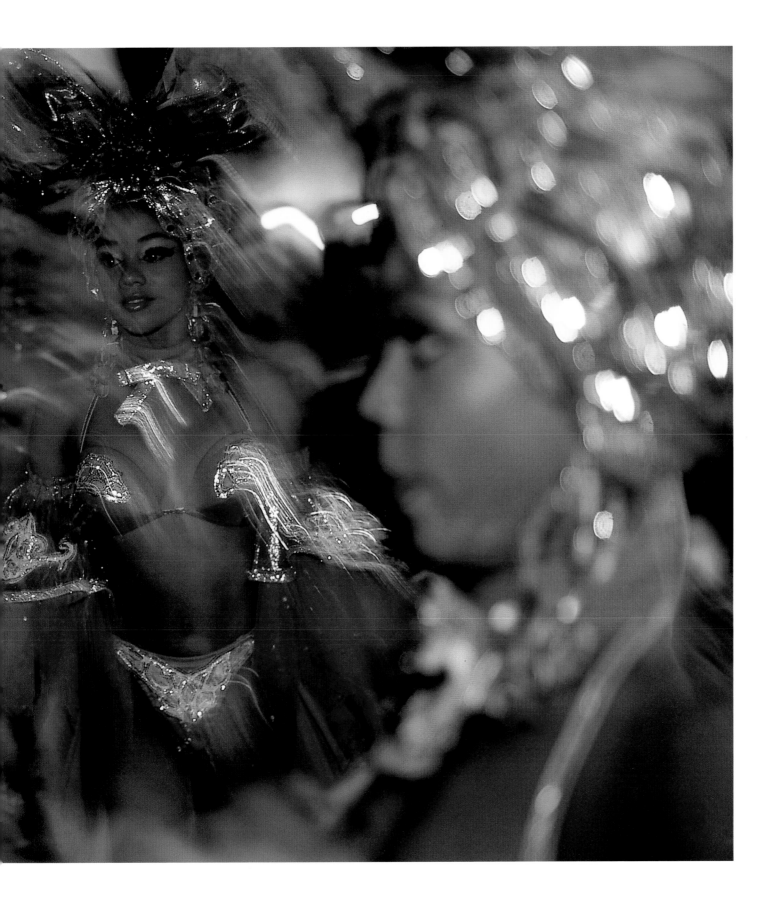

Somewhere under the rainbow—in the rural central Cuba town of Manicaragua, to be exact —five-year-old Claudia Sabina Hernández shows off new shoes to her father and grandfather. The men support their family working a 15-acre tobacco farm. A utility pole tells the story of electrification coming to the region. *Campesinos* such as these reaped the revolution's greatest rewards, besides electricity, medical care and schooling to at least the ninth grade.

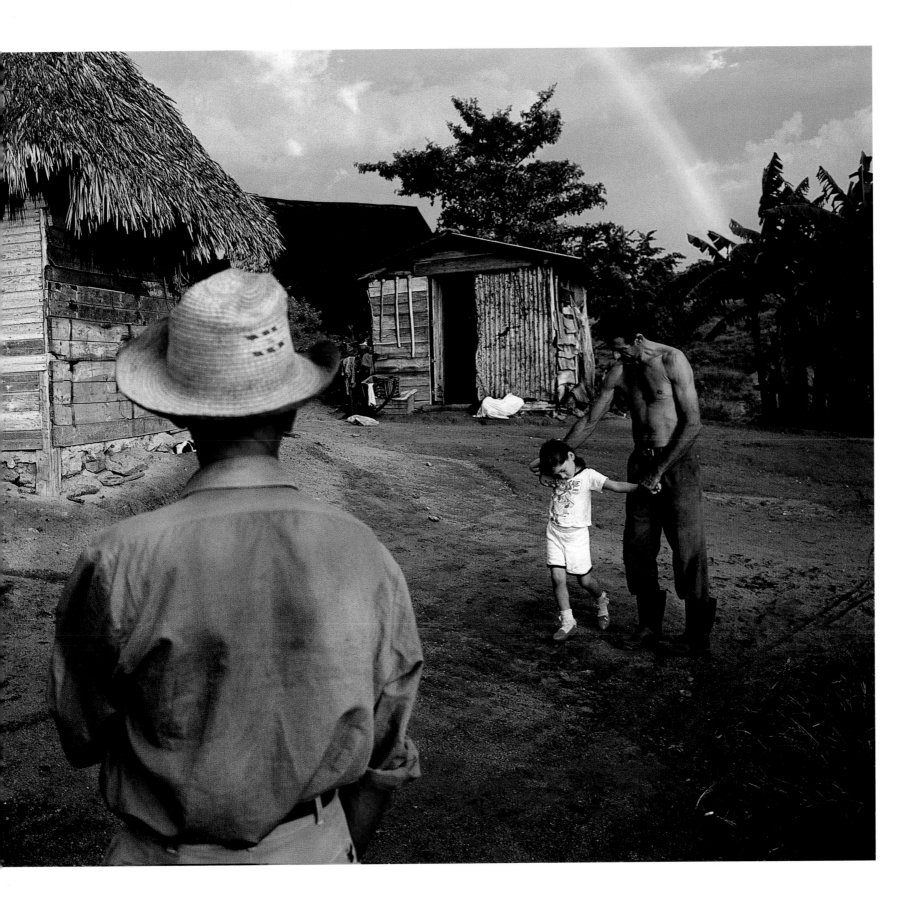

Many Cubans still have heart during their nation's austere times. A teenager walking along Havana's famous waterfront drive, the Malecón—not far from where the U.S. battleship *Maine* exploded in 1898—displays a flash of style that would not be out of place 90 miles across the sea in South Florida.

Likewise, Cuba's aging leadership struggles to keep alive the country's prized social programs, while trying to rebuild its collapsed economy.

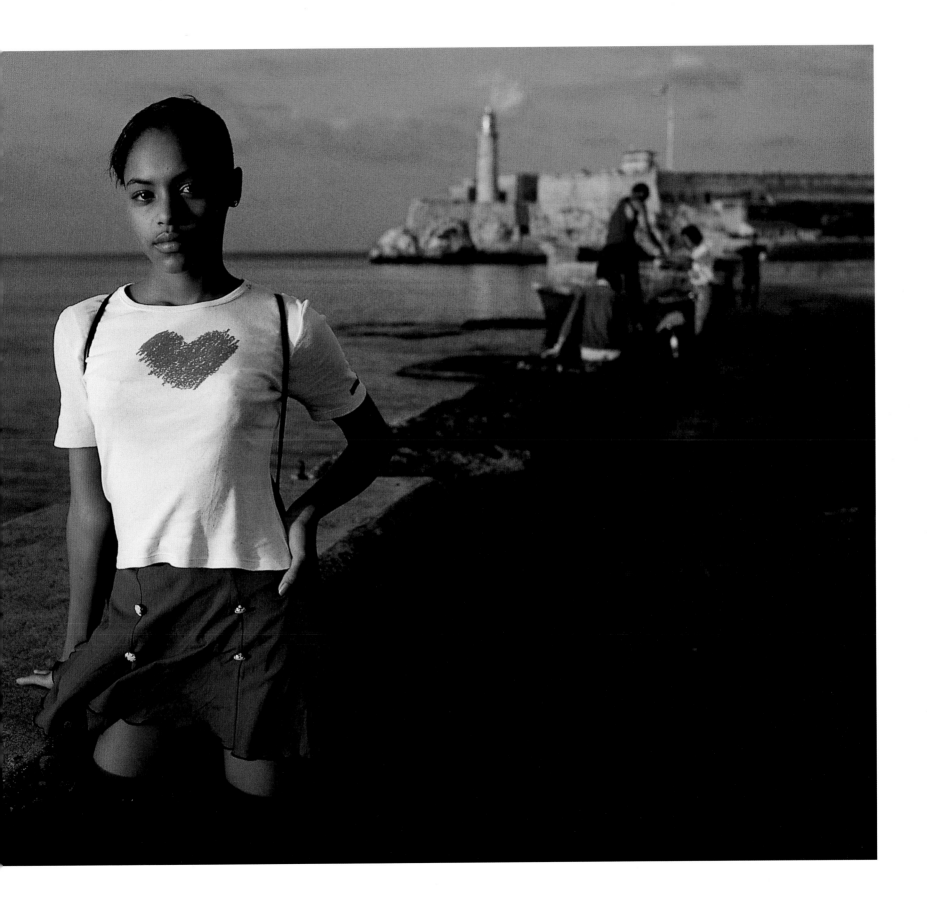

Foreword

David Alan Harvey

IT WAS LATE, AND IT SMELLED LATE. Salt spray from the Atlantic breakers smashed relentlessly into the Malecón and mixed with the aroma of spilled beer, cheap perfume, and sweat. Disco music blared from a below-street-level bar on a block lit by 20-watt bulbs. It seemed all eyes were on me. A foreigner had arrived and the hustlers were moving in for the kill. A hand is on my shoulder. "Taxi?" "Havana cigar?" No, gracias. "Wanna chica?" No. "Rum?" No, gracias. "Well, what do you want?" I just want to walk, alone.

My first hour in Havana, and I was bombarded by Cubans looking for any way they could to get a dollar out of my pocket. And they thought of every possible way. I had been traveling the world for 25 years and thought I'd seen just about everything, but nothing had prepared me for the gantlet I walked through. I was tired from my all-day journey from Washington, and I just wanted to sit and have a beer and think things over. I wanted to observe. Impossible. It was 1996, and just two days before, the Cuban military had shot down two small planes from Miami that had been distributing anti-Castro leaflets over Havana. Tensions between Fidel Castro and the United States were high, and I didn't really want to announce I was an American.

I had come to Cuba to make photographs, continuing my 15-year journey through the Spanish diaspora. I was planning a book on Spanish culture and its transformations in the New World, and Cuba was to be a chapter. My agency, Magnum, had secured a four-day assignment from *Time* to photograph some Cuban medical scientists who had achieved

breakthroughs in biomedical technology. But with planes shot down, an anti-American rally in progress, and prostitutes coming at me from every direction, I realized I couldn't sit alone and have a quiet beer that night. No chance. I made my way to the Hotel Vedado and lay down, dazed and confused.

So began my love affair with Cuba, a love mixed with frustration, fear, passion, and paranoia.

I was neither drawn to nor distracted by the political situation. Experience has taught me that the essence and culture of any country lives on, regardless of politics. Of course, Fidel Castro is an impossible man to ignore. I have never tried so hard to meet someone and failed. As a photojournalist, I have the confidence I can eventually photograph anyone. World leaders, top exec's, movie stars, sports heroes—in 25 years I had never failed to photograph anyone I really wanted to photograph. Until Fidel. Letters, government channels, gifts, backdoors. No dice. Of course I have photographed Castro several times in public situations, but I have never been able to look him in the eye and make a portrait.

Maybe it is for the best. My photographs are of the Cuban people, not political leaders. The Cubans and their basic lifestyles existed before Castro and will continue after, and I hope my work shows what it looks and feels like to be in Cuba today. No one goes to Cuba without making a lifetime friendship. No one goes to Cuba without feeling afraid. No one goes to Cuba without sensing something special, without feeling the music, without realizing he or she is in a country squeezed between the past and the future.

I traveled freely in Cuba. I had access to every part of Cuban life except prisons and military installations. Cuban government officials were polite and helpful. I was picked up and questioned by intelligence officers and police on several occasions—photographing sugar cane, covering a fire, or sometimes for no apparent reason. It always ended up with handshakes and an apology—"just checking." Being watched is just part of everyday life in Cuba, but I never really got used to it.

Traveling across Cuba by car is an adventure in itself. An impressive three- and sometimes four-lane highway cuts across half the island from Pinar del Rio to Santa Clara. But you rarely see a car or truck on it. Military men, women with babies, kids on their way to school, farmers, doctors—all tried to wave me down for a ride. I became a free taxi ride for them, they became a source of information and conversation for me. Each person had a story and I listened. Unlike the street hustlers in Havana, I never had a hitchhiker ask me for anything other than the ride.

CUBA ACTUALLY CAME INTO MY LIFE much earlier than my 1996 assignment. I was 19 and a freshman in college when Soviet Premier Nikita Khrushchev was sending missiles to Cuba. President Kennedy stood his ground and threatened to push the war button. On hearing the news of the developing missile crisis, I immediately considered dropping out of school to join the Navy. I was ready to defend my country against Fidel Castro and Nikita Khrushchev. I was clueless and poorly educated about world history and current affairs. But from that moment on I have remained fascinated with Fidel Castro.

A few years later, newly married and expecting my first child, I headed off to the University of Missouri Graduate School of Journalism. There, in one hour, I met five men who would become intertwined in my career for the next 25 years—Bill Garrett, soon to become the Editor of NATIONAL GEOGRAPHIC; Bob Gilka, the director of photography at the GEOGRAPHIC; Rich Clarkson, director of photography at the Topeka Capital Journal; Kent Kobersteen, a student at the University of Minnesota; and William Albert Allard, newly hired photographer at the GEOGRAPHIC. We have all remained friends.

Clarkson offered me a newspaper job in Topeka and became a tough mentor. I learned from him all the things about this business that I use every day both as a Magnum photographer and as a photographer at the GEOGRAPHIC. The Topeka job was an incredible break for a kid out of college, but I was champing at the bit to move on to the "big time"—magazine photography.

My life changed forever when I was hired by NATIONAL GEOGRAPHIC and began doing general assignment work. Bill Garrett and Bob Gilka sent me to Guatemala and Mexico, my first assignment outside the United States, for a story on the Maya culture. It was 1975. The trip became my key to Cuba. At the time I didn't know much about the Maya, or Guatemala, or Mexico. I was totally unqualified for the assignment. That, however, didn't keep me from taking it. I didn't want to admit to the GEOGRAPHIC editors that I didn't speak Spanish. Many staff photographers at the time spoke at least three languages. I also didn't know there was a generous budget for interpreters, so I just went to Mexico—cold. No experience, no knowledge. No languages.

I crammed by reading all I could on the Maya and meeting with archaeologists and anthropologists working in Guatemala and Mexico. One of the things I learned was that I was repelled by the actions of the Spanish conquistadors. The soldiers had conquered in one way; the priests, in another way. Culture clashed with culture. Blood was spilled and blood was mixed. That forced blending of culture has fascinated me for 25 years. The

works of Cela, Márquez, Fuentes, and Allende became my travel guides. In an unplanned twist of fate, my next assignment was in Spain. The enemy. The conquistadors. I nevertheless immersed myself in Spanish history and culture and the events that had led up to explorations in the Americas.

I geared subsequent assignments around this Spanish world and worked frequently in Mexico, Chile, Honduras, Belize, and Spain. The work became a personal passion, and I realized I should put it all into a book.

About three years ago, fearing that an Anglo dealing with this subject might lack credibility, I took my photographs to Carlos Fuentes in Mexico City. I spread my work around his living room floor and asked him, "Can I do this?" I felt an incredible sense of relief when he said "yes" and we talked of doing a book together. But every time I would sit down to edit my book, the lure of shooting would overtake me, and I would be off on another Spanish assignment. My colleagues at Magnum and NATIONAL GEOGRAPHIC kept saying, "Do your book, David." I stalled, realizing there were still several countries I wanted to photograph—Peru, Ecuador, and most of all Cuba. After the 1996 *Time* assignment I was hooked, and I realized this assignment would lead to my Cuba book.

Cuba native John Echave, senior assistant editor at NATIONAL GEOGRAPHIC, and Kent Kobersteen, director of photography, suggested we jointly make a proposal to Editor Bill Allen, for a comprehensive story on Cuba. The proposal was approved, and so began the most rewarding collaborative effort of my career. John became my picture editor, giving me advice when he saw I needed it and left me free to discover what I wanted to on my own. This combination of ideas, John's tireless efforts, securing permissions from government officials and maintaining a positive but independent relationship with the Cuban government, led us down a journalistic road that I hope gives this book balance and an honest vision of Cuba today.

I was drawn to the ballet of street photography. I hung out with Cubans, listened to their music, drank with them, danced, and ate with them. I visited schools and science labs. I rode buses, lived with families, went to church, and in general soaked it all up. I lived it, felt it, and photographed it.

This book is not a catalog or a travel guide to Cuba. Is it complete? Of course not. But I realized I had to stop shooting and do this book now because we are somewhere near the end of one revolution and the beginning of another.

These photographs are dedicated to Cubans everywhere. ■

Introduction

Elizabeth Newhouse

ON THE MORNING OF JANUARY 8, 1959, I joined a large group of Cubans and Americans on the royal palm-lined drive leading to the Hotel Nacional, a grand 1930s neoclassic landmark perched high on a bluff overlooking Havana Harbor. All residents in Cuba, we were students at schools or colleges in the United States for whom the start of winter term had been delayed by Fidel Castro's New Year's Eve revolution. Confusion and rumor gripped the city, and security was uncertain. Finally the permission came to depart. An armed caravan would escort us to the airport, led by a contingent of Castro's fatigue-clad *barbudos*—young, bearded revolutionaries. We would be aboard the first plane to leave for the U.S. since Castro took power. Television cameras and reporters would meet us in New York. It was a heady moment, full of excitement and anxiety, and of hope and expectation for a new, democratic, socially just Cuba—the fulfillment of a war for independence begun more than six decades before. *"Fidelísimo año, Fidelísimo año,"* was our greeting and goodbye.

Almost exactly 40 years later I returned to stay at the Hotel Nacional. Though I had visited Cuba a number of times in the interim, now the hotel's Moorish arches, grand vaulted lobby, and mosaic tile floors had undergone a thorough restoration, and it looked much as it had in 1959—one of the few intact icons from Havana's elegant, glittering past. Most of the rest of Havana also appeared eerily familiar, its face changed only by decay, but Cuba had become a profoundly different place from what might have been expected in early January 1959.

The richest of Spain's New World colonies until 1895, nominally independent Cuba

was before 1959 one of the richest countries in Latin America, its per capita income second only to Venezuela's with a standard of living comparable to Argentina, Chile, and Spain. Literacy stood at 80 percent, high for the region. Still, though the economy was in excellent shape and growing, there were serious inequalities, and for the seven years prior to 1959 Cuba had been ruled by a corrupt and ruthless dictator supported by the United States. Fidel Castro promised essential social reforms. What he never hinted at was the totalitarianism that would accompany them.

Forty years later Castro is still here—in office longer than any chief of state on the planet. The question often asked is how is that possible, with so much hardship and sacrifice demanded of Cubans through the years? Many people ascribe it to the same national characteristics that kept Spain in charge for nearly four centuries, long after it had been banished from its other American colonies: a pacific nature, a desire to eschew complications, a willingness to adapt, a talent for survival. But there are other reasons. Castro's early achievements were highly significant—he made education and medical care available to all, he brought much greater equality to Cuban society, he turned Cuba into a player for awhile on the international scene, and most important, he made Cubans feel a genuine sense of *Cubanismo*—nationalist pride, for the first time in their history.

The price for this has been high. While succeeding in ridding Cuba of its U.S. patron, he made it a near-subject of the Soviet Union for 30 years. And when the Soviets pulled out in the early 1990s with their subsidies and markets, there was nothing to fall back on. Today freedoms are few, hunger is common, and shortages abound, profoundly compromising the celebrated health care and educational systems; at the same time, the dollar economy and small free market openings have brought back social and racial inequalities reminiscent of the 1950s. Further, lawlessness is rampant, with a large percentage of the population stealing from the workplace and operating outside the official economy. Still, Castro refuses to change, insisting that his revolution, however isolated and anachronistic, is here to stay.

Cubans are extraordinarily attractive, vibrant, and resourceful people, as David Alan Harvey amply shows in the glowing photographs in this book. Both cursed and advantaged by geography, their country was plundered and manipulated by foreign powers and left incapable of effectively managing its own affairs. What will happen next no one knows. But it's the Cuban people's turn to come out ahead, and one can only hope the expectations of those early, heady days in 1959 for a democratic, independent, and socially just society can one day be fulfilled. ■

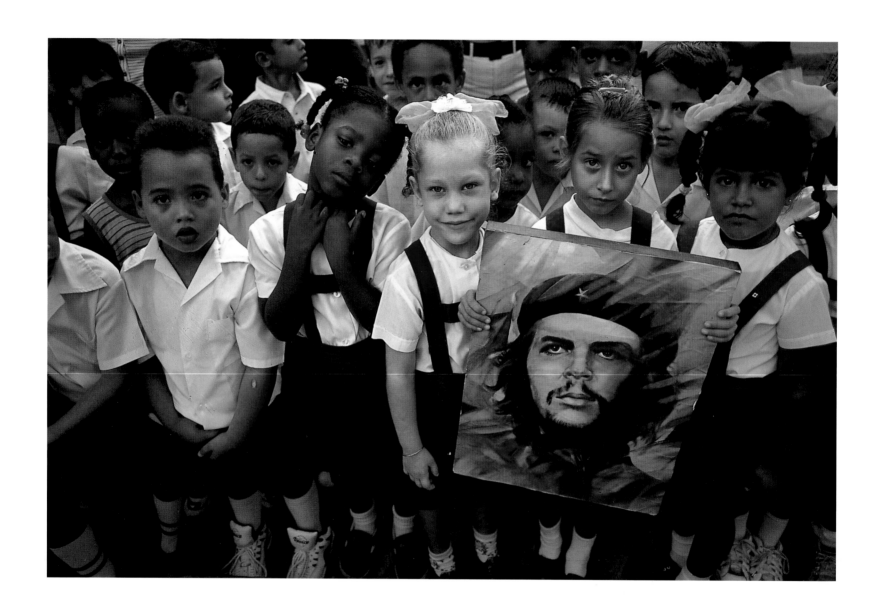

Havana kindergartners proudly display an image of revolutionary hero Ché Guevara on October 8, the anniversary of his death in 1967. This day they will receive neckerchiefs, signaling their new status as pioneros, the first rung in the Communist Party ladder. Only the likeness of 19th-century poet-writer José Martí, regarded as the father of Cuban independence, is as pervasive as Ché's in Cuba.

Six Landings

ON THE NIGHT OF NOVEMBER 24, 1956, a small yacht bought from Americans for some $15,000 set off from Tuxpan, Mexico, its destination Oriente, at that time the easternmost province of Cuba. With 90 rifles, 2 anti-tank guns, 3 light machine guns, 40 hand machine gun pistols, and 82 men, the expedition was led by Fidel Castro, a 30-year-old lawyer and political agitator. Its grandiose mission—to start an uprising that would overthrow Cuba's dictator, Gen. Fulgencio Batista. The culmination of more than a year's planning and fund-raising, the trip began in high spirits but quickly bogged down in winds, choppy seas, and seasickness. Improbably named the *Granma* after the previous owner's grandmother, the boat fetched up in a crab-infested swamp at dawn on December 2, two days late, having missed the beach where supporters waited, poised to whisk the group to mountain hideouts. Although to the rebels the mission appeared a failure, it was anything but—the landing of the *Granma* marked the start of a revolution that would endure for decades, bedevil Cuba's giant neighbor, and briefly threaten the planet with nuclear war.

That revolution aimed to right social wrongs and to challenge the United States, to which Cuba had been tightly bound since 1898. That year the U.S. "liberated" the island from nearly 400 years of Spanish rule, only to turn it into its own de facto colony. Thus began 60 years of misunderstandings, marked by frequently irresponsible, greedy, and violence-prone behavior on the part of Cuban leaders and arrogant, patronizing, and short-sighted behavior on the part of the U.S. Many Cubans felt that by intervening in their war of

independence against Spain, the U.S. had robbed them of their victory and thwarted their revolutionary goals. An effort in the 1930s to restart the revolution was also frustrated by the United States. By 1959 with a corrupt and cruel U.S.-backed regime losing popular support, Cuba was again ripe for revolution.

For more than 450 years men with conquest in mind had been landing on Cuba. Long renowned for its strategic location and ample endowments, the crescent-shaped isle lies at the entrance to the Gulf of Mexico 90 miles from the Florida Keys. More than 1,600 islands, islets, and cays ring the 42,000-square-mile main island, by far the Caribbean's largest and the "Pearl of the Antilles." Its munificent resources include a tropical climate tempered by trade winds; excellent timber; important mineral deposits, especially nickel and copper; a 3,579-mile coastline embellished by hundreds of bays, sugar-sand beaches, aqua shallows, coral reefs, mangrove swamps, and craggy cliffs; expansive plains with large areas of fertile soil set against regions of gentle and rugged mountains; and an extraordinarily rich animal and plant life, including 7,000 species of flowering plants, half of them endemic. American visitor Joseph Dimock commented on the lush flora in his diary in 1859: "The clearness and beauty of the sky is beyond all description, and its effects upon the life and luxuriant growth of vegetation is proportionate....and it is said that in the commencement of summer...all nature seems transformed to flowers."

The first white man to recognize Cuba's many attributes was the unwitting Christopher Columbus, who arrived on October 28, 1492, flying the flag of Spain, and found the most beautiful land he had ever seen. He explored the northeast coast for two weeks but turned southeast toward the island of Hispaniola when he found no gold. Over the following decades, reports of gold and excellent harbors increasingly intrigued the Spanish crown, and in 1511 conquistador Diego Velázquez was dispatched from the Hispaniola outpost. He landed with about 300 men on Cuba's eastern tip, established a settlement at Baracoa in 1512, and set out to conquer the island. The estimated 60,000 or so native inhabitants had neither effective weapons nor fighting skills, and they quickly surrendered or fled into the hills. As soon as the conquest was complete, the crown set up a structure for governing the colony led by a governor, or captain-general, with broad authority to run things as he saw fit.

Two hundred and fifty years after Velázquez's landing, in 1762, another crown set its sights on Cuba—the British. In the last throes of the Seven Years' War, Britain had declared war on a now weakened and impoverished Spain for siding with its enemy, France.

Although Cuba's wealth in gold had proved illusory, the island had become an important service colony, a rendezvous point for Spanish treasure fleets from the New World. After numerous sackings in the 16th century by buccaneers and privateers, the capital city of Havana increased and strengthened its fortifications. It came to be thought of as invincible and had never been captured. Now, the British saw in strategically placed Cuba a way of destroying Spanish communications and stopping the flow of gold and silver to Europe.

On March 5 the British fleet left Portsmouth—5 warships, 30 transport ships carrying 4,000 men, and 19 supply ships. Near Jamaica reinforcements were added, including a number of slaves, and in early June the troops began landing 15 miles east of Havana. Ill-prepared, the Spanish staged a brave but impossible defense; by August 11, with the British surrounding Havana, surrender was inevitable. Lord Albemarle, the commander-in-chief of the British expedition, declared himself captain-general and proceeded to give a series of balls to win over the Creole haute bourgeoisie. Though the British occupation of Havana lasted only 11 months—the prize was returned to Spain in the treaty ending the Seven Years' War—it was significant. During the year, hundreds of British trading ships descended on the island carrying goods restricted by the Spanish, including linen, grain, food, horses, and—most important—slaves. Whereas an estimated total of only 60,000 slaves had been imported throughout the entire 250-year Spanish period, some 4,000 arrived during the brief British occupation, speeding up the transformation of the economy from tobacco and cattle farming to sugar production, an industry that would by the late 1820s turn Cuba into one of the world's richest colonies.

Less than a hundred years after the British departed, Narciso López, a Creole general and romantic extremist with ties to Cuban and U.S. sugar planters, set off from New Orleans in 1851 for another landing on Cuba. López led about 400 men, including Cuban exiles and American Southerners, on a mission that many believe was to annex the island to the United States, a dream that had gathered momentum since the administration of Thomas Jefferson. The arrival in August of this expedition, the fourth organized by López, was timed to coincide with two internal uprisings, but the Spanish Army learned of these and quickly quashed them, capturing and killing their leaders. They soon caught López as well. Tried for treason, he was publicly garroted on September 1. Ironically, the flag flown over Cuba today (and since independence in 1902) was inspired by Narciso López, its single star on a red background and blue and white stripes a symbol of a once powerful dream.

López had the backing of Southern politicians, who shared with the Cuban sugar

planters a strong common interest—the preservation of slavery. As early as 1808 President Jefferson had made known to Spain his interest in buying Cuba as he had Louisiana, particularly if there were any possibility of its falling into British or French hands. Meanwhile, Cuba's Creole planters had watched as slaves rebelled in Haiti in the 1790s and the rest of Spanish America struggled for independence. Slaves represented wealth, and a revolution would clearly threaten their existence. Among the last countries to sign on, Spain finally agreed to abolish the slave trade by 1820. But distant from Cuba and weak, it was hard pressed to enforce the ban there.

Nor was it motivated to do so, for Cuban planters had an ace up their sleeve: They could declare Cuba independent and apply for annexation to the United States. So Spain—its officials eagerly sharing in the spoils—went along with an illegal slave trade. "The Captain-General will allow no African to be imported into the island—except for a consideration," wrote Anthony Trollope, in an 1859 visit to Havana. The results were spectacular—and hugely profitable. With ships and capital coming largely from the U.S., and despite the English Navy's best efforts to police the seas, hundreds of thousands of slaves entered Cuba between 1820 and 1865. They worked on the island's rich tobacco, coffee, and cattle estates, but mainly fueled a sugar industry that grew rapidly into the world's largest.

Throughout this period the planters worried about abolitionism. Further, expansionism was in the air: The U.S. had acquired Texas in 1845, then the territories of California and New Mexico. The slogan "manifest destiny" proclaimed it all but inevitable the U.S. would annex its southern neighbors. The U.S. had sunk deep commercial roots into the island. In 1847 a *New York Sun* article proclaimed, "Cuba by geographical position, necessity, and right...must be ours." In the summer of 1848, President James Polk formally tried to buy the island for 100 million dollars, but Spain refused to sell. By now Narciso López was on the scene. With the backing of extremist Southerners for whom acquiring Cuba was a key to preserving slavery, he embarked to meet his fate. Had the annexation movement succeded, it would greatly have extended the U.S. slave empire.

The general prosperity in Cuba, the fear of a slave rebellion, the opposition of the wealthier Cuban planters and of the U.S., and the unwillingness of the newly independent Spanish-American countries to lend support—all contributed to delaying a Cuban independence movement until quite late in the century. Additionally, an independence effort in the 1820s had brought in 40,000 Spanish troops, turning the country into a fortified garrison, which it remained for more than 50 years. It wasn't until the 1860s that a serious push for

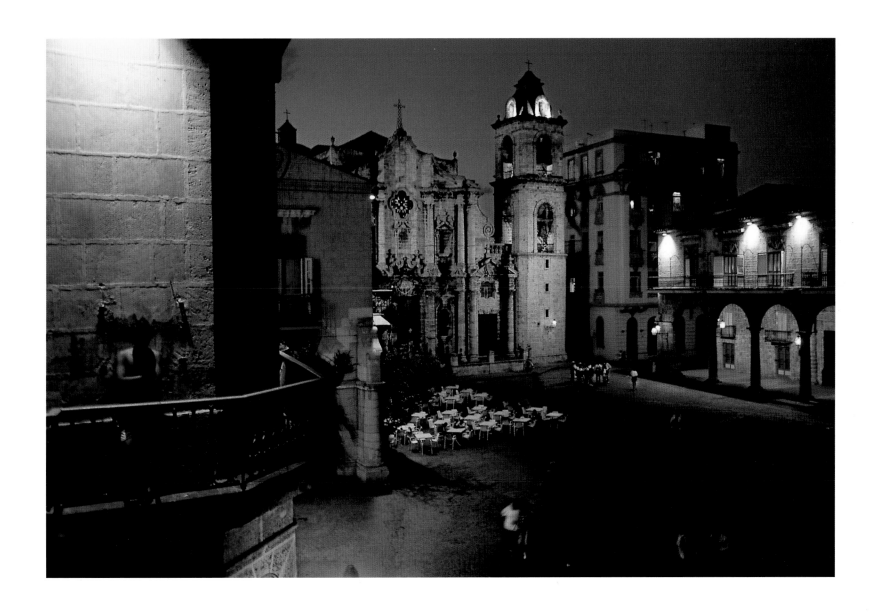

After decades of neglect, Old Havana's Plaza de la Catedral was reborn, thanks to an infusion of foreign investment. The 18th-century Spanish colonial cathedral and square held a papal Mass during Pope John Paul II's 1998 visit. Originally called Plaza of the Swamp, the area in front of the church was the terminus of Spain's first aqueduct in the New World.

independence began. By then the American Civil War had made annexation a dead issue (Lincoln refused to consider acquiring Cuba as long as slavery existed there).

In 1868 a group of planters from the less prosperous eastern part of the island rose up against the repressive Spanish policies. Their proclamation of freedom, the *"Grito de Yara,"* became a rallying cry that soon gathered 12,000 machete-bearing recruits. Carried out mostly by peasants in guerrilla bands against disciplined, well-supplied Spanish troops, the rebellion made little headway in the western provinces. Its leaders disagreed over the question of slavery, and the U.S. refused to lend any backing—to many Cubans one in its long list of historic transgressions. The Ten Years' War failed to overthrow Spanish power, and it was costly: More than 200,000 Spaniards and 50,000 Cubans died, and many properties and fortunes were destroyed. However, the war brought together Cubans from many parts of society, encouraging a sense of nationalism, symbolized by an anthem and a weapon, the machete. It also made heroes of two of the rebels, Antonio Maceo and Máximo Gómez, who with José Martí would lead the next war of independence.

POET, JOURNALIST, AND REVOLUTIONARY, Martí had been writing and teaching in Spain, Mexico, and Guatemala during much of the 1868-1878 war. He returned to Cuba soon after, but suspecting him of revolutionary activities, the Spanish quickly deported him to Spain. He finally settled in New York in 1880 but traveled constantly, raising money and garnering support for the cause of a free Cuba. Determined to avoid past mistakes, he and his fellow conspirators held off giving a green light to an uprising until four of the six Cuban provinces were ready to revolt. On March 25, 1895, Martí issued a manifesto promising a "civilized war" in which private property would be respected and Spanish civilians unharmed. Black participants would be welcome (slavery had been abolished finally in 1886). Afterwards, a republic would be established with a new and progressive economic system.

In early April 1895 a difficult, rainy landing on Cuba's far southeast coast brought José Martí home to lead the war that would at last expel Spain. He succeeded in landing his small boat on a rocky beach and in meeting up with his fellow leaders, but little more than a month later, on May 19, he was shot in a skirmish with the Spanish Army. His death was a terrible tragedy for Cuba. Not only was Martí an eloquent speaker and a gifted political organizer, but he was also a practical visionary with a passionate belief in political liberty and a just society. Although he hated what he saw as a cult of materialism in the United States and deplored its expansionist policies, he greatly admired its work ethic and individ-

ual initiative. Had he survived, Martí would likely have been the first president of an independent Cuba, and its subsequent history might have evolved quite differently. As it was, death turned him into a martyr and an apostle with godlike attributes, claimed both by Fidel Castro and his exiled opponents.

By June 1895, the forces of independence—largely former slaves—confronted 52,000 Spanish troops and 19 warships. But unlike the fractious Ten Years' War, most Cubans were united behind the rebellion. The old dominant plantation class was now broken, and all efforts to move Spain toward reforms had failed. In repeated attacks the guerrillas outmaneuvered the Spaniards. A new and ruthless commander, Gen. Valeriano Weyler, temporarily regained the initiative for Spain, but even he was unable to defeat the rebels. Still, the war lasted three years and prompted U.S. intervention.

A sixth landing on Cuba took place January 25, 1898. That day an American warship, the U.S.S. *Maine*, steamed into Havana harbor and dropped its anchor. Concerned about possible danger to U.S. citizens and property and moved by reports of Spanish harshness toward the Cuban guerrillas, President William McKinley had sent the *Maine* in from Key West to show the flag. The U.S. would hardly stay away: By now large amounts of American capital bolstered Cuba's sugar industry, and the stake in Cuban commerce was profound. With the war still underway and Havana tense, enlisted men were confined to ship. At 9:40 p.m. on the evening of February 15, a massive explosion ripped through the hull of the ship, killing 262 men. Who caused it and why? The question has been debated for decades and is still unresolved. Was it a tragic accident, set off by a fire in the coal bunker? Or was it sabotage, a mine planted by conspirators seeking to widen the war? Either theory is plausible, as computer studies commissioned by the National Geographic Society revealed in 1998.

Whatever the explanation, the explosion of the *Maine* played nicely into the hands of U.S. expansionists and others looking for a "splendid little war" to demonstrate U.S. prowess. Two days after the tragedy, William Randolph Hearst's *New York Journal* trumpeted, "The Warship Maine was Split in Two by an Enemy's Secret Infernal Machine." Hysteria marked the weeks following. When President McKinley sought to quell the furor, Assistant Secretary of the Navy Theodore Roosevelt thundered, "The President has no more backbone than a chocolate éclair." On February 18 the *Journal* reported, "The whole country thrills with war fever." Over the next weeks, as pressure for intervention built, McKinley, the Madrid authorities, and the recently established autonomist government in Havana struggled to find a peaceful solution. Then, in April Gen. Máximo Gómez, the Cuban revolutionary leader,

opened his arms to U.S. intervention. In his response to a plea for reconciliation—and a warning—from the Spanish governor in Havana, Gómez wrote: "Spain has done badly here and the U.S. are carrying out for Cuba a duty of humanity and civilization....I have written to President McKinley and General Miles thanking them for the American intervention...I do not see the danger of our extermination by the U.S. to which you refer." This letter would help seal the fate of Cuba for the next 60 years.

Thus the U.S. went to war with Spain. The press gleefully covered every move, with Hearst himself chief war correspondent and Teddy Roosevelt a chief architect. The outcome was never in doubt. By August 12, almost six months following the explosion aboard the *Maine*, a peace protocol was signed, and the war was over. The U.S. gained Puerto Rico, Guam, and the Philippines, and Spain renounced claim to Cuba. The Spanish American Empire was finished.

An amendment by Sen. Henry M. Teller pledging the U.S. to an independent Cuba had succeeded in passing Congress in April 1898. But the imperial mood of many in Washington made a pipe dream of giving up the prize completely. On the island, disorder prevailed; the war had taken a terrible toll on the land, and famine and malaria were rampant. Further, relations between Cubans and Americans were bad; an American general was known to have called the Cuban army "a lot of degenerates, absolutely devoid of honor or gratitude. They are no more capable of self-government than the savages." More than three years of U.S. military occupation followed. Hospitals were built, yellow fever was wiped out, a public school system established, and municipal elections were held, but Cubans felt robbed of the chance to reconstruct the country themselves and to develop a strong sense of nationhood.

In 1902 independence was finally, nominally, granted. Included in the Cuban Constitution was the controversial amendment proposed by U.S. Senator Orville H. Platt, effectively permitting American access and intervention pretty much at will. A Cuban general spoke of it as reducing "the independence and sovereignty of the Cuban republic to a myth." Other Cubans saw it as preferable to occupation with no end in sight.

OVER THE FOLLOWING DECADES Cubans would find it extremely difficult to establish an effective means of governing. Rarely was there a period free of conflict. The Platt amendment fostered a mentality of dependence by encouraging Cuban leaders to rely on the U.S. to settle their problems, both domestic and foreign. (A political fracas in 1906 brought another U.S.

occupation, lasting almost three years and firmly killing any illusion of independence.) Tolerance for political corruption, a legacy of Spanish colonialism, and a tendency to use violence to settle political squabbles further hindered effective government.

A 1903 commercial treaty bound Cuba even tighter to the U.S. by granting favorable terms for Cuban sugar entering the U.S. in exchange for preferred treatment for U.S. products in Cuba. The treaty assured Cuba's dependence on the U.S. market and on a one-crop economy, held hostage to demand. A long prosperous period, with rising sugar production, came to an abrupt halt in 1920, when the world sugar price precipitously dropped from an extraordinary high of nearly 23 cents per pound in May to just over 3 cents in December. With the ensuing financial chaos came an outcry against U.S. control of the sugar industry, the close economic ties with the U.S., and governmental corruption.

The program of Gerardo Machado, a successful businessman, seemed to fill the need for reform, and in 1924 he was elected president. It soon became apparent that he resembled nothing so much as a "tropical Mussolini." He took control of the political parties and the military, and with his cronies siphoned ten million dollars a year from the national treasury, a fifth of the national product. Meanwhile, his friendliness to business endeared him to the U.S. As student resistance grew and economic conditions worsened—with food scarce and the rural population increasingly sinking into poverty—Machado's treatment of his enemies turned ever more ruthless. The U.S. finally felt compelled to intervene in 1933, sending in as mediator Sumner Welles, one of long line of envoys with extraordinary powers.

In 1911 North American capital in Cuba totalled 200 million dollars; by 1929 it had reached 1.5 billion dollars. Though centered in sugar, U.S. investment permeated most of big business—oil, telephones, electricity, banks, railroads. In addition, Americans had bought up huge tracts of land, as much as a tenth of the island's total. The old 19th-century Creole oligarchy had largely been replaced by North Americans. The U.S.–Cuba political relationship remained ambivalent. Cubans either feared or desired U.S. intervention, depending on their interests, but the threat dominated Cuba's volatile politics.

Never more was this the case than in 1933. Machado and most political factions supported Welles's mission, seeing it in their own interest, but some political leaders and university activists who had battled the dictator since the mid-1920s, strongly opposed it. The students—mostly in their early twenties—came to be known in Cuban history as the "generation of 1930." They saw themselves as heirs to Martí's legacy and their goal as not only the overthrow of Machado but the completion of the revolution the U.S. had cut short in 1898.

Sumner Welles's efforts ended with Machado fleeing the country and the appointment of a provisional president. The event unleashed a new reformist revolution, the students demanding social justice, noninterventionism, and the overthrow of the new president as a U.S. tool. Into the unrest stepped an audacious and forceful army sergeant who would play a major part in Cuban politics for most of the next 25 years.

Sgt. Fulgencio Batista's entrance into Cuban affairs marked a significant turning point in island history, for with him came the Cuban Army. Batista, age 32, the son of a cane cutter, was a handsome and charming mulatto with Indian blood, who had held a number of odd jobs before joining the army and becoming a stenographer. A *New York Times* report observed that he "seemed plausible in the superlative degree." In league with the students, Batista put forth a popular reform program without U.S. support. Its moment was brief, but never forgotten—and its failure convinced many Cubans that there could be no significant structural change in Cuba as long as it remained under U.S. influence.

Their choice as president, former university professor Ramón Grau San Martín, brought to power the generation of 1930. His wide-ranging reformist program included removing Cuba from financial dependence on the United States. Apprehensive about U.S. interests and distrustful of Grau, Ambassador Welles refused to recognize him, thereby encouraging the opposition. Internal conflicts added to the vulnerability of Grau's government. As collapse loomed in 1934, Batista, now army chief, forced Grau's resignation and appointed a new president much more attentive to U.S. interests. A series of puppet presidents followed, all tightly controlled by Batista.

To the United States, Batista represented order and progress under friendly rule. In a book published years later, the State Department's then Latin America desk officer, Laurence Duggan, wrote: "Batista...saw it was hopeless for Cuba, whose life depended on a restored sugar market with the U.S., to risk our disapproval." These early Batista years benefited Cuba. The humiliating Platt amendment was abrogated, a public works program begun, and health care and schools were improved. A 1934 commercial treaty with the U.S. assured Cuba a stable market for Cuban sugar and tobacco, while tying Cuba even more tightly to the purchase of U.S. goods.

In 1940 a new constitution set forth the dreams and goals of the generation of 1930— a single presidential term, civil liberties, social welfare, labor rights, Cuban precedence over foreign interests in new industries, state involvement in economic development. A serious attempt at social democracy, it was rarely observed. Its first president was General Batista,

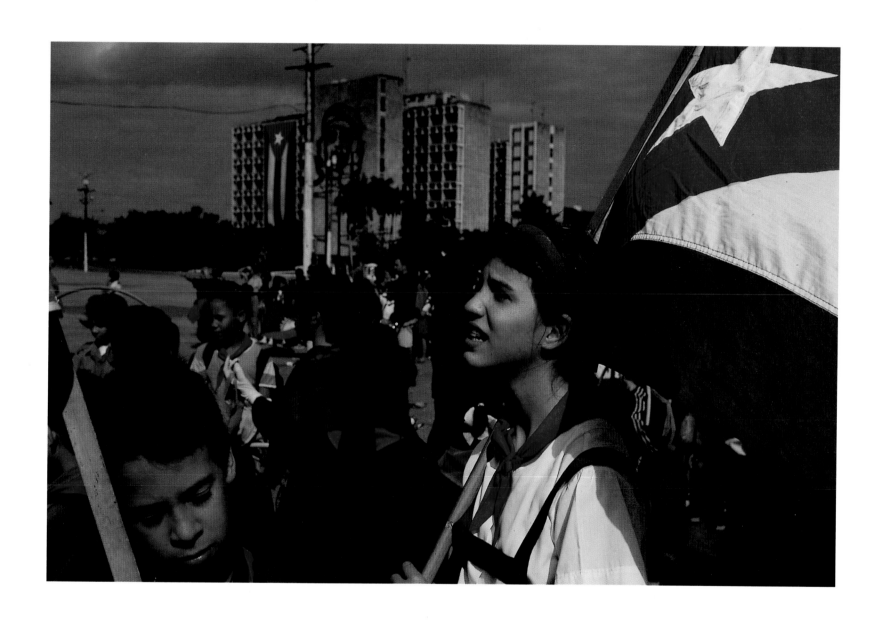

Alternately rapt and bored, schoolchildren listen to a political speech during a José Martí Birthday celebration on Havana's Plaza de la Revolucíon. A poet and orator, Martí spearheaded Cuba's war of independence from Spain in the 1890s, but he was tragically killed in one of its earliest skirmishes.

elected with the support of the U.S., the propertied classes, and the labor unions. Toward the end of World War II, Grau San Martín was elected to succeed Batista, amid renewed hope for a socially conscious government. But by now the reformist zeal of many in the generation of 1930, including Grau himself, had given way to greed and opportunism. The University of Havana became the center of rebellious activity.

Another leader from the generation of 1930 now stepped forward to revive the ideals of Martí's revolution. With incendiary rhetoric, Eduardo Chibás led the call for reform. Demanding a Cuba "free from the economic imperialism of Wall Street," he became the idol of university students—and he paved the way for the revolution that would follow. But in a sensational event in August 1951, Chibás went on the radio, put a gun to his stomach and fatally shot himself. His gesture, like his rhetoric, apparently intended as a dramatic wake-up call to Cubans, Chibás brought on the final disintegration of constitutional rule.

General Batista longed to regain power but could no longer count on reelection. In March 1952 he staged a coup d'état, proclaiming "the people and I are the dictators." The U.S., however, soon embraced its old friend. *Time* magazine featured Batista on the cover, with the Cuban flag swirling about his head.

Fidel Castro, a law student at the university in the 1940s, was one who had become captivated by Eddy Chibás. Years later he would equate his own movement with Chibás's. Castro's father was a Spaniard who had fought for Spain during Cuba's war of independence and later accumulated land in Oriente Province, which grew to a farm with tens of thousands of acres. Rough, ambitious, and unconventional, Angel Castro never bothered to marry his second wife until three chidren were born. Fidel went to Jesuit schools, first in Santiago de Cuba, then in Havana. In 1945 he began studying law at the university. From the start, he was heavily into politics (as a 13-year-old rebel he tried to organize a strike of sugar workers against his father). Energetic and restless, he had unformed ideas but a commanding speaking style (fellow law student Fernando Freyre remembered him as a "person who would throw in his lot with any group he felt could help his political career"). Most important during this period was his adoption of what he later called the "vocation of revolution." By 1953 Castro was leading a group whose aim was to carry on an energetic and resolute struggle against Batista, using violence if necessary. On July 26 he attacked the Moncada military barracks in Oriente Province, hoping it would "light the flame of a general rising in the country." Though the attack failed, it attracted considerable attention.

Meanwhile, in the 1950s Cuba's economy was prospering under Batista's military

dictatorship, and Batista himself basked in the admiration of the business community and the U.S. The sugar industry was expanding, as were efforts to Cubanize it—by the early 1950s Cuban-owned mills produced 55 to 60 percent of Cuba's sugar. Mining, tourism, and cattle raising also grew. The per capita income was one of the highest in Latin America. U.S. companies continued to invest heavily in the island; the large Cuban middle class looked to the U.S. as the model for its way of life. Glittering Havana was experiencing a boom, with huge, luxurious hotels going up. Lavish nightclubs starred top U.S. performers such as Nat King Cole and Lena Horne. Gambling casinos run by Meyer Lansky, Santo Trafficante, and other U.S. mobsters proliferated; so did brothels and pornography. Few people guessed that soon the party would be over.

Yet serious problems remained. The prosperity did little to improve the poor housing, education, and health care in rural areas. Unemployment stood at about 17 percent. The concentration on sugar production was still much too great, making up 85 percent of exports. And Cuba still depended too heavily on U.S. trade and on the U.S. Congress for preferential quotas and prices.

In prison after his failed attack on the barracks, Fidel Castro was gaining a following, writing voluminously against the regime. In 1954 Batista committed a fateful error: He declared an amnesty for political prisoners and freed Castro, who soon left for Mexico to amass a force against Batista. There he met a wandering, young Argentinian revolutionary named Ché Guevara, who signed on to his movement. In 1956 his group of 82 set off from Mexico for Oriente, where six decades earlier José Martí had landed. Castro established his base in the Sierra Maestra, the southernmost, wildest, and highest area of Cuba, and one of its most beautiful. From there he and his followers planned Batista's overthrow.

Mindful of the power of the press, Castro courted journalists, particularly Herbert Matthews of the *New York Times*, who, swept away by the romance of it all, made him an international figure, a sort of Bolivar of the Caribbean. Castro convinced Matthews and others that he was a moderate, whose goal was the restoration of the 1940 constitution. He associated his movement with the ideals of Martí and Chibás and called for mainstream reforms—schools, health care, child welfare, jobs. At no time during his struggle against Batista did he strongly attack the U.S. or hint at Marxism. He spoke of the return of honesty and the rule of law. The U.S. government regarded him warily if ambivalently, some officials and politicans taking Herbert Matthews's benign view, others calling the movement Red-inspired (in fact, the cautious Cuban Communist Party didn't climb aboard until early 1958).

Though supported by business and labor, Batista was never able to muster mass political backing. Opposition to his dictatorship gathered throughout the fifties, with university students again at the forefront. Batista's censorship and repression against opponents increased. His special police used terror and torture in retaliating against Castro's guerrilla fighters; the bullet-ridden corpses of suspected partisans increasingly turned up on city streets. Public revulsion and antagonism toward the government developed. Meanwhile, disaffection, corruption, and disputes within the army prevented it from waging an effective, all-out war against the rebels.

And then, in 1958, the unthinkable happened: The U.S. government, Batista's supporter throughout his years in power, backed off, signaling its unhappiness with an arms embargo. Batista was devastated. The now widespread demoralization in the army and the withdrawal of support by the church and business groups further hastened the regime's demise. On December 17 the U.S. formally told Batista he had best retire. In the early morning of January 1, 1959, he and cadre of close supporters flew off to the Dominican Republic. Cushioning the blow were the many millions of dollars Batista reportedly had sequestered abroad.

AGAINST THE ODDS the 26th of July Movement had prevailed. A mood of rejoicing followed, full of hope for that new dawn that again and again over the century had proved elusive. At long last Martí's revolution could come to fruition. But the views that swirled around Castro were anything but uniform. They ranged from the moderate, which sought a return to the Constitution of 1940, to the radical, espoused by Ché Guevara and Fidel's brother, Raul, who felt only a dictatorship of the proletariat could prevent the U.S. from spoiling a genuine social revolution. It appears that Castro himself was uncertain about his aims, though not about the use of revolutionary techniques to achieve them. In 1964, Ché Guevara said of Castro's view on the eve of the revolution, "I knew he was not a Communist but I believe I knew also that he would become a Communist...and that the development of the Revolution would lead us all to Marxism-Leninism." Inside the U.S. government an important group argued strongly in favor of supporting a genuinely reforming government in Cuba. Thus, the U.S. moved swiftly to recognize the new regime, doing so on January 7, 1959.

Castro's hypnotic speaking style immediately gave him a remarkable hold over the masses, stirring up their feelings of nationalism. At first he preached moderation, insisted he was not a Communist, and promised the living standard would soon surpass that of the U.S. However, it was also clear that he would be the *"máximo líder."* Over the first couple of years,

U.S. policy vacillated between overtures and hostility. As "circus trials" unfolded, in which even some of Castro's early supporters were put to death, freedom of speech and press vanished, political liberties disappeared, and controls on citizens tightened, the U.S.'s efforts at "patience and forbearance" became seriously strained. Middle-class Cubans, many of them former supporters of the regime, began to flee; by March 1961 some 100,000 had emigrated to the U.S. and elsewhere. Before finally stopping his presses, the editor of *Bohemia* magazine, one of Castro's oldest supporters, wrote: "To carry out a profound social revolution, it was not necessary to install a system which degrades man to the condition of the State."

It's likely that relations with the U.S. were doomed to sour. Many intellectuals had dreamed of vengeance against the United States and saw the revolution as a chance to affirm a unique Cubanismo, with Spanish and African, not North American, roots. To be really free, ties would have to be broken. When the Castro government took over U.S. oil refineries for refusing to refine oil from the Soviet Union, the U.S. Congress cut off the sugar quota. Castro deemed it a declaration of economic war. The U.S. imposed a partial economic embargo, and Cuba nationalized remaining U.S. businesses. Relations rapidly disintegrated. By that time the CIA had been given the go-ahead to arm and train Cuban exiles. Campaigning for president in 1960, John F. Kennedy accused President Eisenhower of creating "Communism's first Caribbean base." Expecting imminent attack, Castro mobilized the country, with arms supplied by its new ally, the Soviet Union.

The disastrous April 1961 Bay of Pigs invasion, in which a U.S.-trained and -equipped Cuban exile force attacked the island's south coast, was a gift to Castro, for it brought the country together at a crucial moment. An economic crisis caused by the speedy takeover of most of the country's means of production had thrown the country into confusion; Castro's triumph over a hostile force backed by the U.S. was just what he needed to divert attention and consolidate power. The cry, *"Cuba sí, Yanqui no,"* was heard in the streets. The event also increased Soviet influence. For the first time, on April 16, Castro proclaimed that Cuba was a socialist state. He also called the 1940 constitution obsolete and said there'd be no further need for elections. By late 1961 he was declaring, "I shall be a Marxist–Leninist for the rest of my life." So as not to worsen its relations with the U.S., the Soviet Union initially did not want to meddle in Cuba. But by 1960-61, Soviet and eastern bloc aid began flowing in, and the Russians saw the value of using the island as a center of its Latin American activities. In placing nuclear missiles in Cuba in 1962, the Soviet Union took a gamble that came close to blowing up the planet. After several tense October days during which President Kennedy

demanded their withdrawal, the Cuban Missile Crisis ended with the Soviets dismantling the missiles, a secret U.S. promise to remove missiles from Turkey, and an understanding that the United States would not invade Cuba—the de facto acceptance of a communist country just 90 miles from U.S. shores.

THUS THE SOVIET UNION STEPPED IN to replace the U.S. as Cuba's patron, just as the U.S. had replaced Spain. Since his 1968 speech stating the goal of instituting "Communism and yet more Communism," Castro has tried to control every aspect of society. In that year he shut 50,000 small businesses, the last vestiges of capitalism. His accomplishments have been considerable—schools, health care, and housing for the rural population, the end of social discrimination, and the growth of a genuine nationalist spirit. But the price for these has been high. Even with Soviet subsidies estimated at six billion dollars a year, the economy fared poorly. Despite the outcry against the one-crop economy and the promise of rapid industrialization, the emphasis remained on sugar, and industrialization never happened. Further, sugar production has generally remained at the 1950s levels. Food rationing has been tight. There is limited self-expression and personal freedom. Only one major newspaper exists: *Granma*, the thin, official publication of the Communist Party. Opponents of the regime can be held in prison indefinitely without trial. The need to regulate everyone's life has created a system of government both oppressive and inefficient.

Now, since its abandonment by the Russians, Cuba has been on its own for the first time since the early 1500s. Castro has held power longer than any other political leader alive. His insistence on remaining communist has isolated him politically and economically and created terrible shortages and a living standard estimated by British historian Hugh Thomas to be below that of 1895. But Castro won't be budged. Dogmatic and fanatical, he possesses charisma and oratorical gifts that have enabled him to run Cuban society since 1959—exactly as he wants to. His leadership style has been colorfully described by exiled Cuban journalist Carlos Alberto Montaner, "Fidel sees himself vaguely as a super-macho who exercises a lover-tyrant authority over the country he has conquered. The bedroom where everything is aired is the rostrum. From the speaker's platform, Fidel punishes, loves, or scolds his lover, and all is done according to how 'obedient' and 'loyal'—traditional female virtues—the Cuban people have been. Angry or happy, in a posture of intimate promiscuity that no other political caudillo has attained, Fidel manipulates the Cuban people." ∎

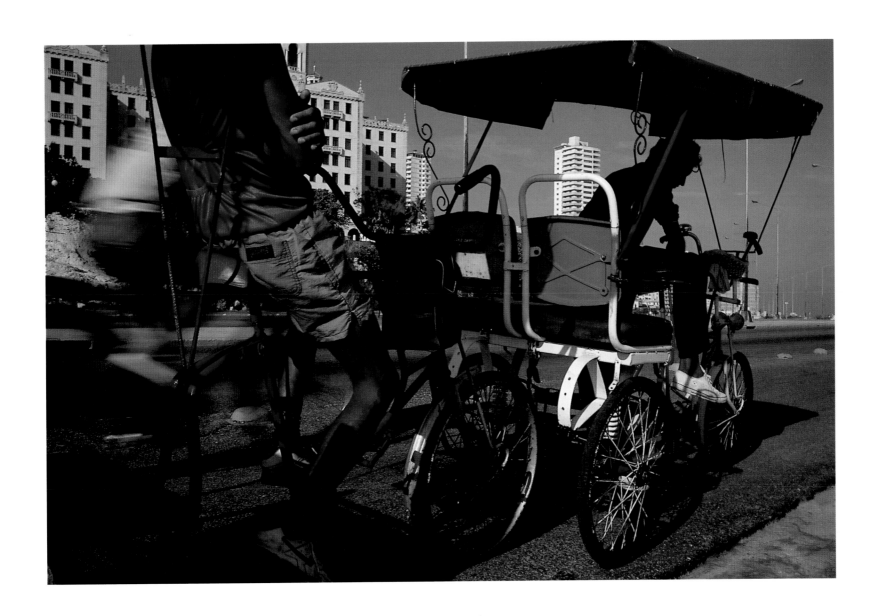

A chauffeured tricycle awaits a fare in front of Havana's Nacional Hotel, a glamorous icon of the pre-Castro days when Cuba–U.S. ties were strong. American movie stars and European royalty danced, dined, and by the late 1950s gambled away the wee hours in the hotel casino owned by U.S. mobster Meyer Lansky.

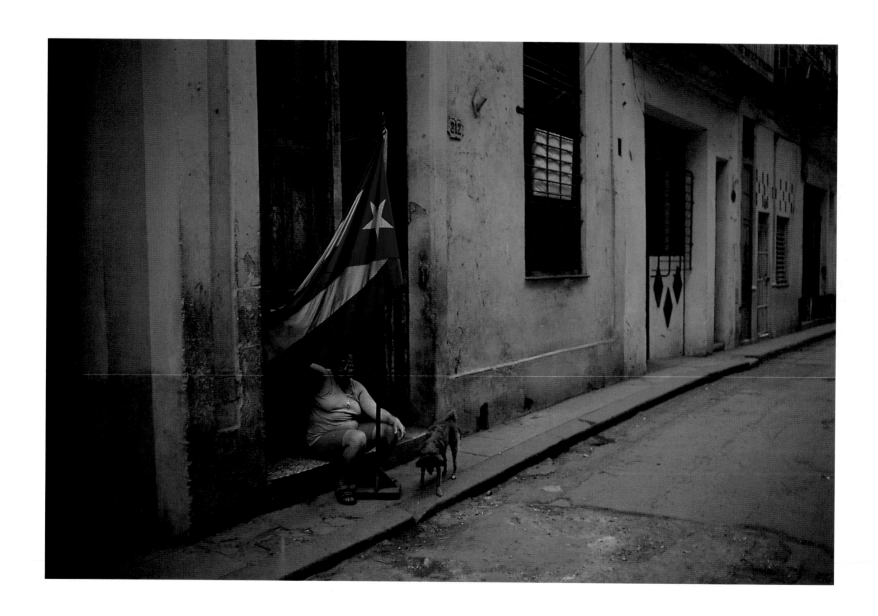

A Cuban flag in the doorway announces a meeting of the local Committee for Defense of the Revolution (CDR) in Havana. Elected block captains run the meetings, at which residents complain about blown street light bulbs, barking dogs, littered gutters—and delegate individuals to deal with the problems.

Illusion and Reality

TODAY, AFTER 40 YEARS OF REVOLUTION, Cuba floats in a sea of isolation and confusion. Cubans at all levels play parts in a surreal drama whose ending is not in sight, yet cannot be far off. Only Fidel Castro and his immediate circle gain from prolonging the drama, but for various complex reasons having to do with fear, demoralization, apathy, nationalism, and probably a residual personal loyalty to Fidel, much of the rest of society goes along. Most Cubans feel the revolution is finished and yearn for change, yet are not ready to buy into a new reality run by exiles in Miami. So they wait "for an outcome, a result, a finale," in the words of Argentine journalist Jacobo Timerman, who calls waiting the "inner dynamic of Cuba." And they debate endlessly about the next act, fearing their country may be rushing headlong toward a social catastrophe they are powerless to prevent.

The drama of Cuba's surreal present and uncertain future plays out against an ideally suited backdrop—beautiful, elegant, decaying Havana, once the "Paris of the Western Hemisphere," by day shimmering like a mirage and by night emerging ghostlike from dimmed street lights. The capital city's Spanish colonial heart and much of its extraordinary collection of 20th-century architecture have been preserved by neglect. Little has been built and little removed since the 1950s, when planners envisaged a steel-and-glass skyline. Today as residents decry overcrowdedness, leaky roofs, and crumbling walls, colonial Old Havana is being gradually restored, while preservationists, both in Cuba and the U.S., debate how to save the rest of the capital, whose range and breadth of 1900s

architectural styles—from art nouveau to modernist—are as rich as any city's in the world.

"Cuba has become one more Caribbean island," laments a Cuban-American living in New York. Her meaning is clear: Cuba has lost its identity, its specialness; it has become a second-class tourist haven, a far cry from the sophisticated and glamorous pre-revolution days. Though her argument is compelling, it's tempered by other evidence. For in one of the island's many contradictions, a cultural life appears to be flourishing. Under the government's very wary eye, music especially, but also art and books and films are breathing life into the island and giving Cubans reasons to keep going. And artists and performers, both Cuban and American, are increasingly beating tracks across the Gulf of Mexico, forging ties for the future.

Ironies and contradictions abound in today's Cuba. Foremost is the fact that the island turns on the U.S. dollar, currency of *yanqui* imperialism. In this communist state, many of life's most basic necessities can be obtained with U.S. dollars only. This obsession with the dollar is a neat metaphor for Cuba's obsession with the United States. Despite the decades-long official hostility, Cuba has stayed closely tied to its northern neighbor through affinity, culture, and family connections.

Before 1993 it was forbidden for Cubans to hold U.S. dollars. In 1991 the Soviet Union ended its estimated $6-billion annual subsidy, and the Cuban economy went into free fall—shrinking 35 percent between 1989 and 1993. As prices soared, salaries remained frozen. The government announced a "special period" of austerity, during which frequent black-outs, school closings, and severe medical and food shortages became commonplace. Social services, of which the revolution had been so proud, were greatly curtailed. And in the black market, an essential source of food for Cubans, prices skyrocketed.

Nearing bankruptcy and fearing riots, the government reluctantly moved to liberalize, including lifting the ban on dollars to individual Cubans to spur a flow of hard currency from abroad. To cycle the private cash into its own coffers, the Cuban government opened its own dollar retail stores selling high-price imported food and other consumer goods. The reform took some of the pressure off the government; families with dollars had legitimate places to spend them. But the dollar economy has created a Cuba divided sharply into two classes—those with dollars and those without them. Whereas before, as the saying went, everything was shared equally, including the poverty.

In late 1993 the government also permitted some limited self-employment. Hairdressers, home restaurateurs, auto mechanics, bicycle repairmen, taxi drivers, artisans, and other

such small entrepreneurs, who did not comptete with government enterprises, could now work for themselves under tight government regulation. To make more food available, farmers' markets were opened, allowing farmers to sell food directly to the public in pesos pegged to dollars. "It's a risk that government leaders have decided to take…because they have no other alternative," an official report states of the market-oriented reforms. Thus, small capitalist steps were needed to put Fidel's communist government back in control.

Party hardliners ("*los duros*") loathe the privatizing measures and discourage them with tough fees and regulations. In speeches Castro ridicules those who've profited as "millionaires"and *"criollitos"* (little Creoles) and accuses them of greed and corruption. "I know them, these little 'criollitos,' when they get hold of a little money, watch out!" he said in July 1998. "We now have elements of capitalism [in our society]… we are surrounded by microbes, vices, and temptations…money here, hard currency there."

You could call Mirta, a 27-year-old chambermaid at the Hotel Nacional, one of the new "millionaires." A lovely, English-speaking mulatto, she graduated from the university with a degree in biochemistry and spent 18 months at hotel school. Mirta now works 10-12 hours a day, 6 days a week, cleaning 15 guestrooms in this recently restored first-class hostelry perched on a bluff overlooking the sea. Although her salary is 248 Cuban pesos (about $12 U.S.) a month, she earns about $350 U.S. a month in tips—a small fortune by Cuban standards. With it she has built her husband and small daughter a house in the suburbs. Each month she contributes $10 U.S. to a hotel fund for employees who don't have direct contact with guests. "The bellboys contribute more because they make so much," she says. Everyone she knows at the hotel is a university or technical school graduate, some with advanced degrees. "I am very happy with my job and feel fortunate. Someday I'll go back to biochemistry; you don't forget what you learn."

An often repeated joke has a wife consulting a psychiatrist about the odd behavior of her husband. All afternoon he has been screaming through his apartment window at passersby: "I'm a bellboy at the Riviera Hotel!" "It's sad," says the doctor, "but clearly he's suffering from delusions of grandeur. Everyone knows he's only a brain surgeon."

The joke conceals the real anger felt by many white-collar professionals at the inequity of the dollar economy. After spending years climbing the ladder and contributing to society, they see themselves left out of this new world. Cubans are known to be smart and practical; they can also be resourceful and entrepreneurial, finding opportunity where little exists—by *inventando*. The nearly one million Cuban immigrants in the United States have been

among the most successful U.S. immigrants, say relief agencies; they led the transformation of South Florida from a 1950s backwater to one of the country's most dynamic regions. (Another joke asks, "What are the revolution's major accomplishments?" Answer: "Education, universal health care, and the city of Miami.") It's hardly surprising that many Cubans—especially those with access to tourists—have used their entrepreneurial talents to exploit the country's small economic openings, some earning several hundreds or thousands of U.S. dollars a month, far more than the monthly peso salary (equivalent to between $8 and $20) of doctors, lawyers, teachers, and government officials.

Before the crumbling of the Soviet bloc, academics like Carlos García, a distinguished chemical engineer, a highly published professor at the University of Havana, and a member of the Academy of Sciences, earned good salaries in relation to prices. They could eat and dress decently and travel inside Cuba; many were assigned cars. Now they feel betrayed because their peso salaries buy them next to nothing. So, like everyone else, they adapt. Some drive taxis; others work in hotels or sell bootlegged videos made off illegal satellite dishes.

In his special position, García is able to supplement his 160 peso ($8 U.S.) monthly salary with expenses-paid invitations to conferences outside Cuba. Rather than use the dollars abroad, he stays at the homes of colleagues, banks the expense money in Florida, and brings it in little by little to live on. Sixtyish and widowed, Garcia lives in a minuscule 4-room apartment outfitted with electronic equipment in a tumbledown building in Havana's Miramar section. He recently acquired the apartment through two housing swaps—the most common way to move since there's no property ownership. Though priviledged himself, he deplores the material deprivations and inequalities his countrymen are subjected to. But what's worst, he says, is how years of repression deaden the spirit. "So many avenues have been closed off that people have no aspirations. There's nowhere for their souls to fly."

THE CUBAN GOVERNMENT LOOKS to the self-employment and the tax revenue it supplies—along with dollar remittances from abroad, tourism, and foreign investment—to spur the economy. But they've imposed such punitive regulations and taxes that many people say "no vale la pena" (it's not worth the effort). Thus the numbers of self-employed dropped to about 150,000 in 1998 from a 1996 high of around 208,000. A family licensed to rent one room in its house, for example, pays as much as $250 U.S. in monthly fees, whether it's rented out or not; a private taxi driver with a broken-down Russian Lada must pay a hefty sum a day to the government, forcing him to work long hours for a small profit. The govern-

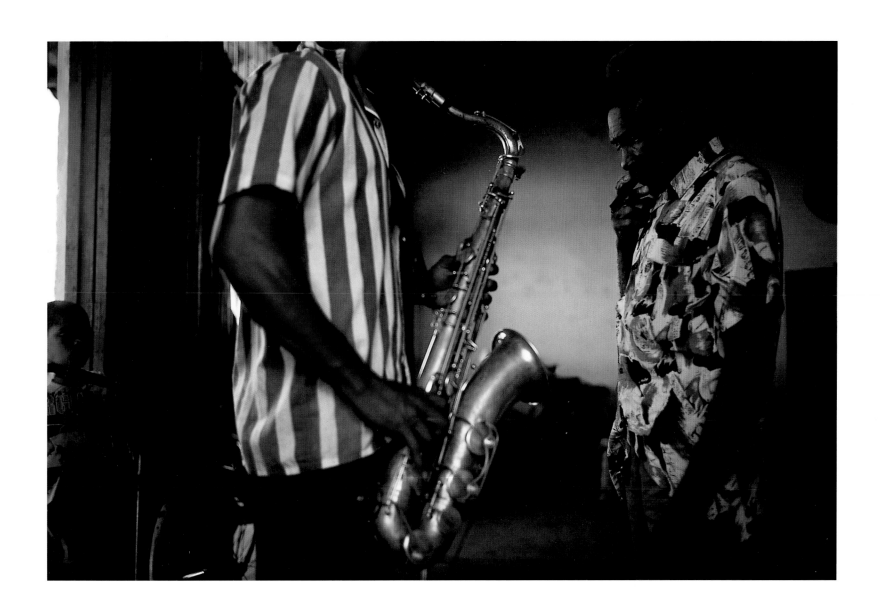

"There's music everywhere you go in Cuba," says photographer Harvey. After a concert by an impromptu band outside Trinidad, the musicians gathered to demonstrate new licks for each other. Cubans seldom get to hear their nation's finest musicians; they spend most of the year overseas on concert tours.

ment does not permit too much success: *Paladares* (restaurants in private homes) that violate the 12-seat maximum, are staffed by other than immediate family, or serve shellfish are fined 1,000 pesos, or shut down; repairmen with too many clients are forced to close their shops. At the artisan markets, inspectors harass craftsmen who look like they're selling too much.

The private enterprise is tolerated only as a buffer against economic crisis; as the situation improves, regulations tighten. The result is an endless push-pull—a continual easing up and cracking down that keeps everyone on edge.

The gulf between official rhetoric and the reality of everyday life has bred a pervasive cynicism. Everyone is forced to get by as best he can by *inventando*. Pilfering from the workplace is common, and in rural areas livestock theft has become so rampant that some farmers take their cows into their houses at night. Efforts to quash *jineteros*—prostitutes—have gotten most off the streets, but other hustlers who feed off tourists carry on openly, including gypsy cab drivers and black market sellers of cigars and rum, bootlegged videos and CDs. "*Bajo la mesa*—under the table" describes many transactions. This breakdown in morality and the social structure alarms many observers, who wonder how you put the genie back in the bottle. And it makes a mockery of the revolution's often stated goal of creating a "new socialist man," devoted to justice and equality over selfish material interests.

Still, life is better than in 1992, when food was so scarce that some cafeterias served only sugared water. The availability of dollars has eased the hardship for many people. With her paladar in Vedado, María Contrera earns in a month nearly 90 times what she once earned working as a government accountant. "The worst is over," she says. "We were starving, but things are much better now. People are happier." Yet few dreams remain. "Before it was possible to dream within the system, to travel to socialist countries, to have a house, to buy a TV," says Héctor Pérez, a 39-year-old black intellectual. "Now the dream is to work somewhere you can get dollars, or to get out."

The access to dollars has also created a keen taste for *ropa de marca*—designer labels— electronic equipment, and other trappings of capitalism. Among scores of dollar stores in Cuban cities and towns, the Carlos III is a four-story mall in Central Havana selling brand-name washing machines, toys, watches, linens, dresses, stereos, sporting goods, as well as hip Nikes and Reeboks. A food court offers ice cream, pizza, and Coca-Cola. Elevators blare music. A few blocks away sits a typical peso store. Dimly lit and bleak, its barren shelves display a few bolts of low-grade fabric, some poor quality costume jewelry, a small selection of baseball caps and scarves, a couple of ceramic figurines. In no stores are computers,

copiers, or faxes available to ordinary Cubans, regardless of means; the regime considers such equipment potentially threatening and subversive.

What alarms outsiders are the differences between the peso and dollar food stores and pharmacies. The largest dollar market in Havana, known to many as the *diplomercado* for its pre-1993 status as a diplomats-and-foreigners-only store, resembles a U.S. supermarket, albeit a seedy one, with self-service shelves brimming with imported, brand-name canned and packaged goods, bakery items, produce, dairy products, soft drinks, beer, and wines. At the small peso food shops, by contrast, basic and meager foodstuffs sit in bulk containers behind counters and are carefully measured out and noted in the *libreta*—ration book. Peso pharmacies try to stock medicines for chronic conditions, but other essentials from chemotherapy drugs to antibiotics to aspirin are scarce or nonexistent, replaced by a variety of herbal concoctions, while the dollar pharmacies stock most medicines, imported from abroad. The ordinary Cuban without dollars can purchase a drug only at the one peso pharmacy his doctor's signature allows him access to. To try to find a medicine at another store, the patient must track down its assigned doctor and get him to sign a form. "*No tiene la firma*—you don't have the correct signature," is the common, disheartening refrain.

But medical care is free to all Cubans, and in Havana hundreds of dedicated family doctors work long hours under difficult circumstances to do their best for their patients. Many take the attitude of Dr. Luis Brito, who receives a furnished apartment and 400 pesos ($20) a month from the government: "You must understand that I am a son of the revolution," he says. "I grew up with the revolution, and I believe there is always a solution here." Doctors proudly point to the low infant mortality rate, similar to that of the developed world.

Héctor Pérez is also a son of the revolution, one with occasional access to dollars. Highly educated, Pérez spends his days in a job at the University of Havana. He and his wife, who works at a nursery school, together earn about what Dr. Brito does. They have two children, ages 4 and 7, and live in three rooms in a poor neighborhood, without phone, running water, or amenities except a television. Héctor's father was a Communist before 1959 and a strong supporter of the revolution. Héctor grew up very pro-Fidel, but today makes no secret of his unhappiness. He resents the obsession with control and longs for a better life for his family. Of Fidel's speeches proclaiming the revolution's accomplishments, Héctor scoffs: "They speak of a world that doesn't exist."

But Héctor, like most other Cubans, ponders a dilemma: What will come next?

To him and his friends, who endlessly debate the future (he jokes that a common sign on

front doors is *"Prohibido hablar de eso"* (forbidden to speak of that), the central question is how can Cuba maintain its independence vis-á-vis the United States? How can Cuba avoid being overrun by the predominately white Cuban-American exiles in Miami? How can the country accept the huge amount of U.S. aid that will be necessary to get it back on its feet, providing it's offered, without again becoming a U.S. vassel? "By inviting in socialism, we also invited in backwardness. Who is going to bail us out and what price will we have to pay?" he asks.

To Héctor and countless others the deepest problem is race, "the burning heart of the matter." Blacks, along with *campesinos*—small farmers—have benefited most from the education and health policies of the revolution, and today Cuba has a far less white population than it did in 1959 (more than 50 percent is black or mulatto compared to perhaps a third in the 1950s). Cuba was never as segregated as the United States, and though racial discrimination existed, it was much less rampant than in the U.S. The Constitution of 1940 expressly forbade it, and Fidel Castro never mentioned a race problem in speeches or writings before 1959. General Batista, Fidel's predecessor, was himself a mulatto, and his army and police force were full of men of color. Blacks saw in him one of their own and for the most part supported him against Castro.

Before 1959 black and white illiteracy rates were similar; the quality of education and health care had much more to do with where one lived than with one's color. Though blacks were well represented in the arts and sports and in the tobacco industry and many lower-class professions, there were few black doctors, lawyers, or teachers. In the 40 years of revolution, both blacks and whites have benefited from more schools across the island, including 57 institutes of higher learning, and have risen on the social ladder as doctors, lawyers, professors, and army officers. Blacks took pride in Cuba's involvement in Africa's 1960s and 1970s wars of liberation and in efforts to revive Afro-Cuban culture in the name of nationalism. Though one has only to look at the largely Caucasian top ranks of the Communist Party and the military to see that communism has not stamped out racism, in public people of all black and white shades mix easily.

So while blacks like Héctor have no illusions about where the revolution is going, they are not ready to overthrow Castro in favor of the financially powerful, predominately white majority of Miami Cubans. Castro fans the flames of this fear. On his first trip to the U.S., Héctor was amazed to find that as a black he was treated with friendship and respect, contrary to everything he'd been taught to expect. But blacks in Cuba already see their status eroding. They felt slighted when the pope visited in 1998 and met with representatives of

Sometimes Castro allows citizens to open their homes as restaurants; sometimes he doesn't. Here, a woman and her family offer visitors one of Havana's most beautiful sunset views overlooking the Malecón and Castillo del Morro. The menu at this home restaurant is standard Cuban fare: seafood, pork, and chicken, along with fried plantains and moros y cristianos—mixed rice and beans.

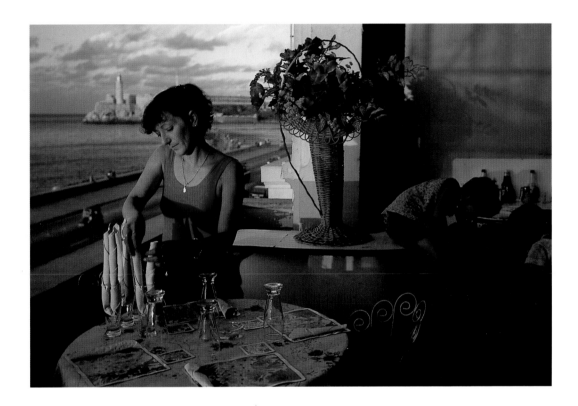

the Jewish and Protestant faiths but refused to see members of the Afro-Cuban sects. Blacks are much less likely to have relatives abroad with dollars to send. They also feel discriminated against by Europeans in joint ventures, especially in hotels and other businesses catering to tourists. Thus, in the two-tiered economy a great many on the lower tier are black.

"Everyone is trying to figure out where they fit in the new world," Héctor Pérez says. He himself makes a modest go of it by arranging to give lectures abroad every year or two. He could easily defect but wouldn't think of leaving his family behind. His goal is to bring home $600 each year; that combined with the meager and uncertain government ration of sugar, rice, beans, a few eggs, some cooking oil, a few ounces of coffee, and the occasional bit of toothpaste, soap, and detergent will sustain the four of them on a very basic level for a year. "*Con $50 al mes se va tirando*" (With $50 a month you get along).

Héctor is startled to hear about Jorge, one of his fellow countrymen who does a lot better than just get along, earning on some days up to $50. A gregarious, 40ish, self-taught

English-speaking "fixer" for foreign businessmen, Jorge is one of the new breed of successful entrepreneurs, proficient at working the system and unafraid of risk. Like everyone else, he's on the make, only he's more successful at it. He likes his amenities—a suburban house he shares with his brother, stereo equipment, American CDs, restaurant meals, girlfriends. He'd leave Cuba in a flash were that possible (and every year that the U.S. holds an immigration lottery he applies), but his next greatest desire also eludes him—to acquire a car.

You have only to take a short walk on a Havana street to see the lengths Cubans go to keep their beloved cars running. The 1950s Buicks, Plymouths, Fords, Studebakers are famous—no one knows exactly how they hold together. Soviet Ladas from the 1970s are also much in evidence. Today you also see recent Fiats, Toyotas, and Hyundais, driven by VIPs, official taxi drivers, foreign residents, and tourists. However, it's nearly impossible for an ordinary Cuban to own a car, and many Cubans dream of having one. Jorge is among a tiny minority who could actually afford the purchase price. Ordinary Cubans can buy pre-1960 cars, if they can find a working one for sale, but only foreigners or status Cubans, such as government officials or recognized musicians or artists, are permitted to buy more recent models. And anyone who wants to sell a car, other than the classic models, must do so to the government. The only way Jorge can buy a car is first to unofficially "lease" the permit of a status Cuban for $1,500, but it's risky because he'd have no claim on the car's title.

FOR A SMALL ISLAND NATION, Cuba traditionally held an outsized place in world culture. From the 1930s its music enjoyed worldwide renown, and its literary tradition is one of the oldest in the Americas. José Martí ranks among the 19th-century's greatest prose writers in Spanish. Many Cuban names, such as José Lezama Lima, Alejo Carpentier, poet Nicolás Guillén, Guillermo Cabrera Infante, rank among the best writers of the 20th-century Spanish world. Many of the best writers went into exile, however, and the revolution's control of all publishing made it a near impossibility to get into print any but the most politically correct works. With the help of a writers and artists union formed in the early 1990s, some of the old boldness and originality now appear to be resurfacing in stories and novels that bespeak the pain of dashed hopes, explore gay lives, and celebrate survival.

In the visual arts today the range and quality of painting, sculpture, pottery, photography, poster art, and filmmaking are impressive. Paintings vibrate with passion, color, and sensuality, often mixing Afro-Cuban and Roman Catholic icons in a rich, exotic surrealism. Numerous sanctioned artists, such as Nelson Domínguez, Zaída del Río, Roberto Fabelo,

and Pedro Pablo Oliva enjoy international reputations and exhibit abroad. In Havana, art schools and exhibitions, including a prestigious Biennale, abound. A film festival held every winter attracts important actors and filmmakers from the U.S., Europe, and elsewhere in Latin America. Students from all over the developing world attend the international film school at San Antonio de los Baños, sponsored by Colombian writer and Nobel prize-winner Gabriel García Márquez. Cuban films and comedy get away with hilariously, and poignantly, spoofing the economy, tourism apartheid, jineteros, and the endless scrounging for dollars.

But above all Cuba is music. The island has always been a mainspring of sound, expressing Cubans' intense joy in life, sensuality, and machismo. García Márquez calls it the "most dance oriented society on earth." "That Fidel Castro is the only Cuban who can't dance," says a Cuban-American, "should have warned people about him from the start." Cuba's Africanness mixed with the Spanish and suffused with North American jazz accounts for the rich originality of the sound. Many of the dances such as the conga, rumba, and mambo evolved directly from African religious dances, and from the marriage of Spanish guitar and earthy African rhythms came the classic Cuban *son*, which forms the roots of today's salsa. In the 1920s jazz became part of the mix. Cuban son swept the world from the 1930s until the revolution. Led by such bandleader greats as Beny Moré and Pérez Prado, it spawned new dance music throughout Latin America and created Latin crazes in Europe and the U.S. The famous Havana nightlife of the '50s was as much about music as it was nightclubs, gambling, and prostitutes. Early on the revolution tried to replace dance music with a '60s type of folk music damning Yankee imperialism and extolling revolution, but most Cubans never warmed to it.

Today once again the Afro-Cuban beat is very much alive—and it's hot. More than ever music holds the country together, acting as a refuge and a solace. Even baseball games vibrate to the undulating beat. Now son is enjoying a revival, with modern arrangements, chords, new derivatives, and groups such as Los Van Van, the Afro-Cuban All Stars, the Buena Vista Social Club, and Arte Mixto all basking in fame abroad. The sound of the moment is called timba, a mix of jazz and rumba seasoned with reggae and funk. Today some 12,000 state-salaried musicians play nearly 30 different genres; a handful have become stars—and prime examples of Castro's new *millonarios*. As in many other areas, the regime both profits from and deplores the freedom the music scene represents and continually looks for ways to control, to regulate, to crack down. The freedom is tolerated because recordings and foreign tours bring in hard currency—and attract tourists to the island.

The rich vibrancy of Cuban music and art flows directly from the religions of Africa. Though Roman Catholicism was the official religion until the revolution, it was never much practiced beyond the urban middle and upper classes. Even Anthony Trollope in his 1859 visit noted that "Roman Catholic worship [is] at a lower ebb in Cuba than almost anywhere else." The masses mostly subscribed to a system of mystical spiritualism, whose most important branch, Santería, fuses the religion of the Yoruba-speaking people of Africa with Catholicism. It developed during slavery, when the practice of African religions took cover in the guise of Christianity. Thus, the African *orishas*, spirits representing powerful forces, correspond to icons in the Catholic hagiography. *Santeros* or *babalaos* act as mediums, interpreting commands and listening to complaints, advising, and solving problems. Offerings are made to the orisha and sometimes sprinkled with the sacrificial blood of animals. Magic plays a central role. Today, Santería's pervasiveness, and that of similar sects Abakuá and Palo monte, is striking—and by no means among blacks alone. Many white-collar professionals, artists, musicans, and TV people—both black and white—subscribe to it, seeing in it an affirmation of their national identity, their *cubanía*.

That this identity includes a religious dualism with strong elements of magic figures in the irony and ambiguity, the mystery and intrigue that permeate so much of society. It's not unusual for educated Cubans to practice Santería at home and attend Mass on Catholic holy days. In the years before 1991, the year the government sanctioned the practice of religion, Santería was tolerated as a cultural expression. Now it's part of a general resurgence in religion, apparently spurred by the pope's 1998 visit, as well as by the general disillusionment, the breakdown in morality, and a hunger for answers to life's questions that Marxism can't supply.

IF MUSIC AND ART AND RELIGION feed the spirit of the Cubans, the restoration of Old Havana is breathing new life into one corner of its capital city. It's astonishing what's happening there—and how it's being accomplished—through the energy, drive, and connections of one man, Eusebio Leal Spengler, and his mini-capitalist empire. Whereas much of the rest of Havana proceeds at a slow, dispirited pace—with queuing and loitering major occupations—the old city hops, its streets bursting with people and activity. Workers on the restoration not only labor at a clip, but seem genuinely excited about what they're doing.

From its beginnings in 1519 as a frontier port town, San Cristóbal de la Habana grew to become the Key to the New World and the chief transfer point for ships carrying treasure from the Americas to Spain. Ever present threats from pirates led to the building of

fortresses, sentry towers, and by 1767 a massive city wall, which turned Havana into one of the Americas' most fortified cities. Inside the wall were 179 blocks, 56 streets, 5 plazas, 14 churches and convents, and 6 military barracks. The city soon expanded beyond the ramparts; and in the 19th century, as sugar transformed the island from a gold and silver warehouse into an economic power in its own right, the pirate attacks waned, and the walls were pulled down. Today, the area known as Old Havana encompasses 530 acres, 242 city blocks, and some 4,000 buildings, of which 900 are considered of major cultural importance. These include churches, convents, plazas, parks, factories and warehouses, and mansions with large porticoes and loggias, where Creole gentry once took their ease.

All of this was deteriorating by the early 20th century. By then the rich Cubans had largely abandoned Old Havana for western and southern suburbs increasingly American in style. In the 1930s, restoration began on a few of the most prominent colonial structures, such as the cathedral, but in the fifties efforts flagged. Though the revolution took up historical preservation as part of its efforts to promote nationalism, the absence of funding slowed its progress. Old Havana's 1982 designation by UNESCO as a World Heritage site brought ambitious plans but little money. Lack of maintenance in the high heat, humidity, and salt air, plus persistent termites, had taken a terrible toll. The area had become a slum with mansions now *ciudadelas*—little cities, made up of families living in single rooms amid decay and rotting garbage. It was not until 1994 that preservation efforts began in earnest, under the tight control and supervision of Eusebio Leal, the official historian of the city.

A scholar and politician, member of the Communist Party's central committee and an intimate of Castro, Leal is a dynamic, charismatic, and compulsive visionary, whose fondness for the public eye cannot obscure his success in reviving Old Havana. The state-owned companies he controls, independent of any government agency, manage real estate and develop and run hotels, restaurants, cafés, offices, art galleries, and shops in the restored buildings. In yet another striking irony, Leal uses restoration the way American architects and developers do—as a means of development. The grandest structures are turned into museums or used for other cultural purposes. Most of the new hotels—five opened in 1999—are joint ventures with foreign companies. The Old Customs House, funded jointly with the Spanish, now has 79 foreign companies as tenants. The profits from Leal's enterprise—more than $40 million in 1998—are divided between his restoration projects and the government.

No restoration or business venture in Old Havana proceeds without Leal's approval. Since residents have no claims on property, Leal can displace them at will, though those who cooperate end up in better housing either in the area or elsewhere. And he's determined to keep Old Havana alive as a residential community with apartments, schools, social programs, and hospitals. Given Leal's large presence on the scene in person, as well as in books, articles, videos, and a weekly TV show, it's hardly surprising he draws

criticism—from some city planners and architects, who feel that too much money is being spent on colonial buildings at the expense of the rest of the city; from critics who see a tourist enclave of picturesque perfection emerging, an "Old Havanaland"; and (sotto voce) from government officials who resent Leal's power and would love to see him fail.

The results, however, are visually stunning. Scores of handsome Spanish baroque and neoclassical structures have risen from the ruins, the work of technically sophisticated young architects. Though a huge amount of work remains to be done—the ambitious master plan stretches well into the future—the Old Havana restoration is already succeeding in at least one respect: It's helping draw large numbers of visitors to Cuba and toward a goal deemed essential to the government's economic recovery plans—2 million tourists by the year 2000.

But what of the rest of Havana?

"They do not have any consciousness of the breadth of 20th-century architecture in Havana, where we received every style in a very short period," Eduardo Luis Rodríguez, a young Cuban architectural scholar, is quoted as saying of the government and potential foreign investors. "But unlike the colonial buildings none of it is protected." One can see the range and quality all over the city and suburbs—beaux-arts clubs and casinos, art deco sky-scrapers and cinemas, Spanish colonial mansions, post World War II modernist houses and commercial buildings. Spectacular in its ambition, the architecture speaks poignantly of Havana's former place as one of the world's most elegant and cosmopolitan cities. Mer-chants, industrialists, and sugar barons, who fled after the revolution, owned most of the grand houses; today, though some are occupied by foreigners or used by the government, most lie abandoned or appropriated as ciudadelas and have dangerously deteriorated.

That urban development will come at the expense of the architectural heritage greatly concerns many Cuban architects, scholars, and planners. They despair that the country's economic plight makes the government incapable of coherent planning; of repairing older buildings; and of being discriminate in approving new development projects, even ones that jeopardize important architecture. And it's not politically correct to criticize such projects; those who do are labelled "aestheticists." In a final, sublime irony, it is a group of Cuban-Americans in Miami who are loudly lobbying the communist government to adopt building codes and other protective regulations to save this architectural treasurehouse from destruction. Says Raúl Rodríguez, a Coral Gables architect, "Too strong an infusion of unregulated capital will bring it down. Isn't it significant that it is those of us who live under a capitalist system who are now preaching abstinence?" ■

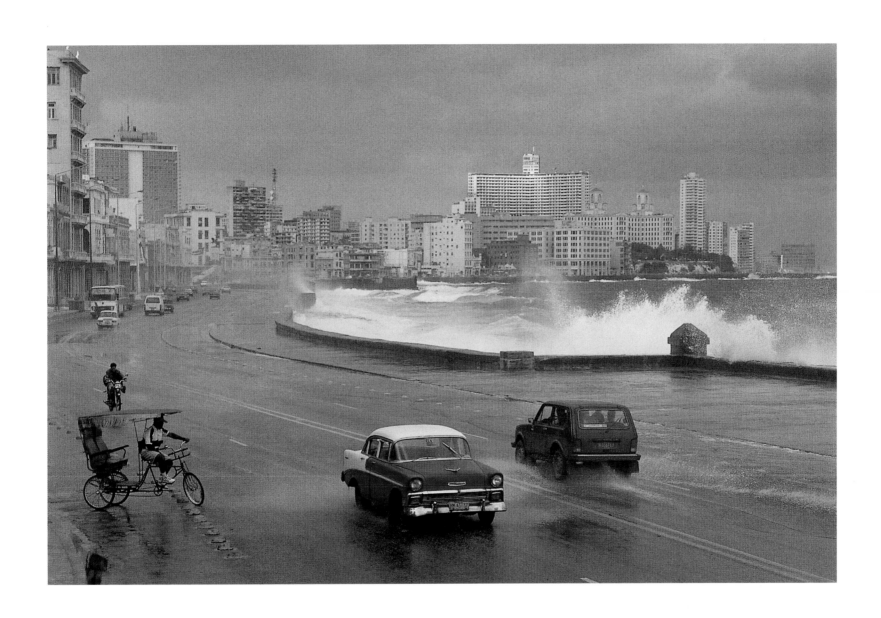

Waves across the Malecón spray haves and have-nots alike as a sea change in finance erodes hard-line Cuban socialism. Foreign investors, excluding Americans, come to the high-rises of Havana to get in on projects like hotels, textile plants, and mines. "You have to be here if you want to do business," says a German railroad consultant.

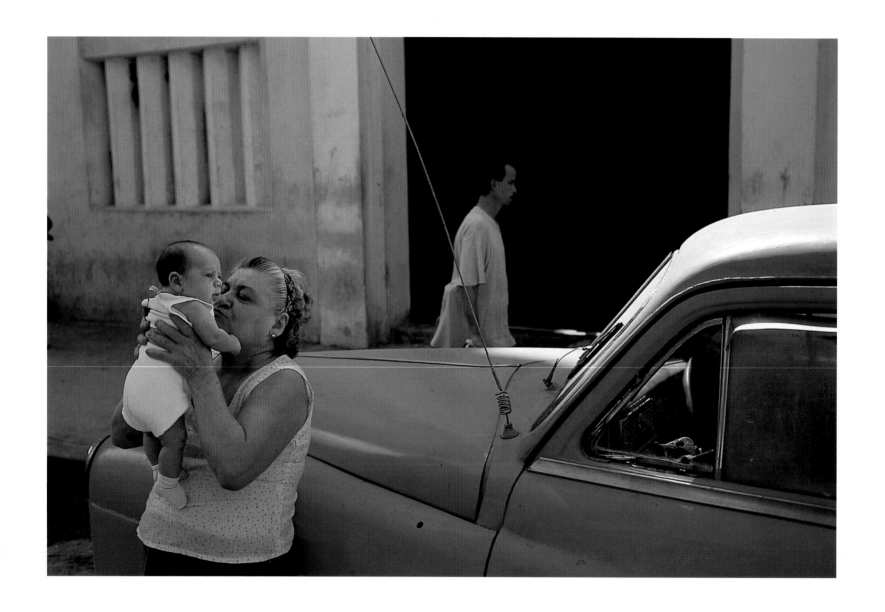

Some 2.2 million people live in Havana, the magnificent, crumbling capital of Cuba. Downtown is a center for business and tourism, but there are thousands of residences as well: among them once-grand houses dating from the 18th to the mid-20th century, as well as Soviet-style apartments, built since the revolution.

Havana

Havana days are the softest I know, the golden light of dusk spangling the cool buildings in the tree-lined streets; Havana nights are the most vibrant and electric with dark-eyed, scarlet girls leaning against the fins of chrome-polished '57 Chryslers under the floodlit mango trees of Prohibition-era nightclubs. Whatever else you may say about Cuba, you cannot fail to see why Christopher Columbus, upon landing on the soft-breezed isle, called it "the most beautiful land ever seen."

PICO IYER, FROM *FALLING OFF THE MAP*, 1993

Hot clothes and cool cash from abroad brighten Cubans' lives. Against Havana's gray stucco-and-concrete canvas, fashion-minded Cubans create splashes of unexpected color. Relatives send as much as 800 million dollars a year. "If I didn't get money from my daughter in Miami," says a Havana retiree, "I couldn't make it."

Disadvantaged in the stratified Cuban economy are those who rely on government stipends of food and pesos for survival.

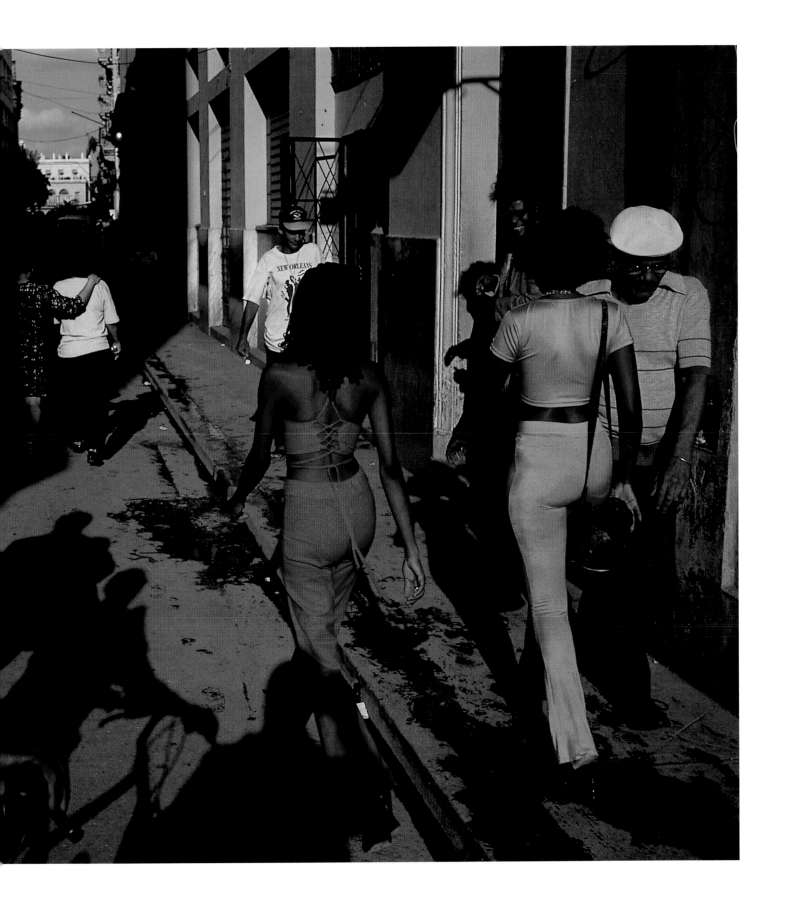

Through the door of a Havana farmers market, an *agromercado*, farmers from the surrounding countryside bring their surplus crops of root and green vegetables, fruit, grains, and meat. The government alternately tightens and loosens free enterprise, but none of the market farmers are getting rich. Currency at the stalls is strictly limited to nearly worthless pesos.

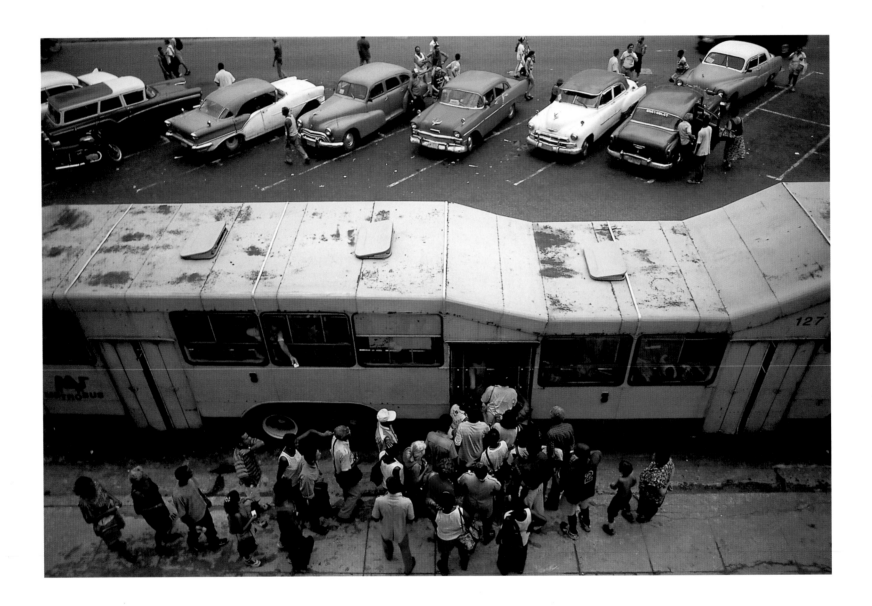

They're hot, they're jam packed, they're unreliable, they're a breeding ground for pickpockets and Casanovas with wandering hands: They're Havana's buses, nicknamed "camels" for their humpbacked appearance. Up to 300 people crush onto a camel at a time (opposite), their conversations drowned by the sound of the diesel truck that tows the trailerlike beast through the streets. Still, at a couple of pesos a ride, it's nearly free.

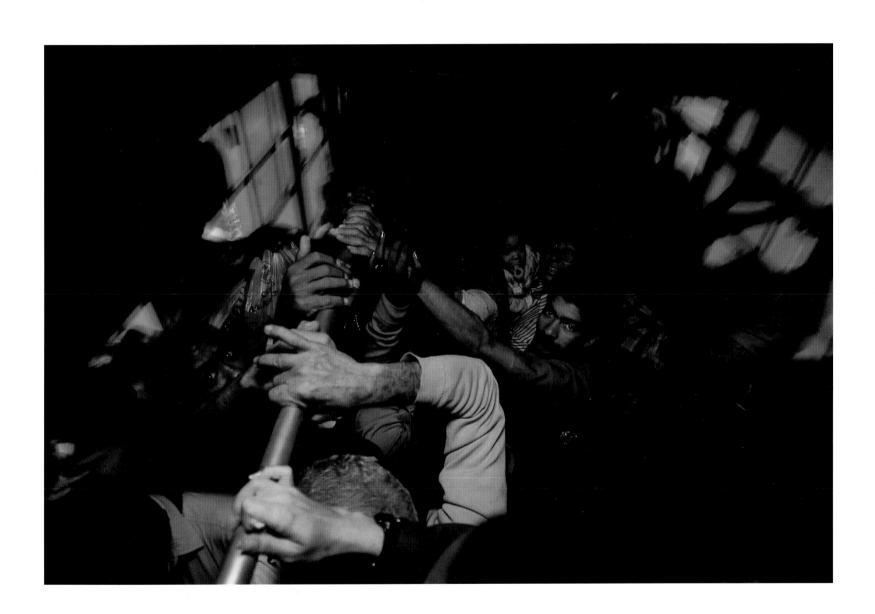

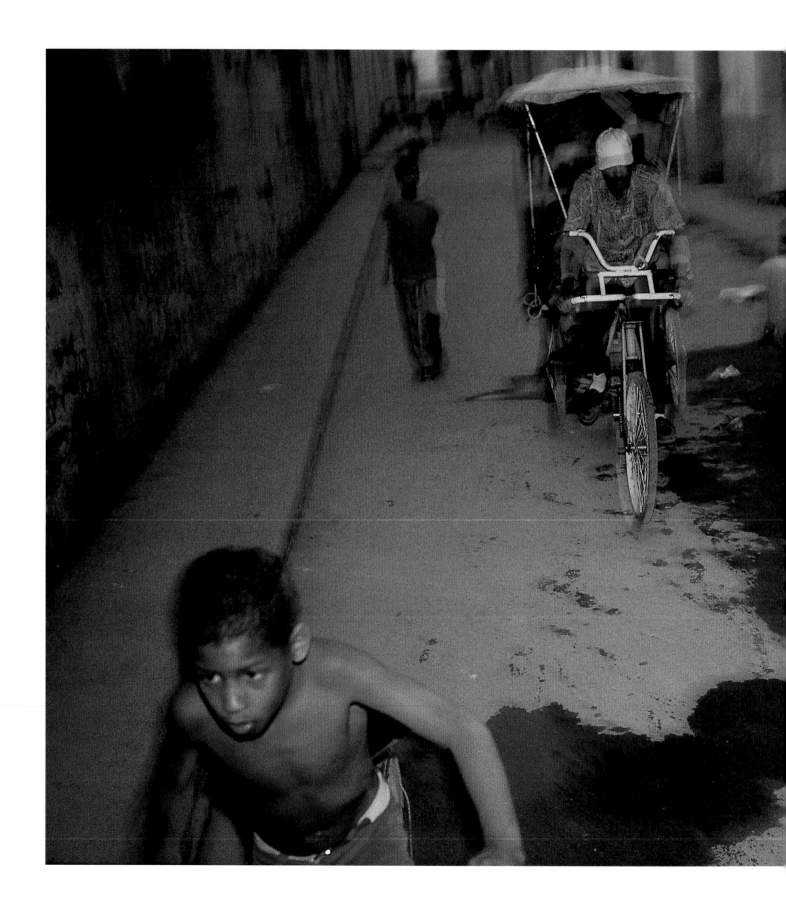

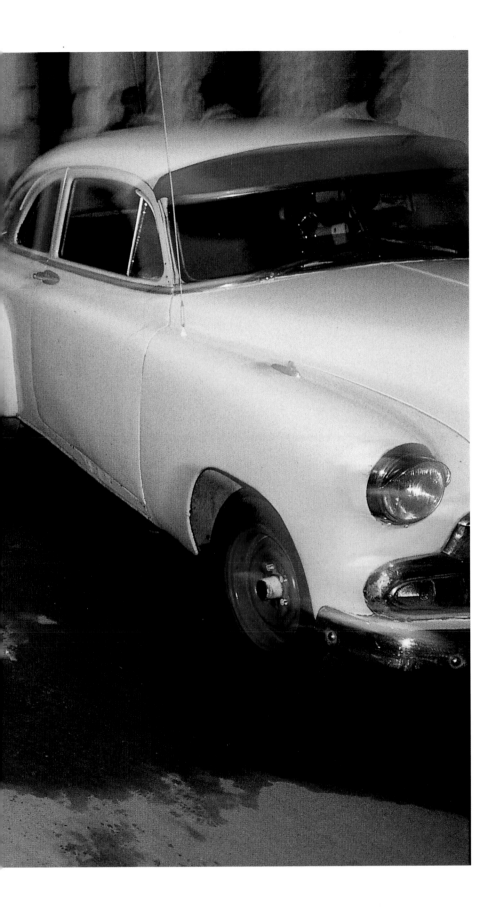

Depending on the time
of day, it's often faster to
get around Old Havana
on a rented tricycle taxi.
And if you happen to be
Cuban, it may be one of
your few options.

The produce that local farmers roll into Havana's markets is fresh by necessity: There are no refrigerated trucks for hauling vegetables and fruits from distant reaches of the island.

After the Communist revolution, some 12 percent of Cuba's arable land was left in private hands. Except for a period in the 1980s, however, free farm produce markets were not allowed until 1994, after the collapse of the Soviet Union and its devastating impact on Cuba's economy.

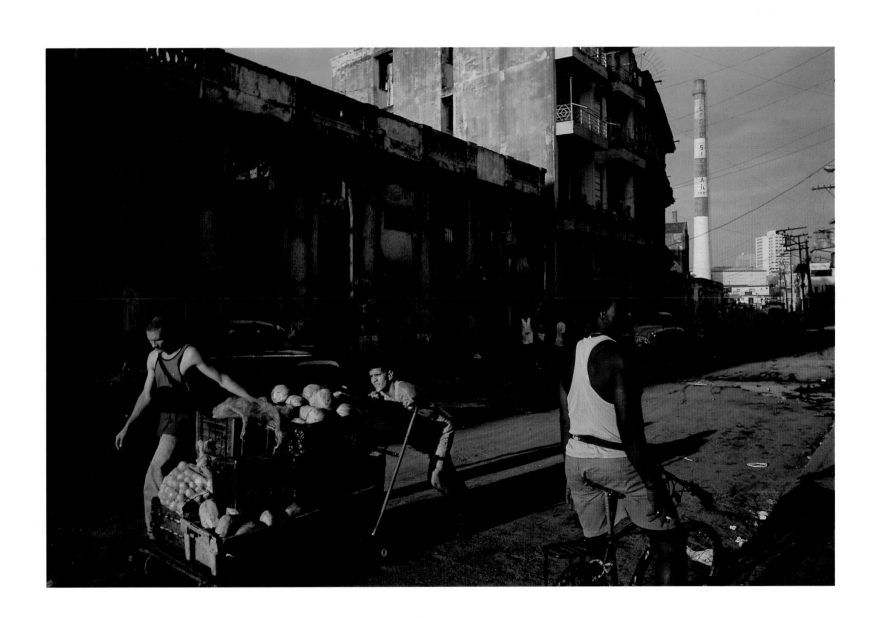

They call it baseball, but the batter hits the ball with his hand, and a teammate is poised for a mad dash to first base—which also happens to be the only base on this "field," a paved area between two Havana buldings.

"In some ways," says Harvey, "it's more like the British game of cricket than baseball."

But it is baseball that is Cuba's sports passion. And like a bunch of stickball-playing kids dodging traffic on a busy Brooklyn street, these youngsters have put a decidedly local twist on Cuba's most beloved American import.

"We love U.S. culture," says one city resident. "We play your sports, study your language, and know all of your Hollywood stars."

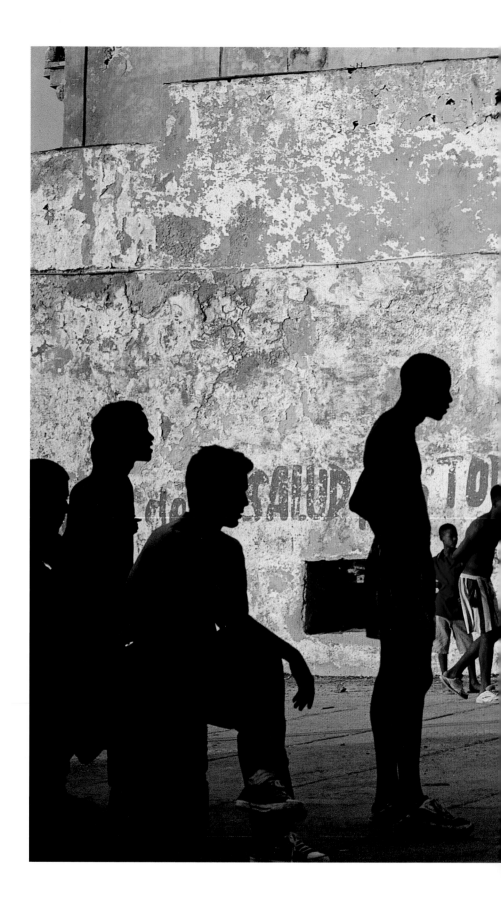

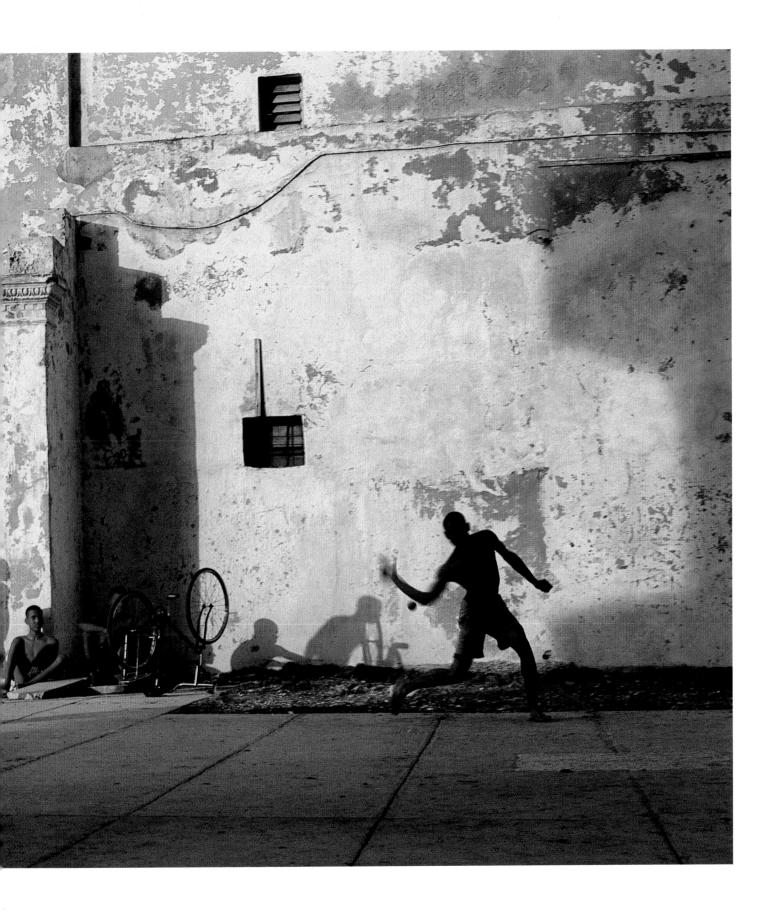

Big-league dreams come true for a lucky youngster who takes the field with the Havana Industriales, one of the city's professional baseball teams (above and opposite). They play in Estadio Latinoamericano, the Yankee Stadium of Cuba, where in 1999 the visiting Baltimore Orioles barely eked out an extra-innings win against a Cuban all-star team. The Orioles' yearly payroll is $78 million. The Cubans combined make $2,250.

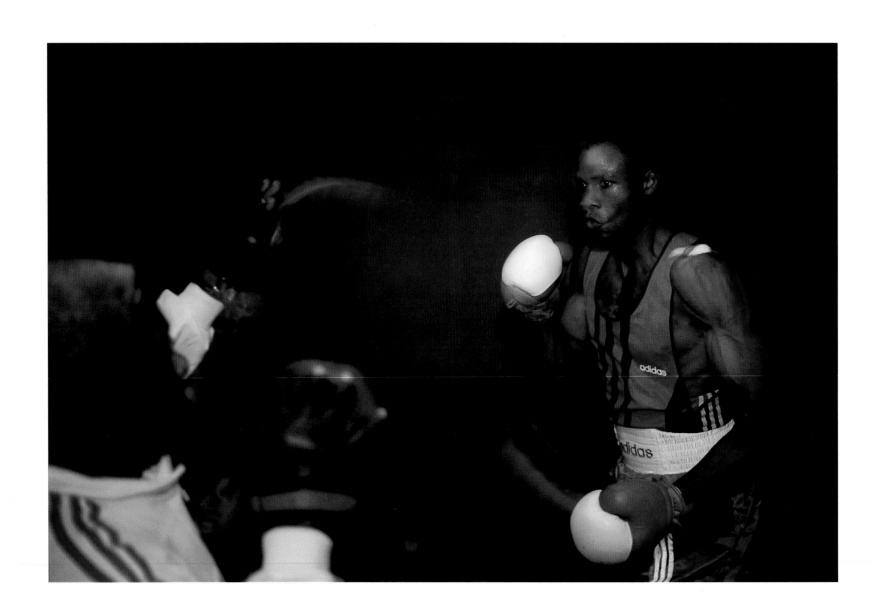

Eyes aflame, boxer Felix Saban of Guantanamo spars with his manager, Pablo Torres (above). A fellow
National Boxing Team member is less intense as he shares a drink with friends (opposite)—but both
represent Cuba's latest round of world-class fighters.

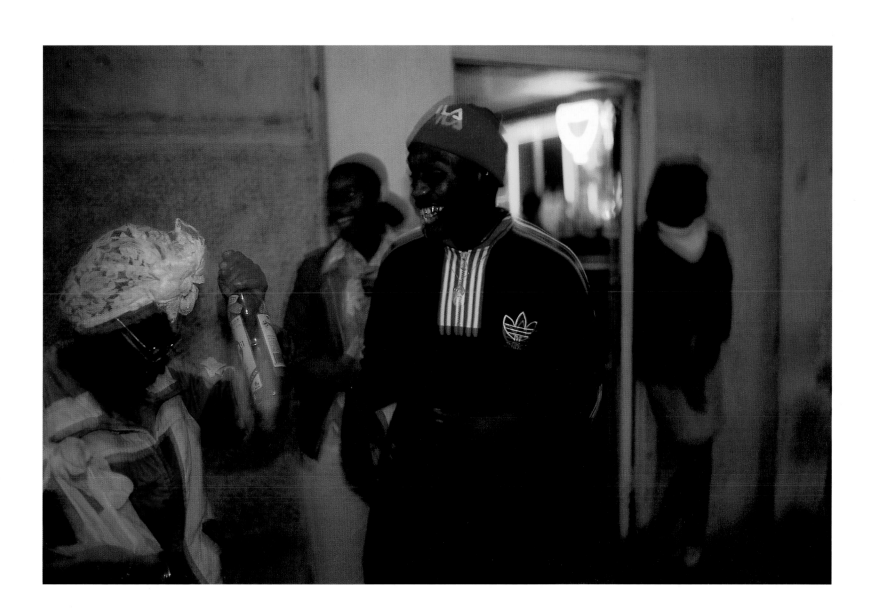

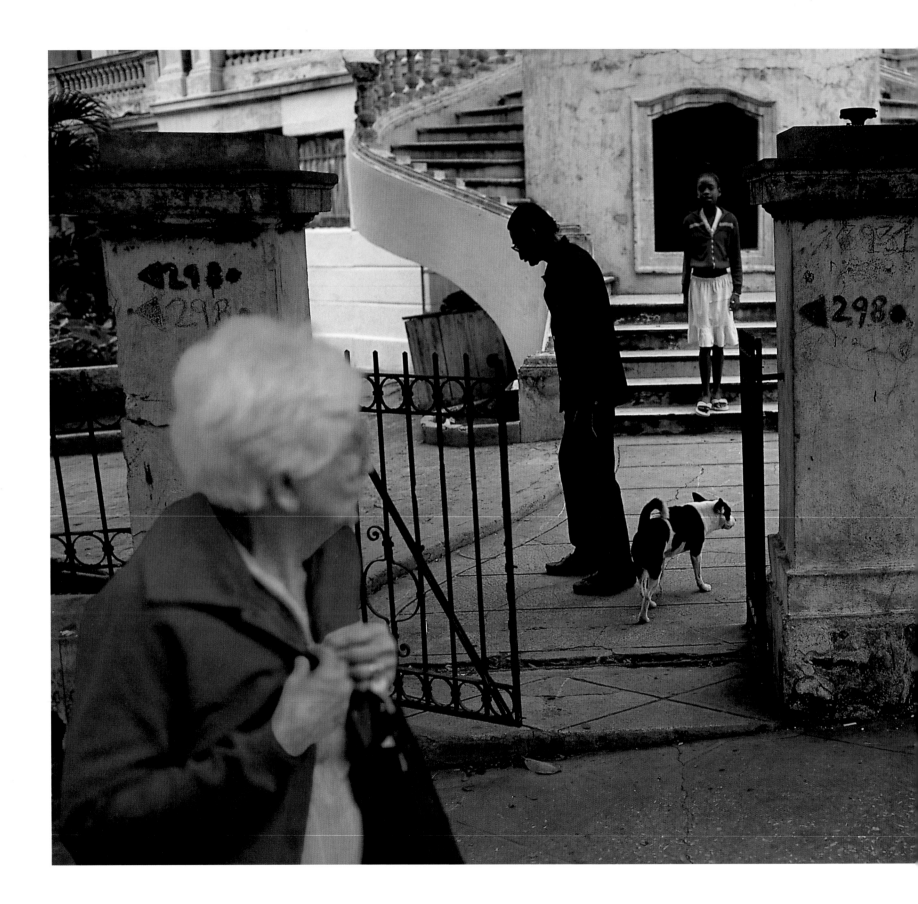

Once it was a palatial private home in Vedado, a cool, wooded, hilly suburb of Havana, where in the early 1900s Cuba's wealthiest city dwellers built their mansions. Then came the revolution: Now this and other crumbling estates in the neighborhood are property of the state—and often *ciudadelas*, home to multiple families.

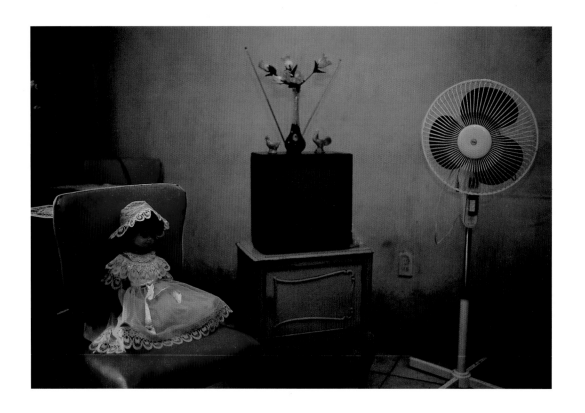

Above Havana's central market, a woman (opposite) lives alone in a two-bedroom apartment, large by Havana standards, with a living room and kitchen. There's also the ever present black-and-white TV. "When I first got to Cuba, I wondered why everyone had a TV, but no one watched during the day," says Harvey. "Then I found out there's no TV until 4 p.m."

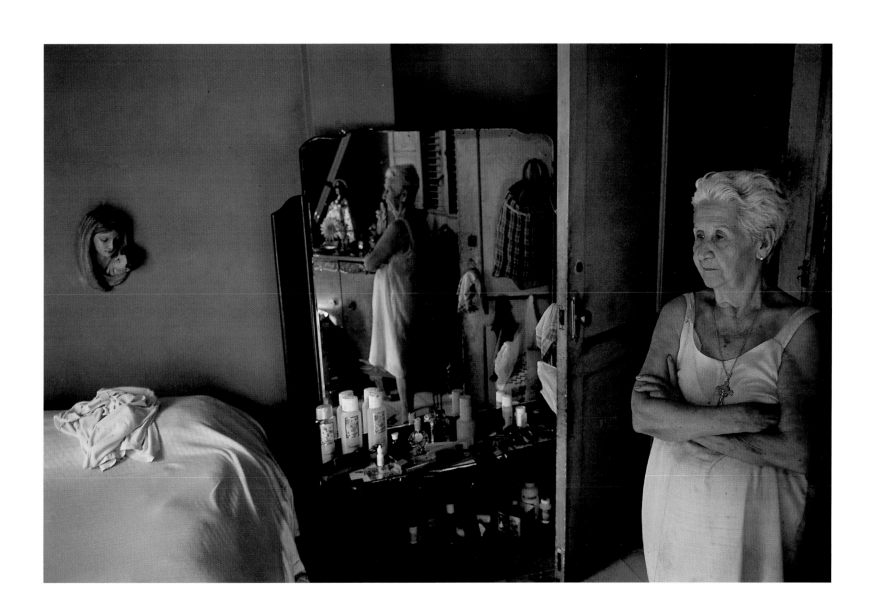

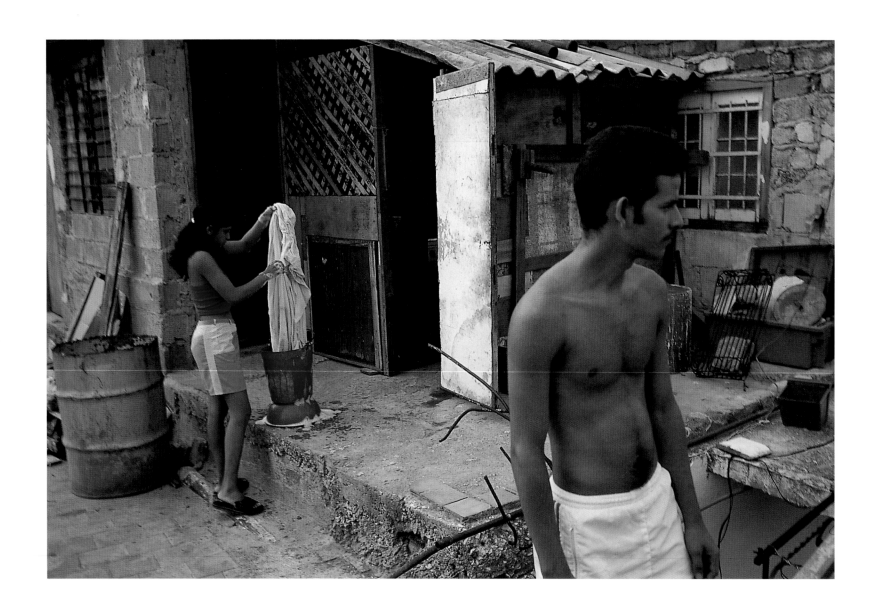

A bucket of soapy water makes a rooftop laundry for a young couple in Havana. Modern appliances are dreams from the pages of American magazines to most Cubans, and their primitive replacements can be dangerous: A kerosene stove, common on the island, was the suspected cause of a blaze (opposite) that virtually destroyed a neighborhood before firemen arrived with a water hose.

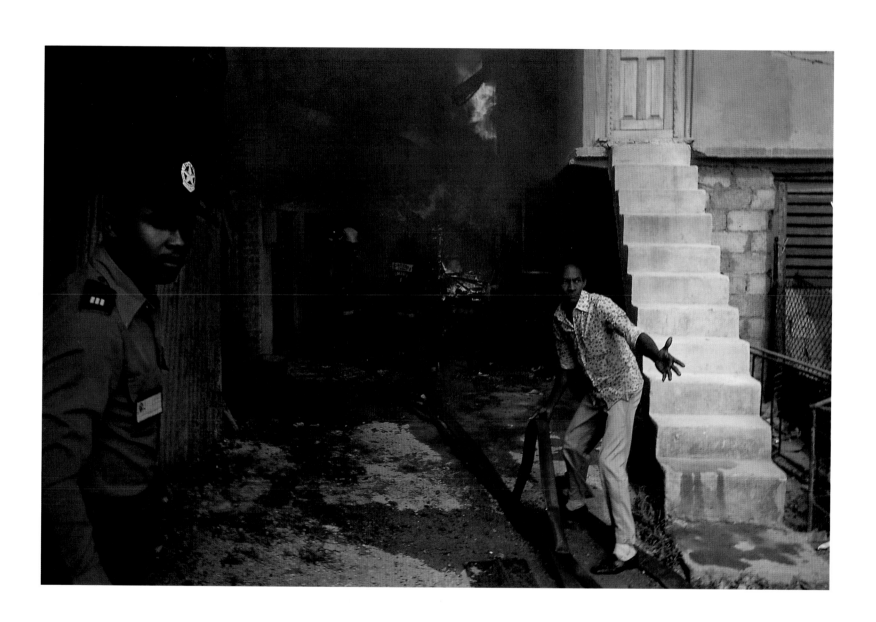

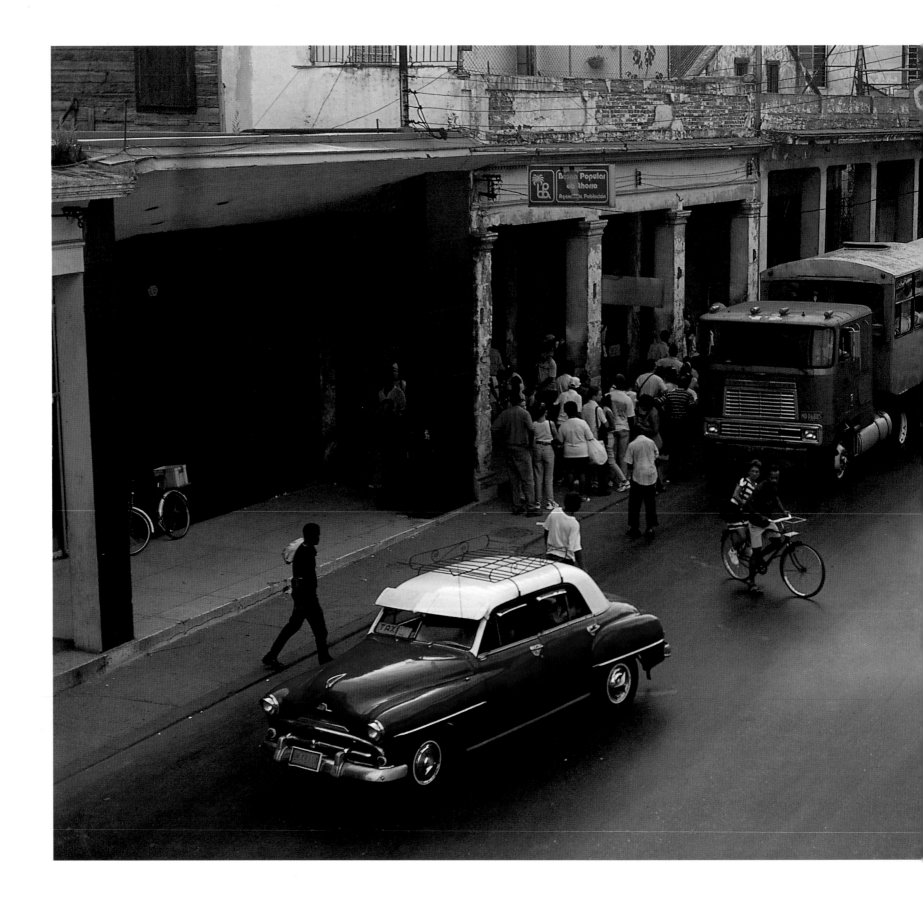

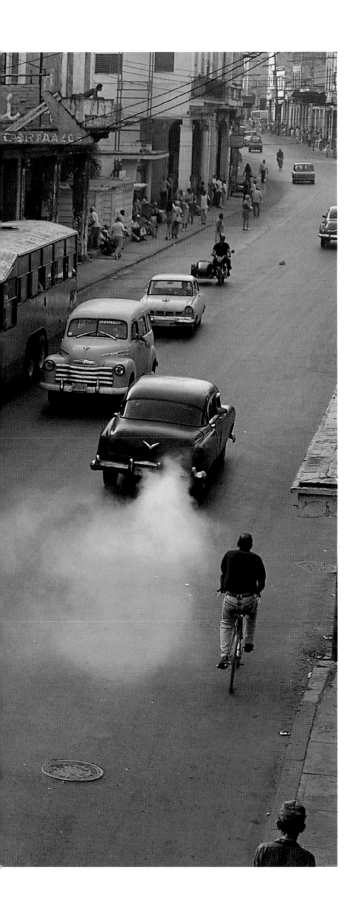

Given the choice of jamming onto the hulking camel buses or maneuvering the streets of Havana in expensive, repair-prone cars, many Cubans opt for bicycles. It's a government-endorsed option: Several years ago Castro imported more than a million bicycles from China to help his people get around by pedal power.

Cigar smoke and prayers
cleanse the spirit of
13-year-old Nayade García
as her mother performs a
ritual of spiritism in their
Havana apartment.

The family—and
millions of other Cubans—
also practice Santería, a
belief system that blends
Roman Catholic traditions
with African religious
roots. Despite their wildly
enthusiastic reception for
Pope John Paul II, more
Cubans are thought to
practice Santería than
Roman Catholicism.

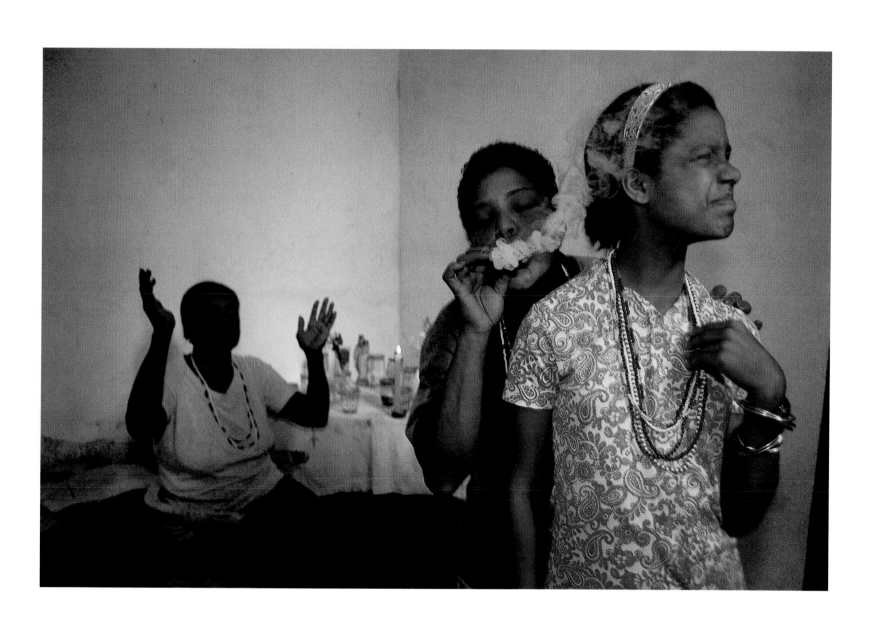

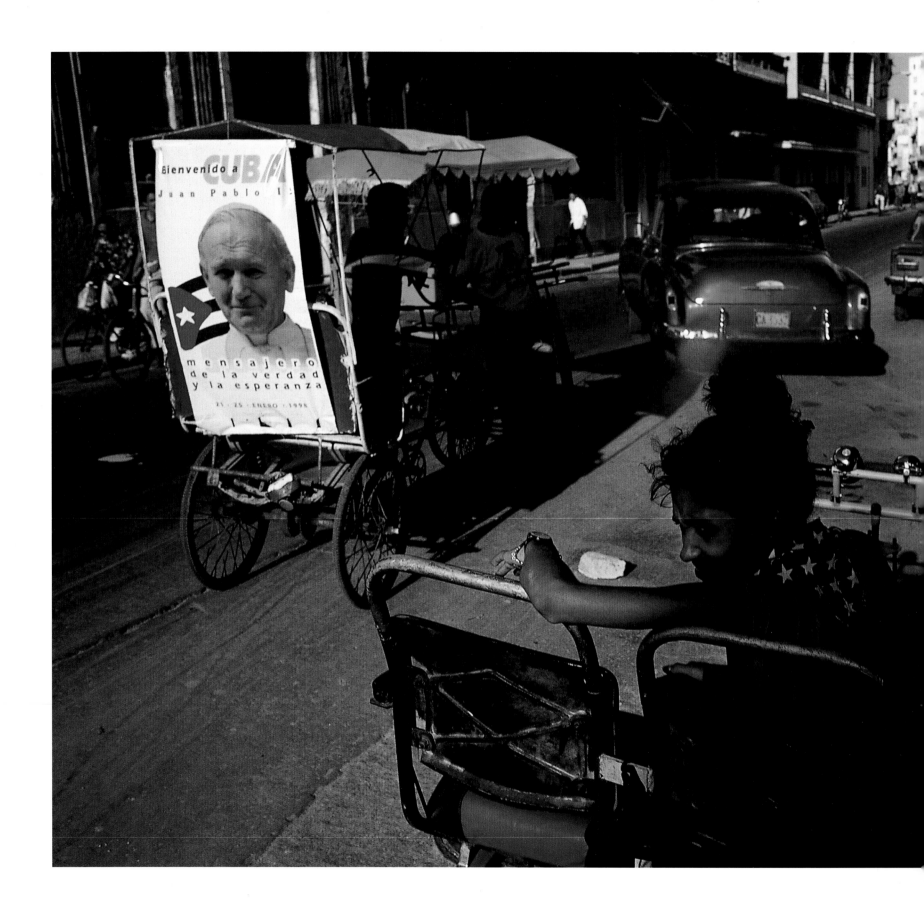

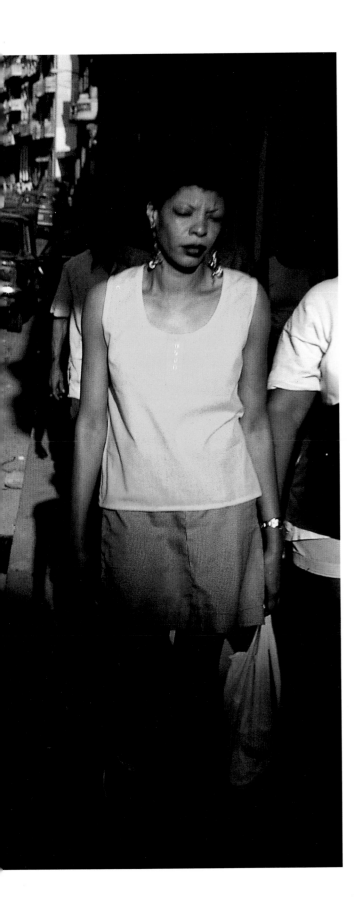

Eyes cast abroad, Cubans look beyond their tightly controlled environment to the world beyond. Colorful fashions, stars-and-stripes motifs, and welcome for a pontiff who preaches freedom and tolerance punctuate a typical downtown street scene.

"Cuba in many ways looks like a third-world country, but its people don't have a third-world mentality," says Harvey. "They are educated; they know what the rest of the world is like. And they want a piece of that."

Students at one of the Western Hemisphere's oldest colleges, University of Havana youth are enthusiastic participants in a torchlight Martí Birthday demonstration—and privileged beneficiaries of Castro's emphasis on higher education. The university, founded in 1728, produces doctors, lawyers, artists, and scientists. Their procession ends at a downtown intersection, where their torches create a raging bonfire (opposite).

86

"In theory I am responsible for 120 families," says Dr. Luis Brito, a neighborhood physician in Havana, "but it's actually 130. More than 500 people in three blocks."

He earns $20 a month.

In his spare, dimly lit examining room, he uses a brass stethoscope to hear an unborn baby's heartbeat.

Cuban doctors are well-trained, but due to economic pressures they lack medicine and equipment.

"I am a son of the revolution," he says. "I grew up with the revolution, and I believe there is always a solution here." If one medicine is lacking, he says, he'll prescribe another.

"And there is the possibility of alternative medicines: acupuncture, homeopathy."

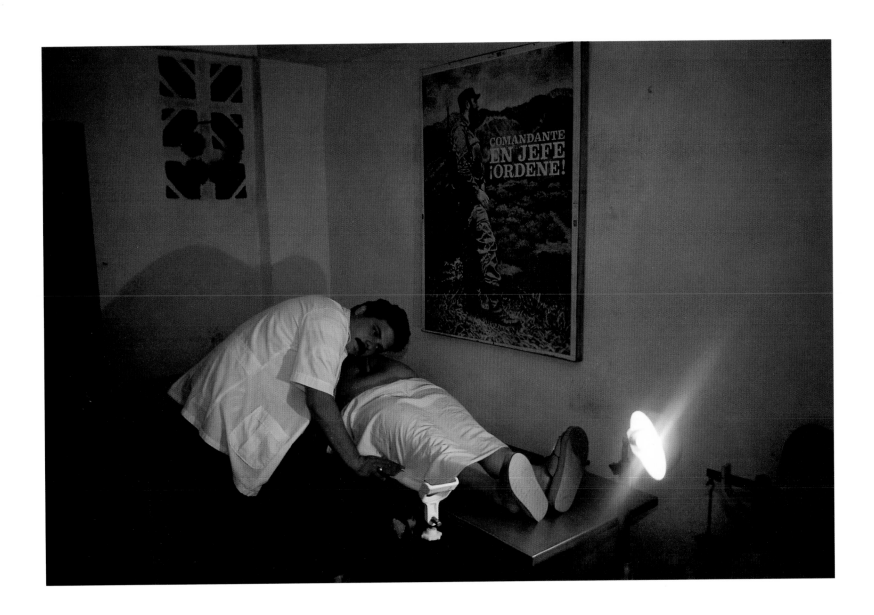

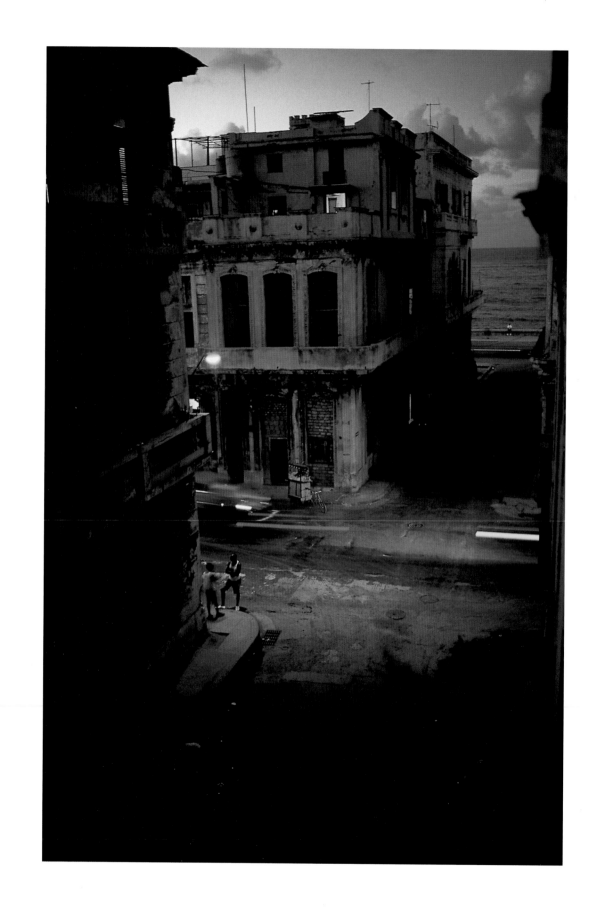

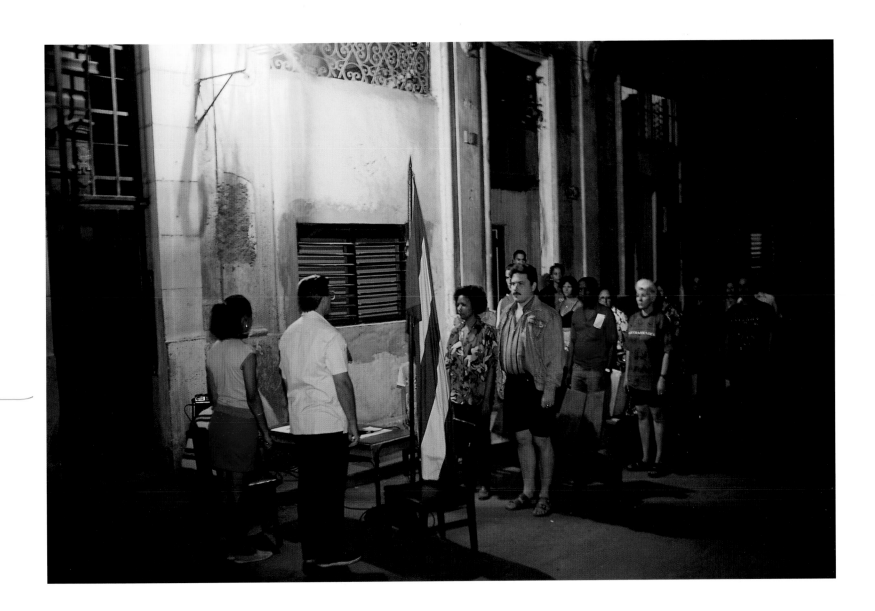

As the cool night descends on Central Havana (opposite), Cuba's radically limited democracy blooms. During a neighborhood meeting of the Committee for the Defense of the Revolution (CDR), a boom box intones the Cuban national anthem as citizens stand at attention. "It's funny—Cubans I talked to think they have a democracy," says photographer Harvey. "They have no say on a national level, but they elect local people who deal with their day-to-day problems."

"You'd have to be crazy to walk down a street this dark and lonely in virtually any city," says Harvey. "But in Havana, even a child is safe wandering the sidewalks.

 "That motorbike was just left there running by a guy who ran into the building for a few minutes."

Blackouts are a fact of life
in Cuba, and to a teenage
student they are no excuse
for shirking her homework.
So when the lights go out,
candles are lit, and it's back
to work.

"Every Thursday from
7 to 11 p.m. they cut the
electricity in this neighbor-
hood," said Liliana Nuñez.
"We use the time to visit
friends who have electricity,
and we also use the time
to do all the things we put
off because we'd rather
watch television."

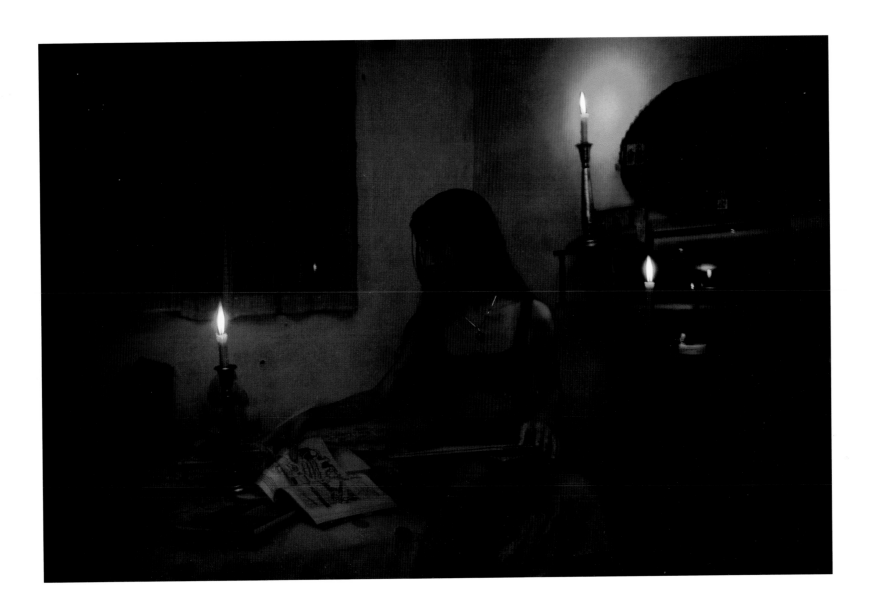

As millions of dollars pour into the restoration of Old Havana, other portions of the city continue to deteriorate.

"Once these were extremely elegant neighborhoods," says photographer Harvey. "And in the dark, you can kind of squint and imagine what they must have been like in their prime."

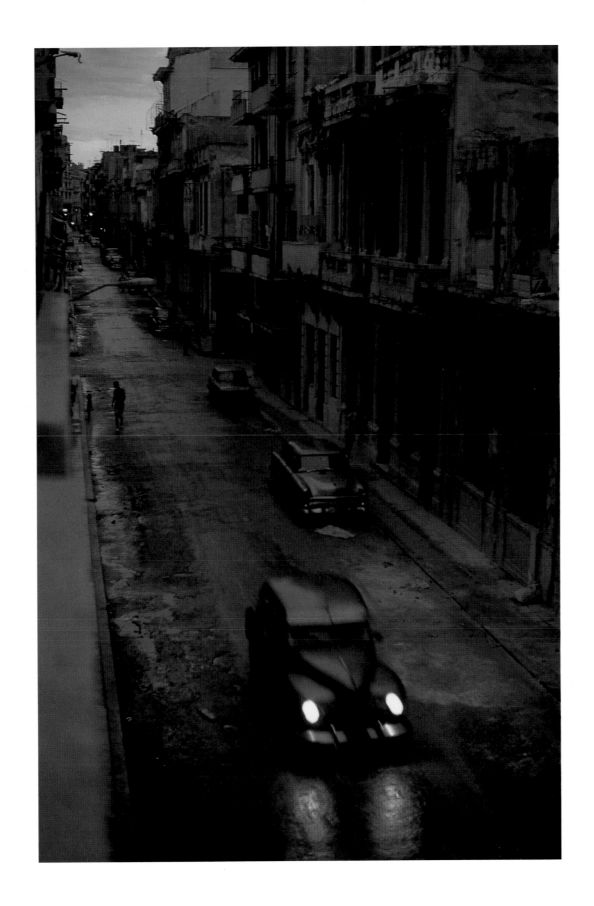

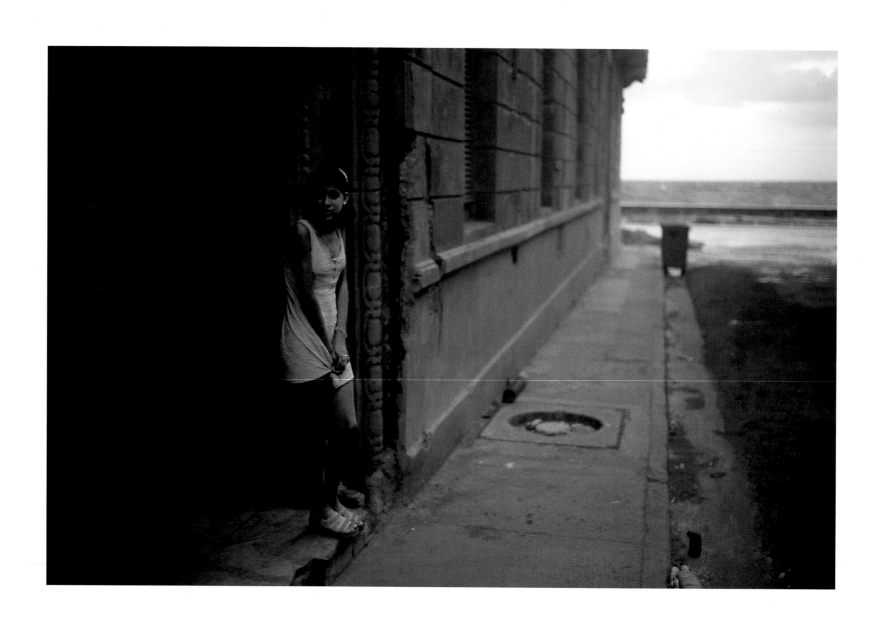

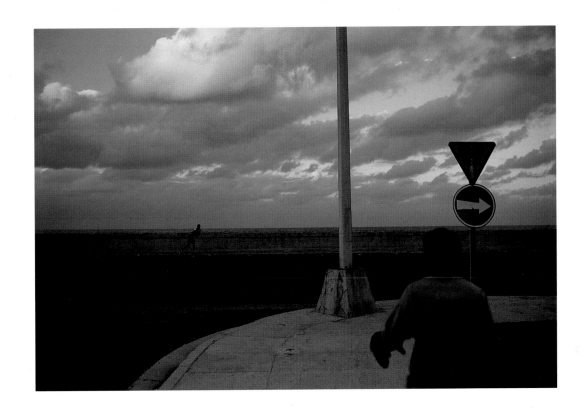

At dawn (opposite) and dusk (above), neighborhoods near the Malecón, Havana's lovely seaside drive, enjoy the sea breezes. On cloudy, windswept days like this, it is a lonely stretch of road. But on hot summer days, says Harvey, "Central Havana empties itself onto the Malecón."

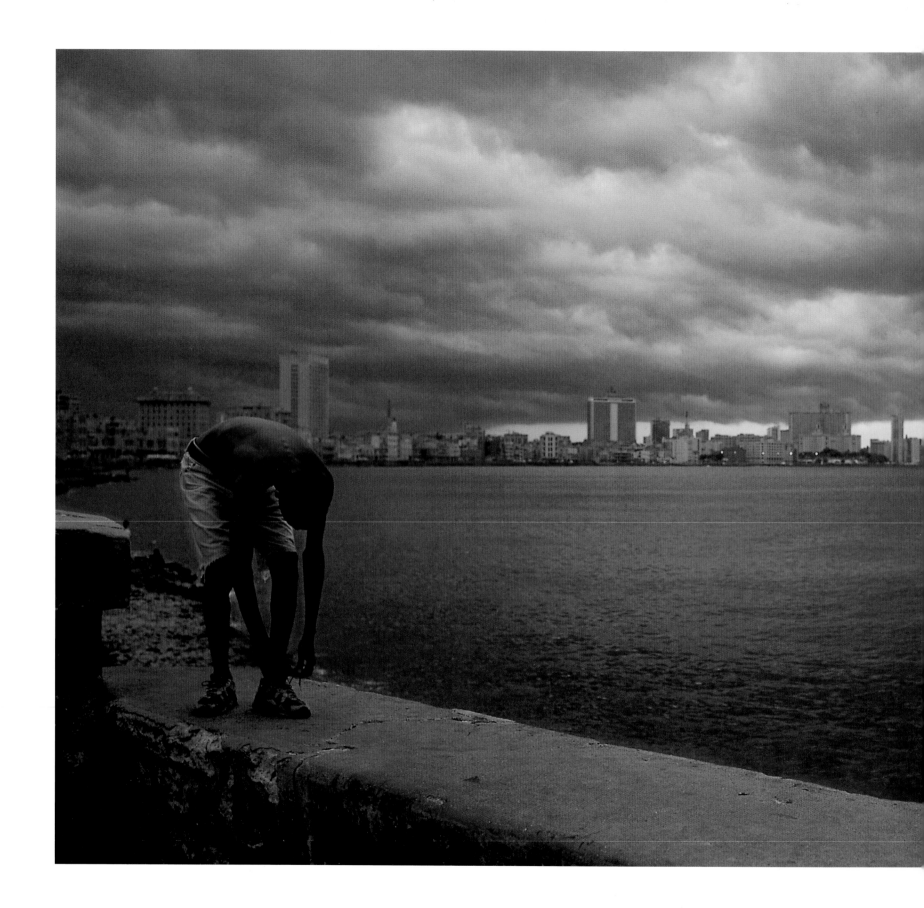

A plaque along this stretch of the Malecón reminds Cubans that it was built in part by the U.S. Army Corps of Engineers. Its formidable strength still keeps raging seas at bay during the stormy season. On the horizon, the last large building to the right of Havana's downtown skyline is the U.S. Interests Section. If it were an official foreign embassy, it would be the largest in the country.

Cubans are generally forbidden to visit the island's fanciest nightclubs, but there are occasional periods of flexibility, and the locals took full advantage when the doors of Old Havana's Café Paris were opened to them.

"When locals and foreigners get together like that, the locals will find ways to get some money by selling something," says photographer Harvey "Or else they're just happy to have someone buy them a soda."

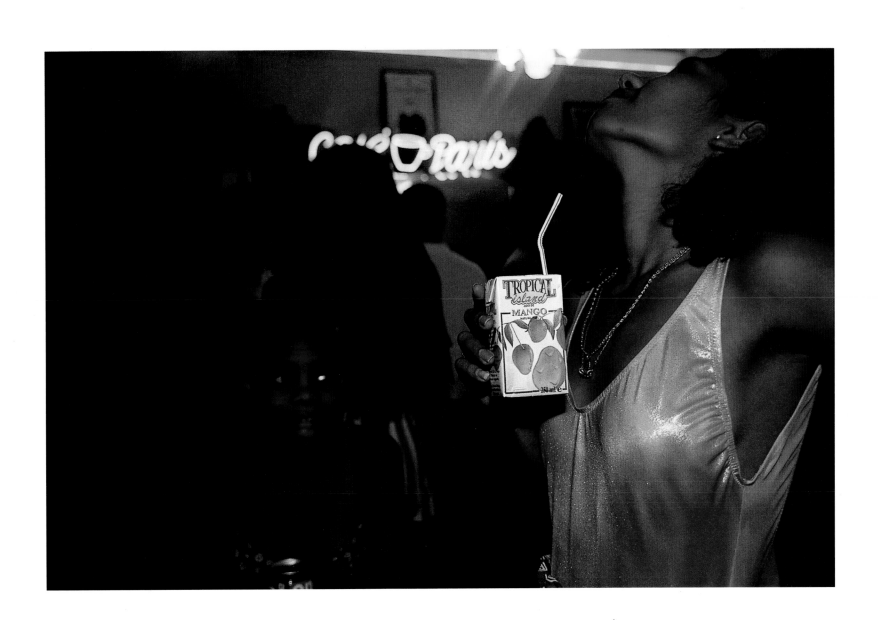

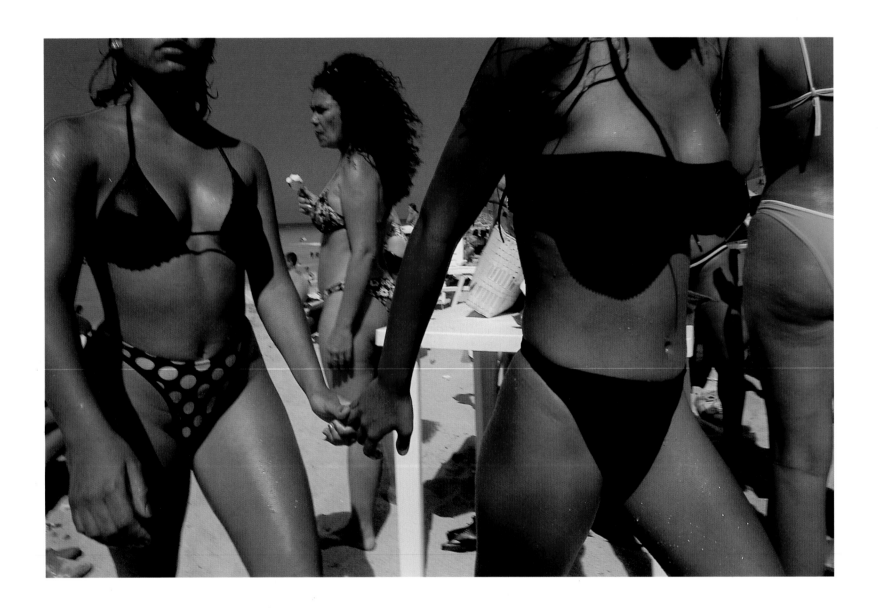

Surf, sand, and sex are the tropical draws at Santa María del Mar, a long, open stretch of beach less than 20 miles from Havana. Officially, it's a beach for tourists—Cubans go to nearby Guanabo Beach—but the locals still find reasons to mingle with foreign visitors both on the beach and in bars (opposite) that line it.

Waving fistfuls of dollars, it's not hard for foreigners to get noticed on Santa María del Mar beach. Some find simple companionship, others come looking for something more.

"Fidel has cracked down on the sex trade in Cuba," says Harvey. "Everywhere, that is, except for the beach."

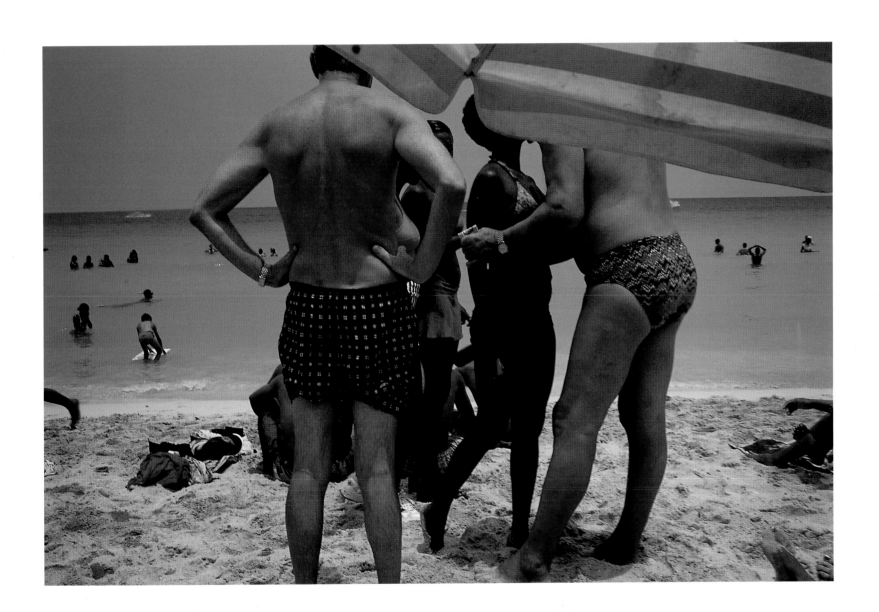

Havana sizzles, especially at carnival time, when kiosks are set up to sell beer and soda along the Malecón. Revelers who can't afford to buy? They simply celebrate as they live, laughing at what they lack and sharing what they can. Though some Cubans dream of an easier life elsewhere, most love their land, problems and all. "I always come back to Cuba," says an artist who travels abroad. "My roots are here. My heart is here and will be until the day I die."

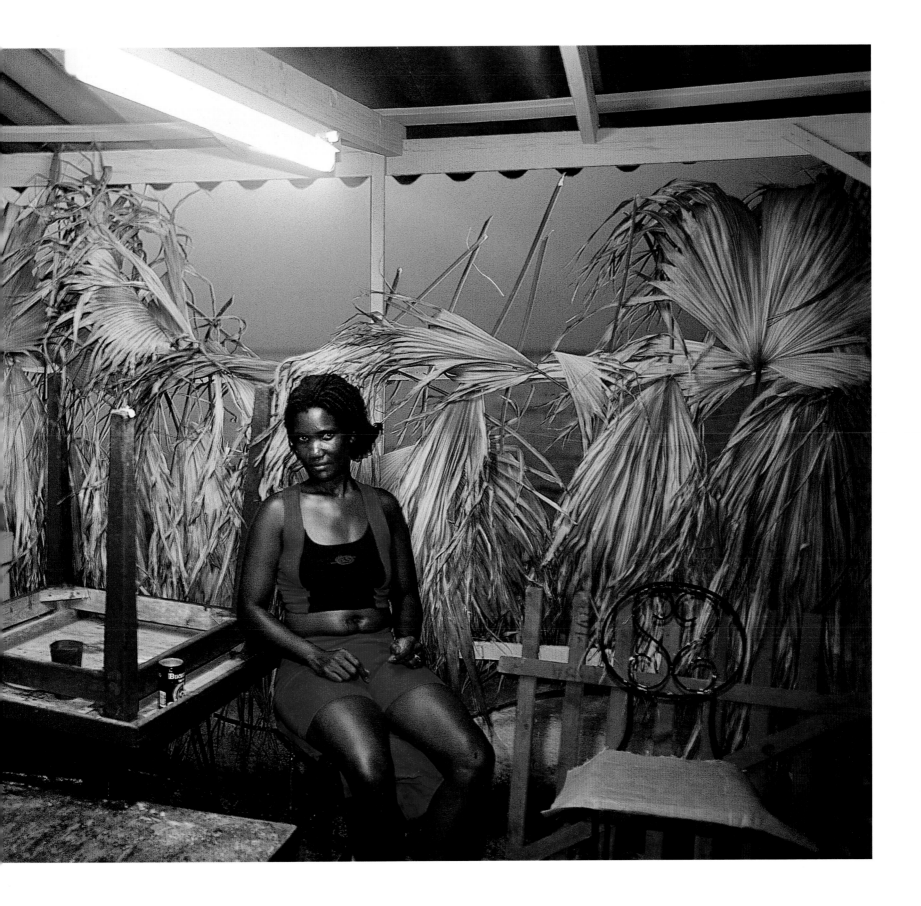

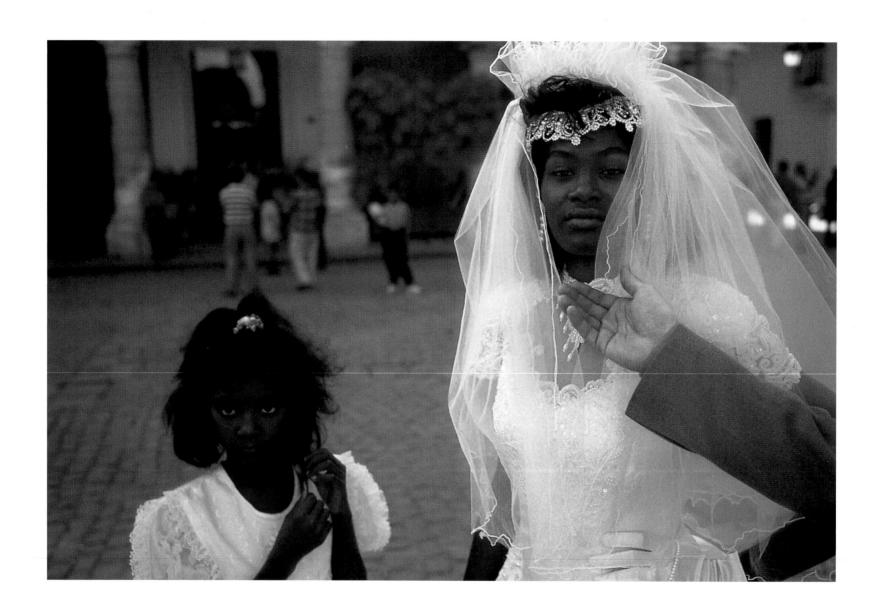

She met him when he came to Cuba as a tourist. Now, after their wedding, the Italian husband affectionately adjusts her veil outside the cathedral in Old Havana—where cultures have met and mixed for centuries.

Old Havana

My short stay here seems like a dream; but it is a dream of too bright things to be forgotten. The groves of oranges and palm, the odor of the thousand sweet flowers, the cool nights and sunny days of the tropics, smiling skies and laughing waters, the volantes, military parades, the Plaza d'Armas, and the music of the splendid band each evening, the *paseo* and the bright eyed señoritas, the gardens and fountains—the beautiful harbor of Havana, guarded by its grim fortresses and batteries...all these and a thousand other pleasant memories come trooping through the mind as my thoughts turn homeward.

FROM THE DIARY OF JOSEPH J. DIMOCK, 1859

Life rolls along with new energy on the Plaza Vieja, a centerpiece of the ongoing rehabilitation of Old Havana, the Cuban capital's Spanish colonial quarter. Paving stones and a fountain of Italian marble replace a parking lot.

It is a race against time as blazing sun and decades of neglect take their toll on the historic area.

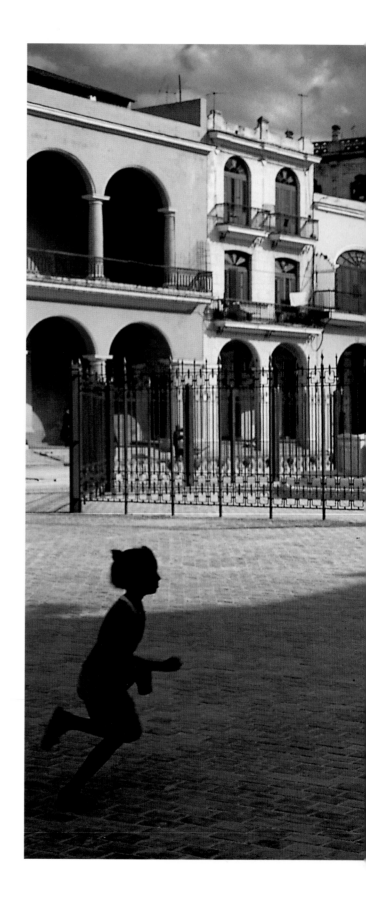

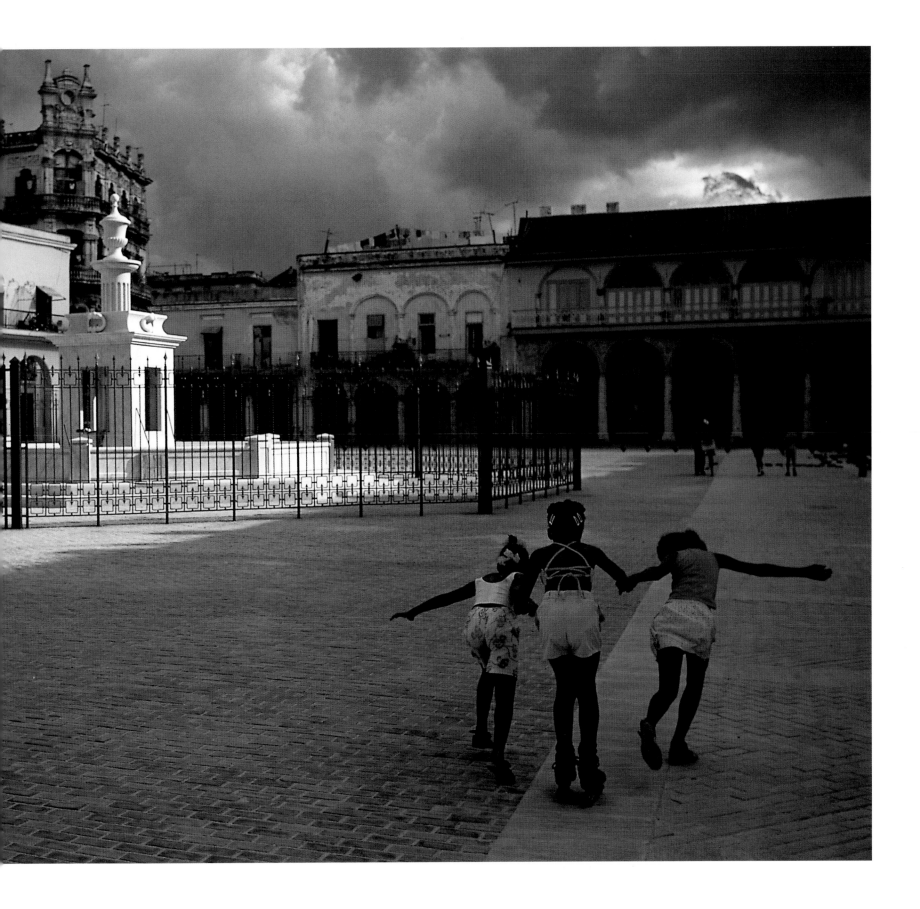

"We have treasures here, everything from the 1500s to the present century," says city historian Eusebio Leal Spengler, who heads the Old Havana restoration effort. Work on the 18th-century Casa del Marqués de Arcos began with structural stabilization.

As renovation progresses, eight-year-old Adel Acea paints a picture for his art class. "We encourage such field trips for local students," says historian Azalia Arias González. "It gives them an appreciation for their culture that they wouldn't get any other way."

The house, former residence of a noble family, will become an art museum and boutiques.

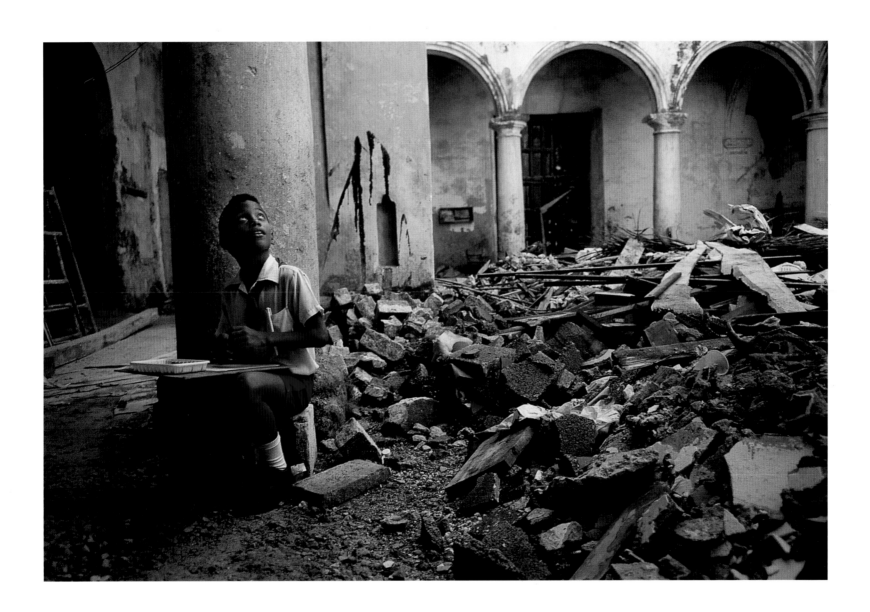

Breaking through, workers convert an early 1900s office building into offices, shops, and apartments (above). New brickwork for the Plaza Vieja (opposite) provides an elegant front yard for seven collonaded mansions dating from the 1700s. At one end of the plaza is the new Fondo Cubano de Bienes Culturales, a cultural center featuring performances and folk art for sale.

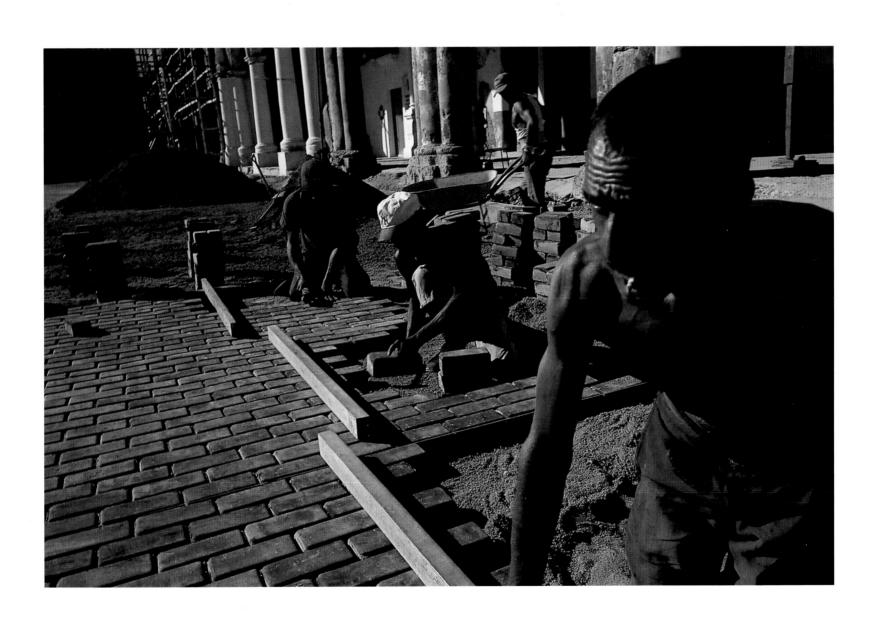

Amid the construction, the new museums, and the old monuments, Old Havana remains a living community. Local kids still head off for school, take shortcuts through restored plazas, and cavort in the playgrounds until it is time to head home for dinner.

"Some historic restoration projects I've seen around the world, the last thing they want is actual people running around," says photographer Harvey. "In Old Havana, the people are staying right there in their neighborhood."

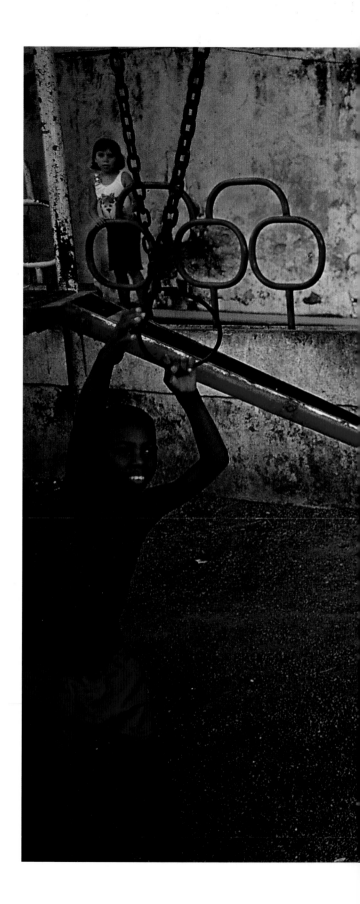

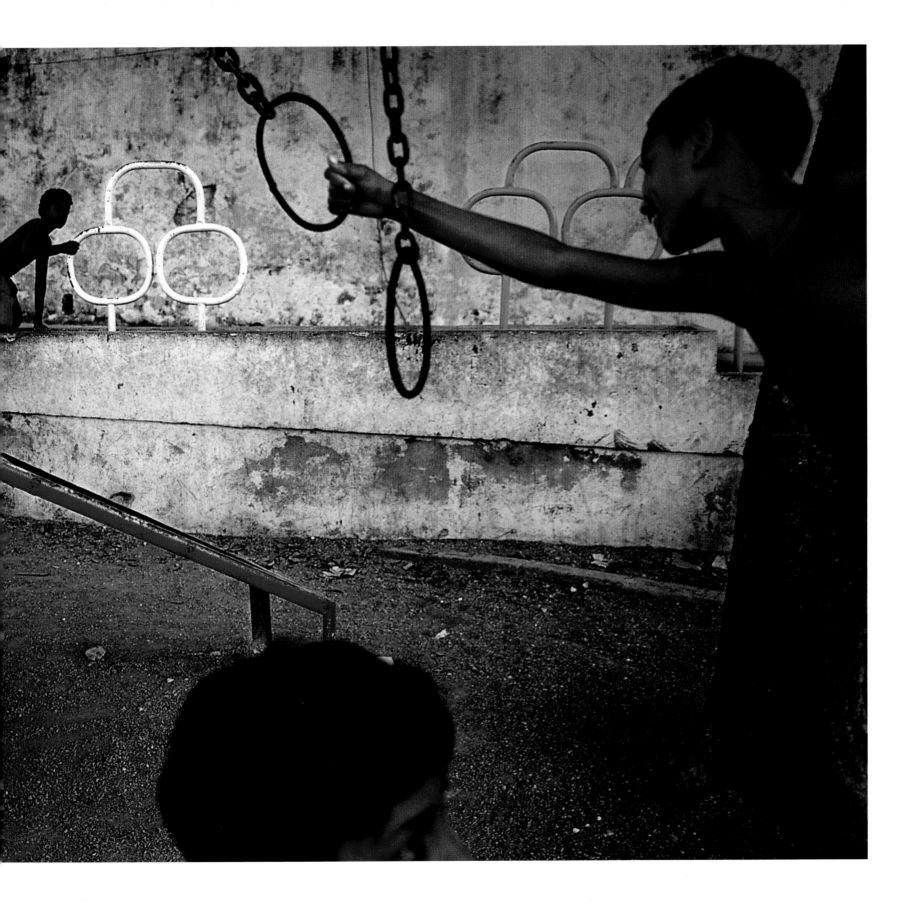

Thinking it over, second grader Alejandro Espinosa González de Valle hangs his head in the hall after being ejected from a class in the recently restored convent at the church of San Francisco. Besides their usual subjects, students in such schools also study Old Havana's art and history. And there's little tolerance for playing in class, as seven-year-old Alejandro found out.

"I took this picture," says David Harvey, "because he reminds me of myself."

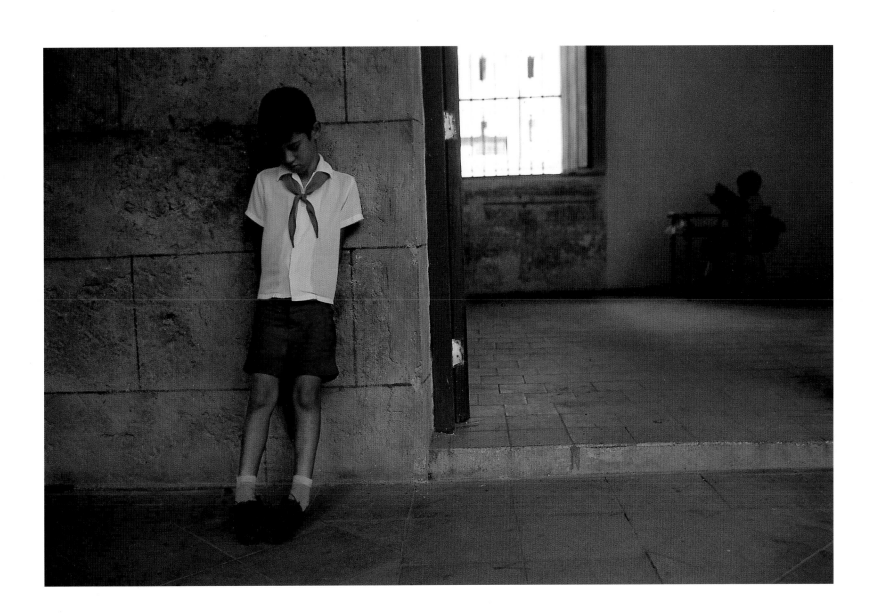

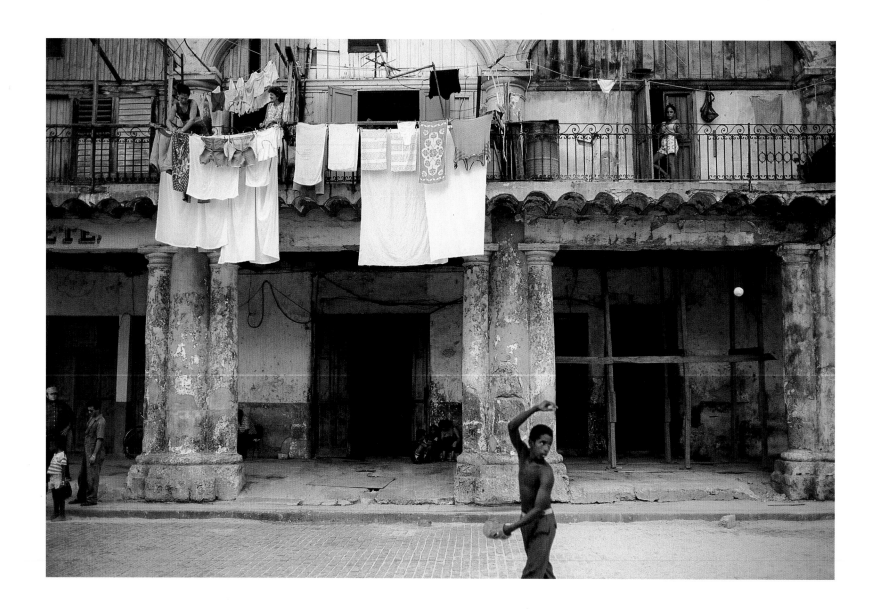

A palace turned tenement on the Plaza Vieja is next in line for renovation. While most Old Havana residents will get to stay in their old neighborhoods, residents of such prime properties (opposite)—many of whom have lived in them their entire lives—may have to move out to make way for museums or shops. Says historian Arias González, "As people see their surroundings improve, we hope they will be more optimistic about the future."

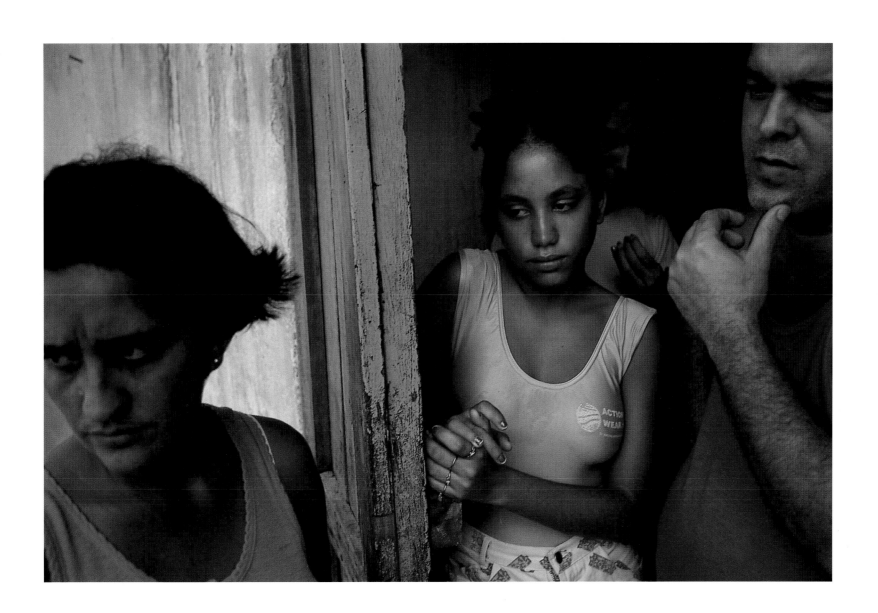

"We want this to remain a living part of the city, with homes and shops as well as the colonial forts and palaces that tourists come to see," says city historian Leal Spengler. True to that goal, a number of restored structures retain their original function. A shelter for expectant mothers built in 1859 reopened two years ago as the Doña Leonor Pérez de Martí center, named for the mother of José Martí, the father of Cuban independence.

As part of the free national health care system, the center houses women with high-risk pregnancies. In addition to gathering in the lounge for lectures on prenatal health, patients often attend public concerts and plays in newly renovated grand old houses that have become cultural centers.

Radiating in all directions from the 16th-century Castillo de la Real Fuerza, renovation has advanced along blocks of cobbled streets. After a building is refurbished, it may be rented to a commercial tenant. Or the restoration effort's umbrella company, Habaguanex, S.A., may run a business itself, as is the case with the Hotel Ambos Mundos, where author Ernest Hemingway once lived.

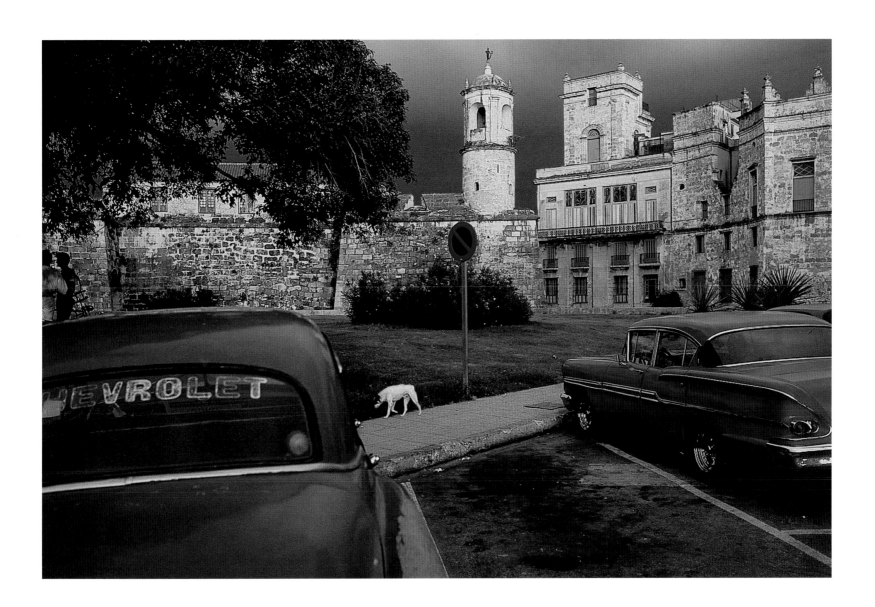

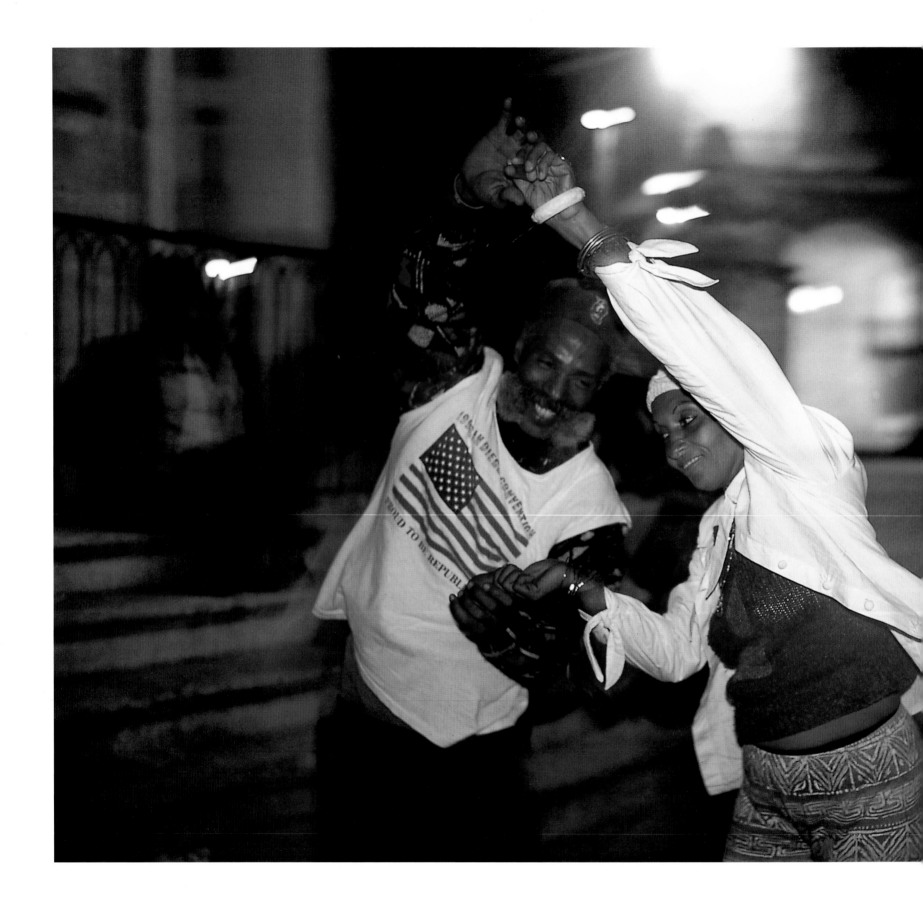

They're not allowed inside
an Old Havana tourist club,
but that doesn't stop a
Cuban couple from danc-
ing to the music that spills
over the plaza outside.

"The American flag is all
over the place in Cuba,"
says Harvey. "Whenever I
spent time with anyone, as I
left they'd say, 'Bring me an
American flag next time.'

"Fact is, if someone's
walking around with a Ché
Guevara T-shirt, they're
probably a tourist. If
they're wearing an Ameri-
can flag shirt, they're
almost certainly Cuban."

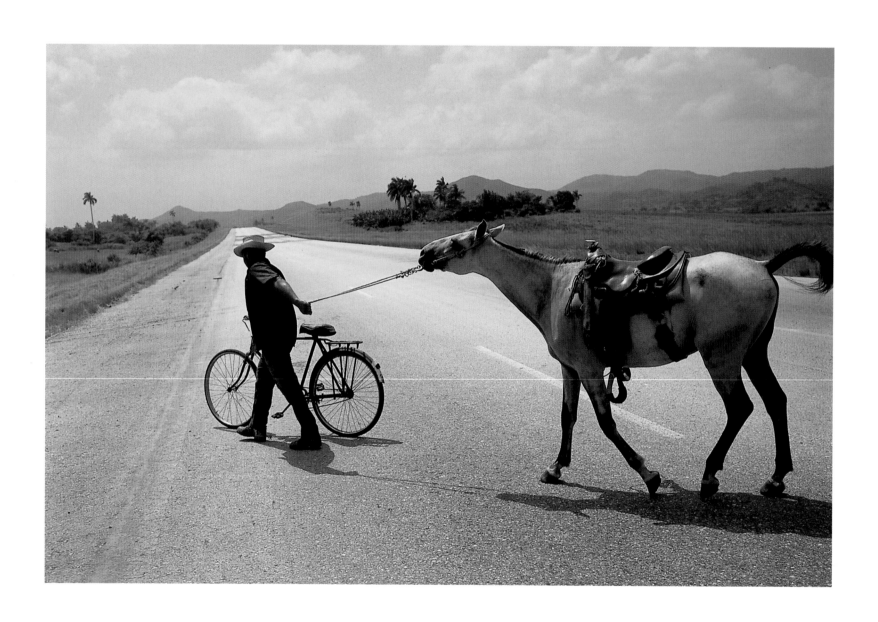

A broken bike, a riderless horse, a barely used highway. In Cuba's rural frontiers—in this case along the Central Highway that traces the island's spine—even modest conveniences of city life are little more than rumor.

The Countryside

The beautiful rolling country, dotted with quaint, palm-thatched huts, and the stately royal palms, like huge feather dusters are never-ending sources of delight. The open fields are eye-filling scenes of green, splashed here and there with other colors.

To watch a sunset over one of these living pictures is a never-to-be-forgotten event, for the sky is a riot of brilliant, glowing colors, blending and merging in delicate nuances of elusive tints. Then darkness—suddenly dropped like a curtain.

ENRIQUE C. CANOVA, FROM "CUBA—THE ISLE OF ROMANCE,"
NATIONAL GEOGRAPHIC MAGAZINE, 1933

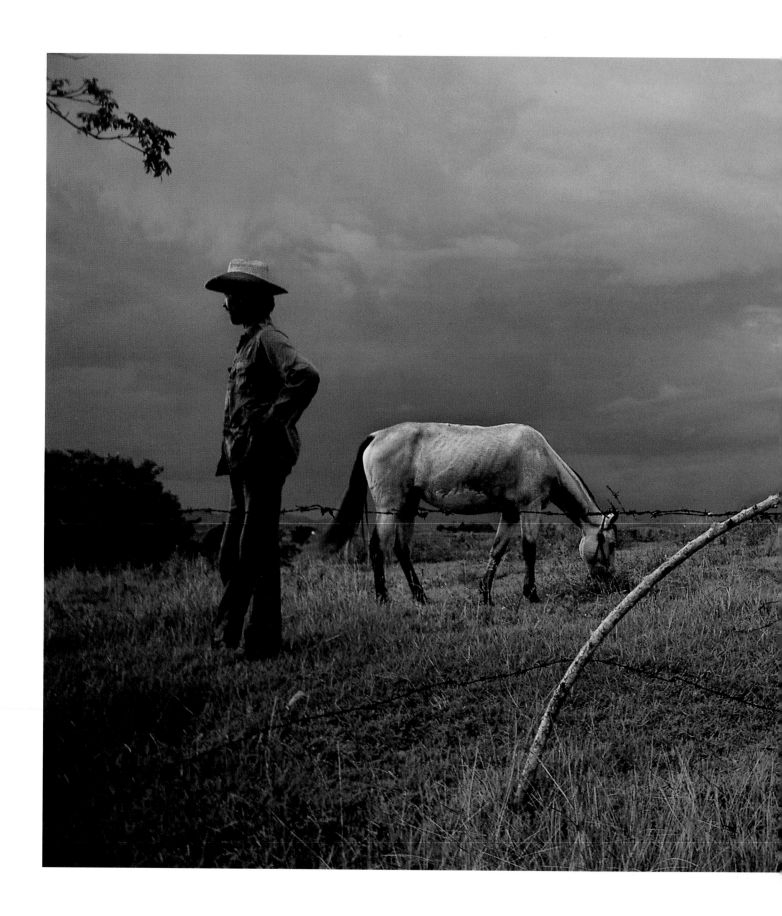

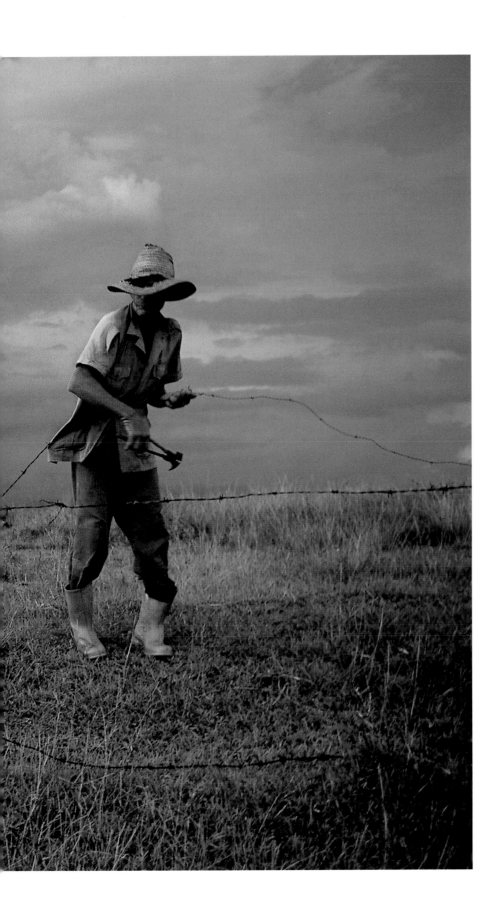

New wire for fence mending is hard to come by, so tobacco farmers Nolverio Hernández and Osiris Sanchez manage to splice together what they have. Farmers in their region of Manicaragua in some ways live better than many city dwellers. A horse takes them on errands, and a kitchen garden helps keep them well fed.

Second to sugar in production on the island, tobacco nevertheless is closest to Cuban hearts. It was the island's first important cash crop, blooming with tobacco just decades after smoking and snuff took Europe by storm in the late 1500s.

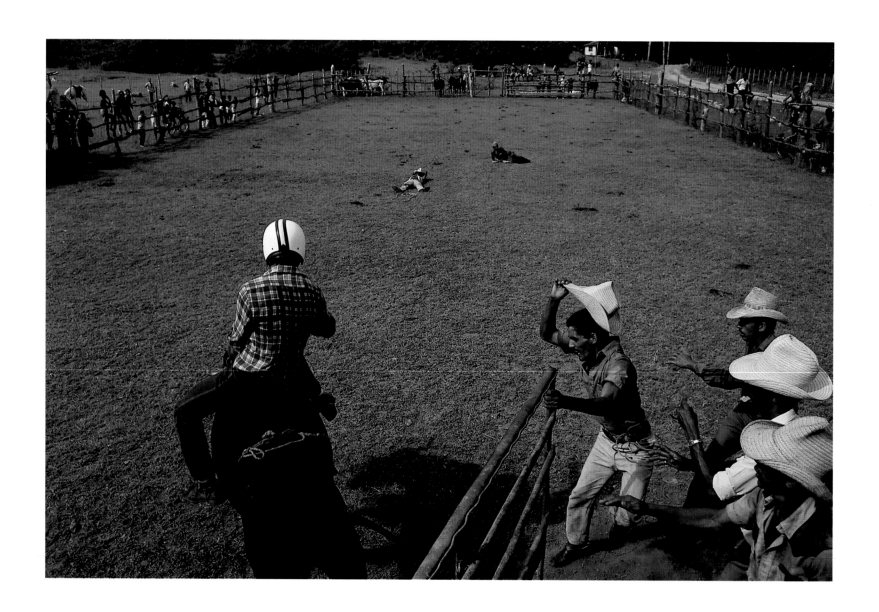

The rodeo doesn't come to town in the mountains of southeast Cuba—the rodeo is the town. Donning foot-
ball helmets and charging onlookers a few pesos' admission, local cowboys rope (opposite), ride, and whoop
their way to local legend. Some aspects are familiar to U.S. fans, such as the red-clad rodeo clown reclining in
the arena. Not so familiar: the inebriated rodeogoer who wove his way to the center and lay down beside him.

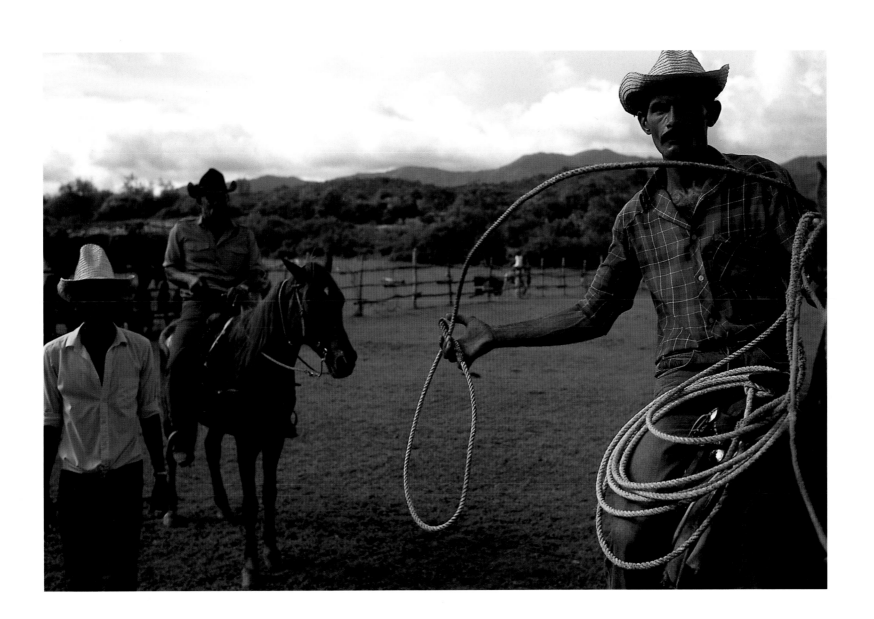

When the sugarcane crop comes in near Trinidad, on Cuba's southern coast, old-timers from town volunteer to head out and help with the harvest.

"A lot of the harvesting is done by machine now," says photographer Harvey. "But on rolling land, like they have outside Trinidad, they need to do it by hand."

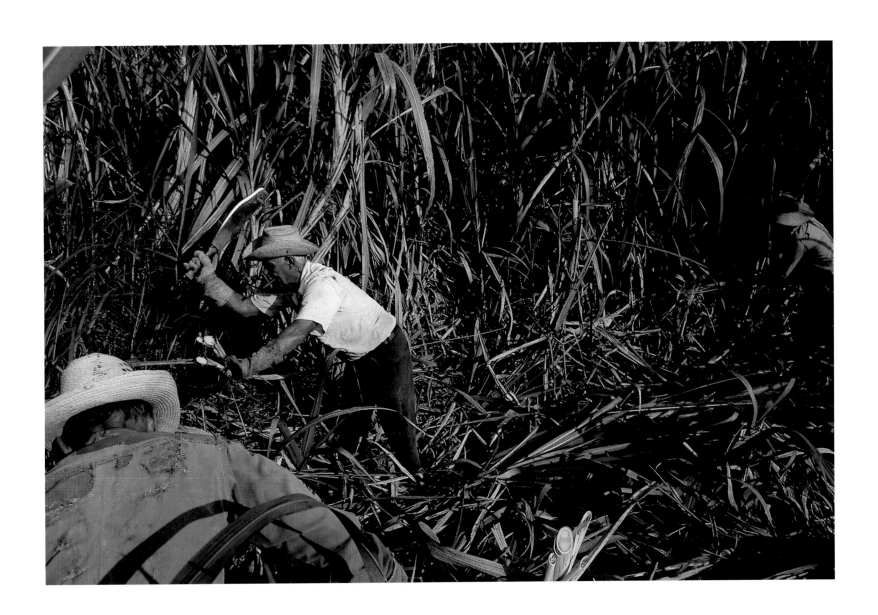

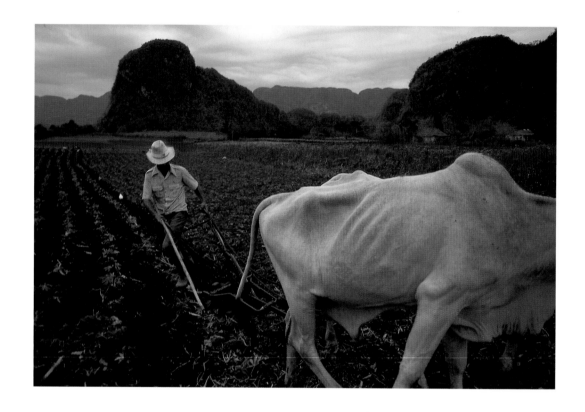

His eyes are on the rich, red soil that grows some of Cuba's finest tobacco, but rising around this farmer in Valle de Viñales are dramatic *mogotes*, limestone karst monoliths that date back 150 million years. Mature tobacco leaves get tender care from Juan Gómez (right),whose broad mustache, straw hat, and clenched cigar make him a central-casting example of a *guajiro*, or farmer peasant.

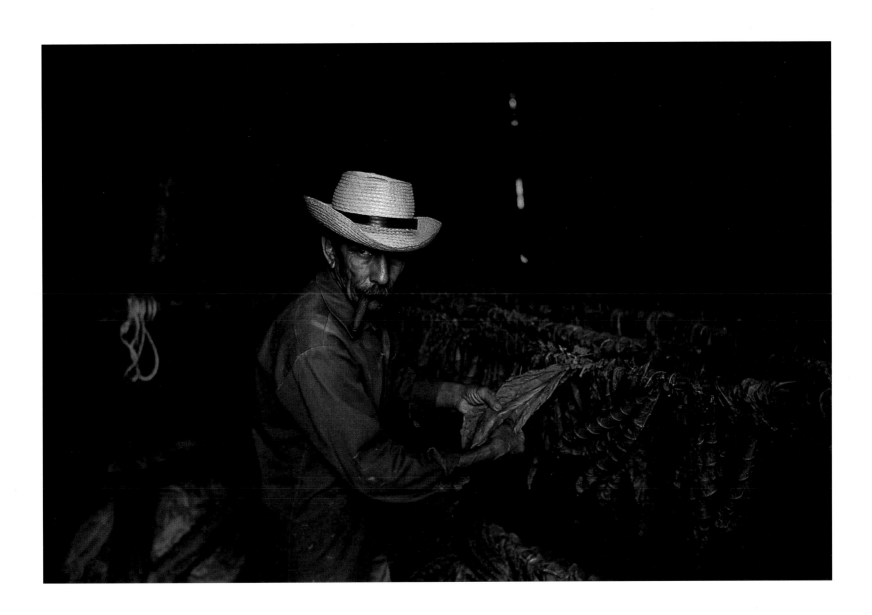

"This is a postcard picture of Valle de Viñales—to Cubans, the view is like looking at Niagara Falls or the rim of the Grand Canyon," says Harvey. "But to outsiders, it's still breathtaking."

Hotel Horizontes, the hilltop hotel that over-looks the valley, is a tourist facility not officially open to locals.

"But these people I photographed on the terrace were Cuban. They were just hanging out around the pool, having a good time with everybody else."

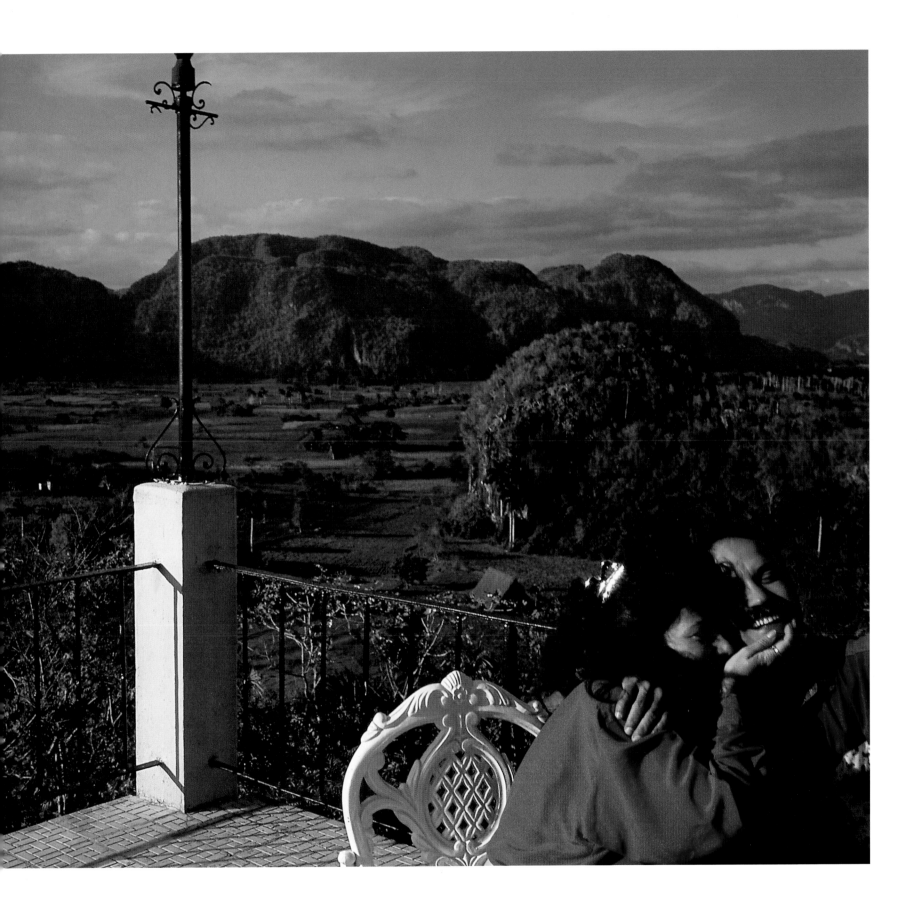

The most important day in
a Cuban girl's life is the
fiesta Quinceañera, the day
she turns 15. Her mother
makes—or rents—her a
beautiful dress, and all her
friends and relatives gather
for the most lavish party her
family can possibly afford.

"This girl was waiting for
her ride to the party for her
fiesta," says Harvey. "The
girls feel like they're queens
for a day, and their mothers
are frantic."

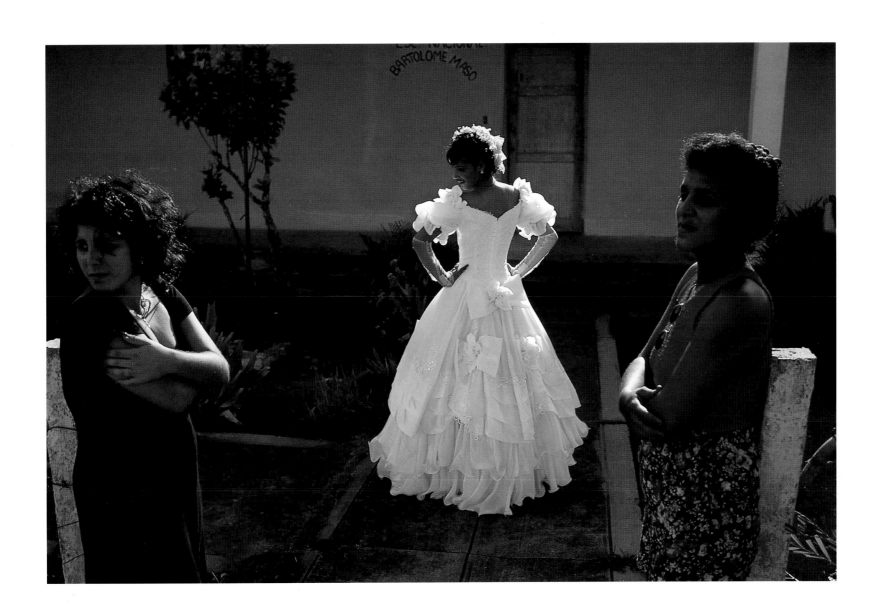

Cuba's third-largest city,
Cienfuegos, is a mix of new
residential high-rises, turn-
of-the-century sugar mag-
nate mansions—and a
working fleet of southern
coastal fishermen.

"Along the shore, they
fish for bait fish so they can
go out and catch big fish,"
says Harvey. "They're not
allowed to have big boats—
even though from this part
of Cuba, it would be crazy
to try and make it to the
U.S. But there's a shelf just
a couple of miles out, and
they can get out there to
catch tuna and swordfish."

Cuba's biggest business, tourism grosses almost two billion dollars a year, partly from the resort town of Varadero, a lush 12-mile-long sandbar east of Havana that has close to 30,000 rooms. Hotels catering to well-off tourists include the former DuPont estate (above), and cost up to $200 a night. Less pricey are modest oceanside bungalows on the south side of Cuba (opposite), which go for as little as five dollars.

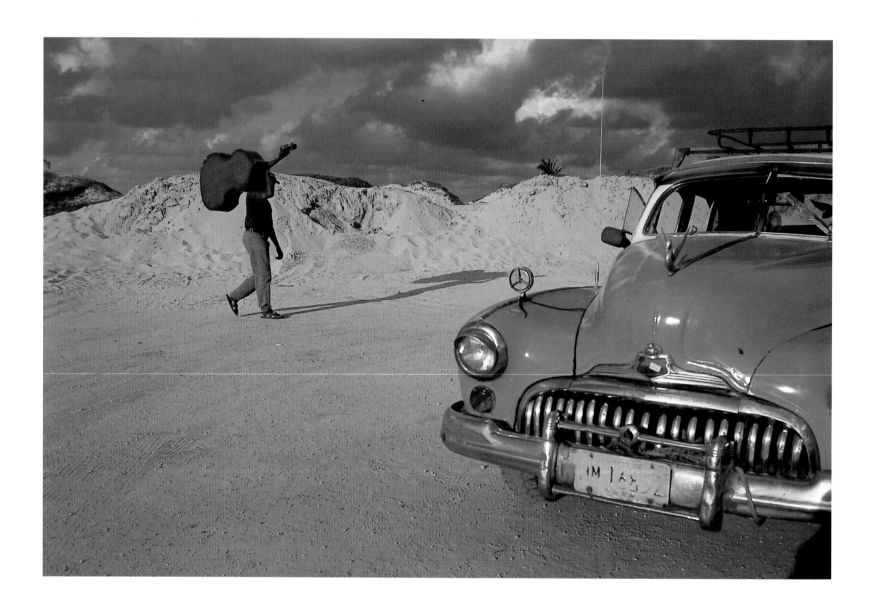

For many coastal Cubans, the beach is the last resort for escaping city life. Just short of the tourists-only Varadero, beachgoers can drive right onto the sand for sun worshipping—and occasional performances by wandering musicians (above). When David Harvey's car broke down, he hitched a ride with some Havana kids (opposite), who'd driven to the cool mountains of Viñales.

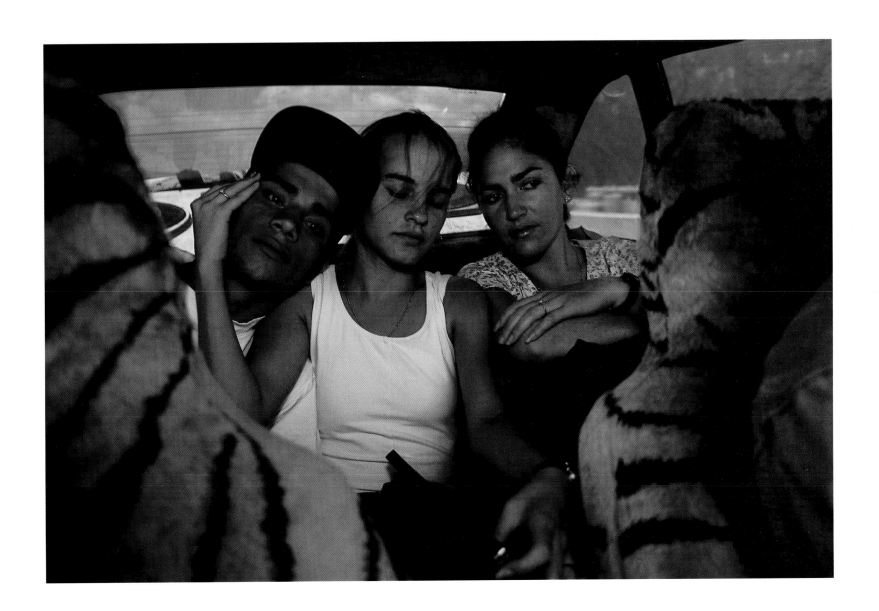

In their shiny Chevy truck with its canvas canopy and "Pass"-"Don't Pass" signs, they could have been barreling along Alligator Alley in central Florida. These smiling passengers are part of a Cuban culture that assimilates whatever it can from the U.S.

"They know everything about us," says Harvey. "I found that when I was talking with people in Cuba, I had to answer a lot more questions than I got to ask. One school teacher asked if I'd bring back the recent issue of *Vibe* magazine with an article about Busta Rhymes."

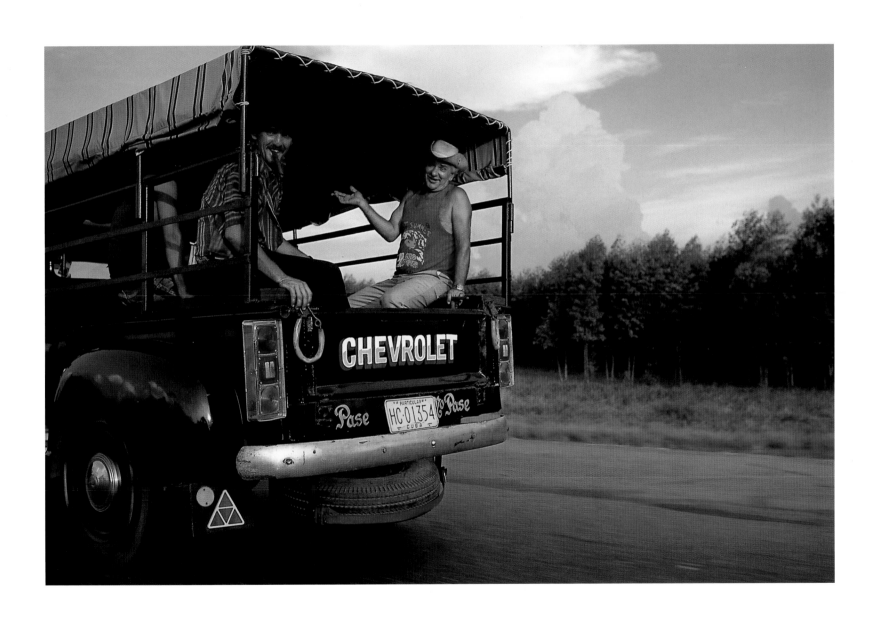

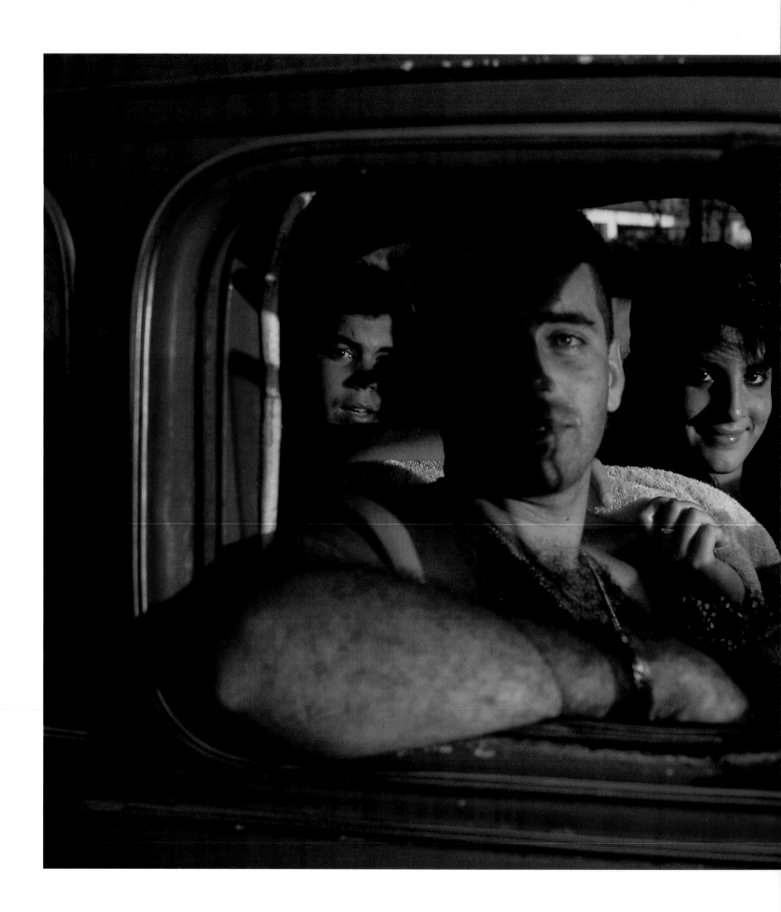

152

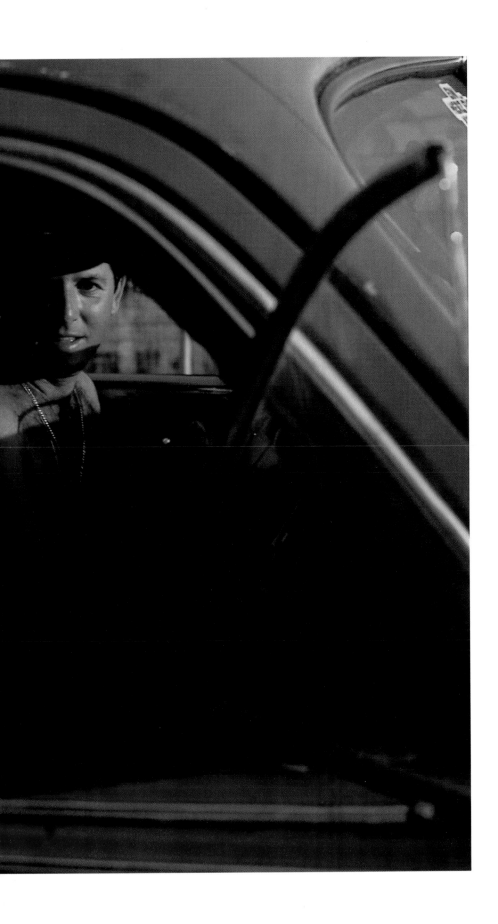

Children of the revolution born since 1959—as are almost two-thirds of Cuba's 11 million people—ride to Guanabo, a beach just east of Havana, in an American relic from pre-Castro days.

"I was struck by these kids just out cruising in a car," says Harvey. "It's so rare to see that in Cuba, with gasoline so expensive and cars so scarce. But here they were, in late afternoon, just being kids. It was so familiar, and so unusual."

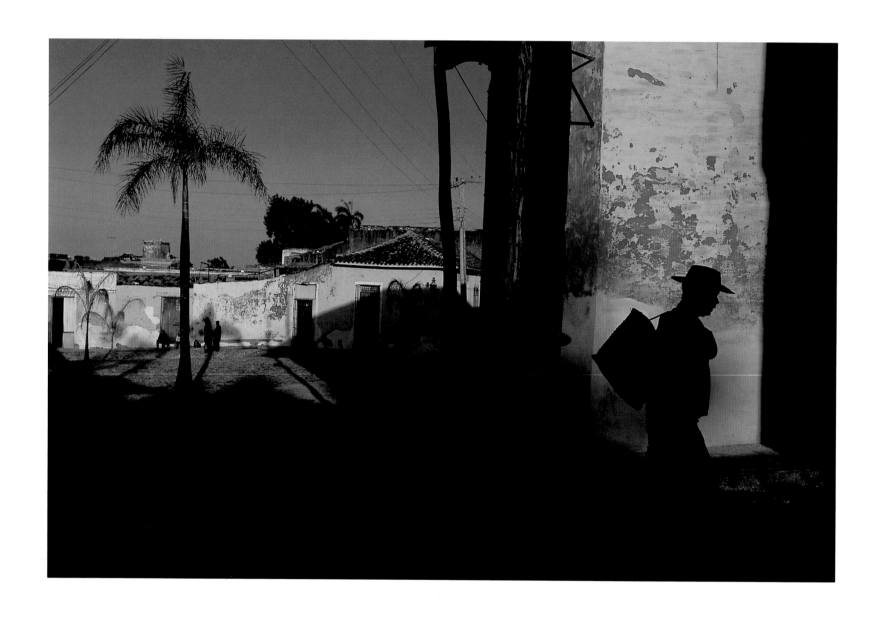

Nestled between ocean and mountains, Trinidad, a jewel of a colonial town on Cuba's southern coast, boasts the
island's most inviting climate. Despite hard economic times, breezes of hope and pride waft through its narrow streets.

154

Trinidad

Trinidad is a beauty....It is an unspoiled colonial town, most of it late eighteenth- and early nineteenth-century, but inhabited from the sixteenth century. The streets are cobbled, the houses one storey high, with vast, handsome wood doors, wide enough for a carriage, and bowed iron grille-work on the front windows. Every house is painted, and paint makes the difference—pale green, pink, blue, yellow. The Cathedral, at the top of the town, is yellow trimmed in white, and fronts a flowery square that descends in steps to the houses.

MARTHA GELLHORN, FROM "CUBA REVISITED," 1986

Coming of age at 15, Yunisleidis de la Cruz Mendoza Lozano shows off her party dress. Neighbors came from their houses, applauded, and cheered as Yunisleidis emerged from her grandmother's home in a modest neighborhood called Tres Cruces.

"I celebrated my Quinceañera in this neighborhood," says her mother, who now lives in another part of Trinidad, "and my daughter's will be in the same place."

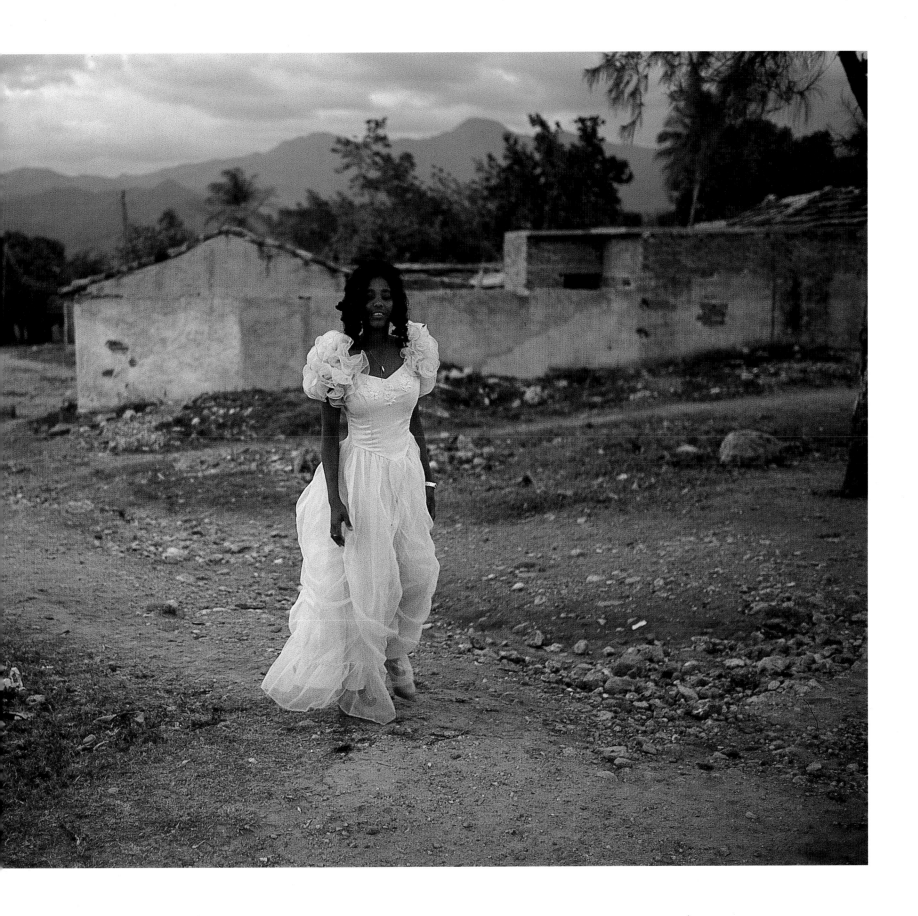

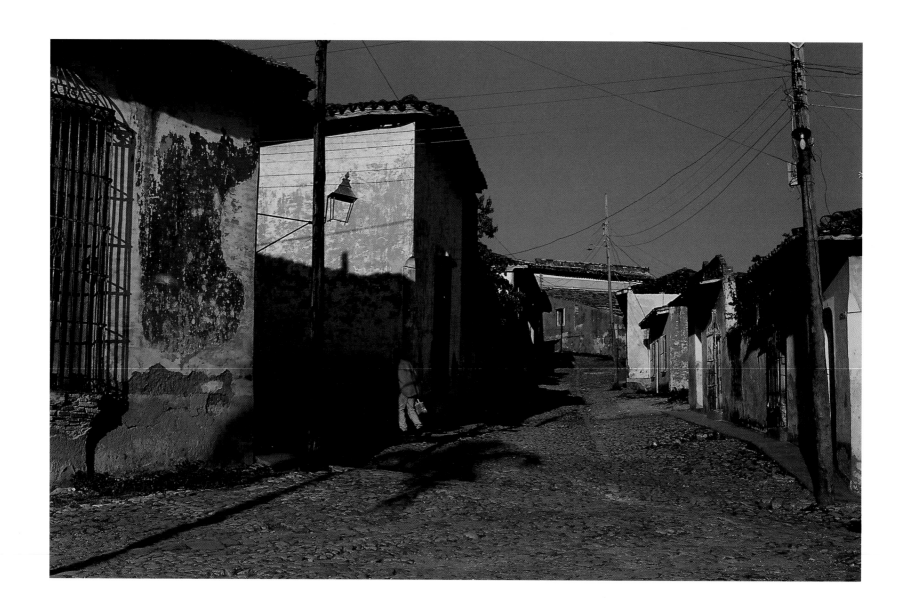

Tourist buses roll into Trinidad regularly, yet it remains decidedly undeveloped. The narrow cobblestone streets and brightly colored one-story houses date from the 18th and 19th centuries at the height of Cuba's sugar boom, when the town was a sugar gateway for an empire. Legend has it that the cobblestone streets were built with ballast from sailing ships that brought the stones from Boston and returned laden with sugar.

158

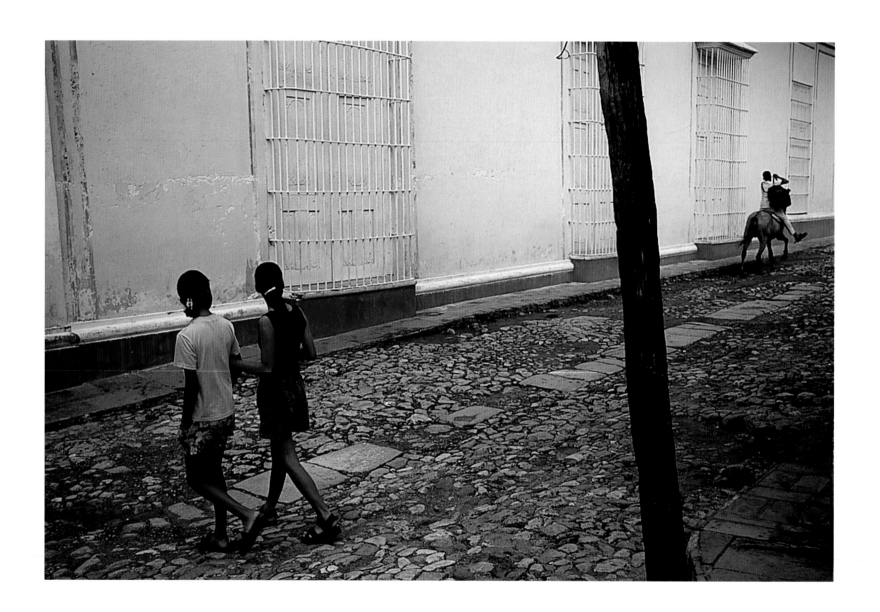

Along streets resonant with the clip-clop of horses' hoofs and the squeak of bicycles, life moves at a pace reminiscent of decades past. A young man tinkers with a U.S.-made jalopy by the curb (opposite), while a more reliable mode of transportation ambles by. A glimmer of elegance from the time when Trinidad was a cosmopolitan center of culture and trade glows in the tall, shuttered windows of colonial era mansions (above).

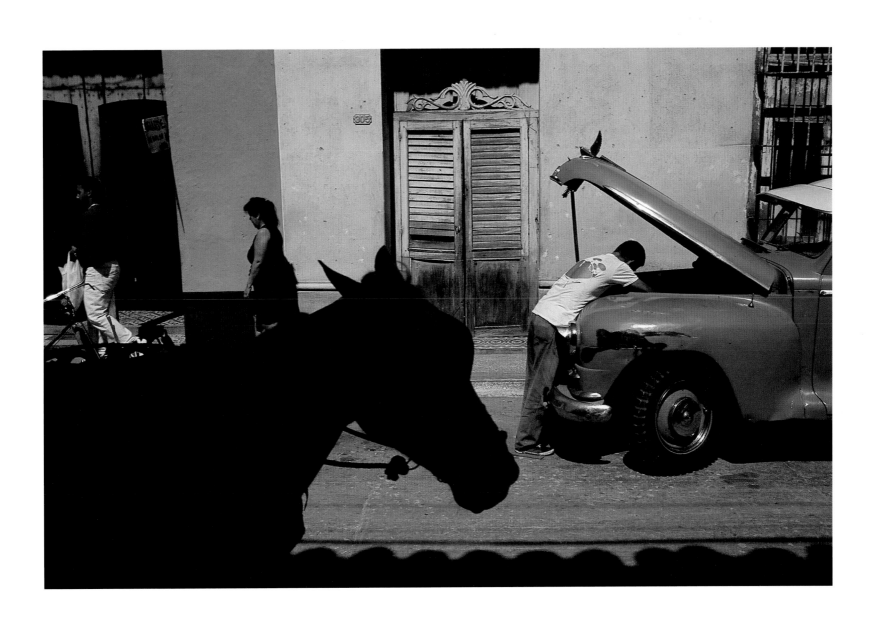

Parked overnight on a porch, a horse will soon be put to work. With public and private vehicles scarce in Cuba, Trinitarios continue to rely on horses and burros to carry children to school, take vendors on their rounds, and even pull the trash-collection cart.

Built in the early 1700s, Nuestra Señora de la Candelaria de la Popa is the oldest Trinidad church still standing—but barely. Its wood roof, installed after a fire nearly destroyed the church in the 18th century, has collapsed from termite damage.

Now the congregation is trying to raise money for restoration. In the meantime, it is closed to the public, and townspeople gather on its hilltop site to watch the sun set.

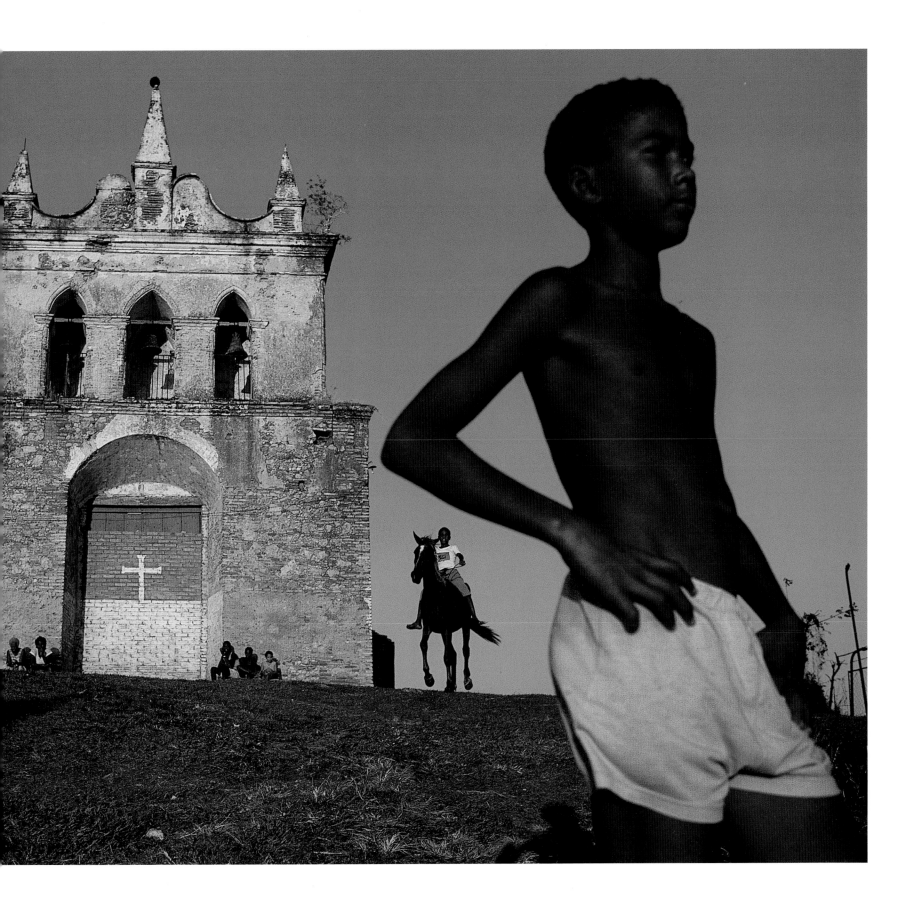

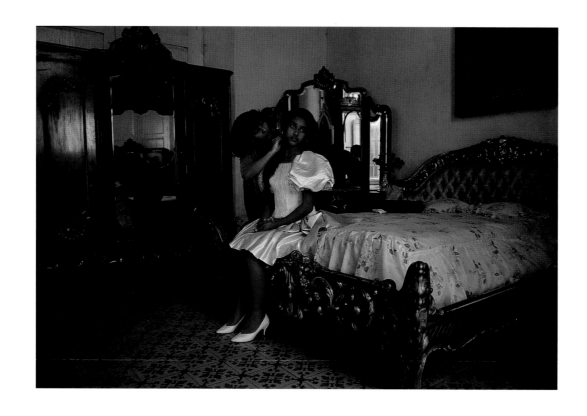

In one of Trinidad's preserved grand old 18th-century houses, Elsa Zayas Mendoza prepares her niece Annalien for her 15th-birthday photographs. With her eyes fixed on the future, Annalien dreams of studying acting in Havana. Barber Orestes Ramírez Soa's shop (opposite) is also the front bedroom of his home.

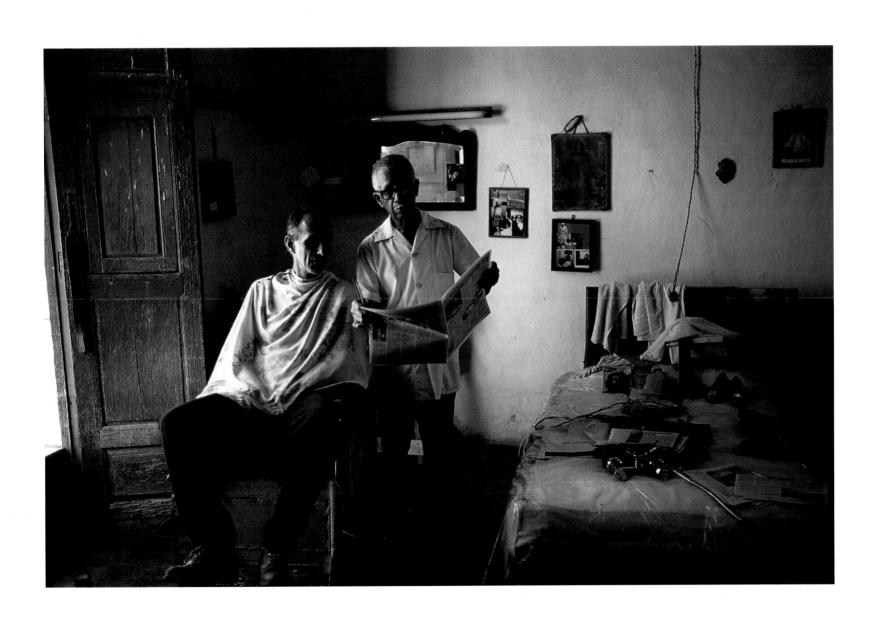

Music fills every corner of culturally rich Trinidad. In an empty courtyard on weekday mornings the Trinidad Folkloric Ballet moves to Afro-Cuban rhythms, preparing their repertoire for audiences at home and abroad.

"Some of our dance traditions are similar to those in other parts of Cuba, but others are specific to here," says Gisela Zerquera Calderón, the group's director. "We think it's important to keep them alive and show them to the world."

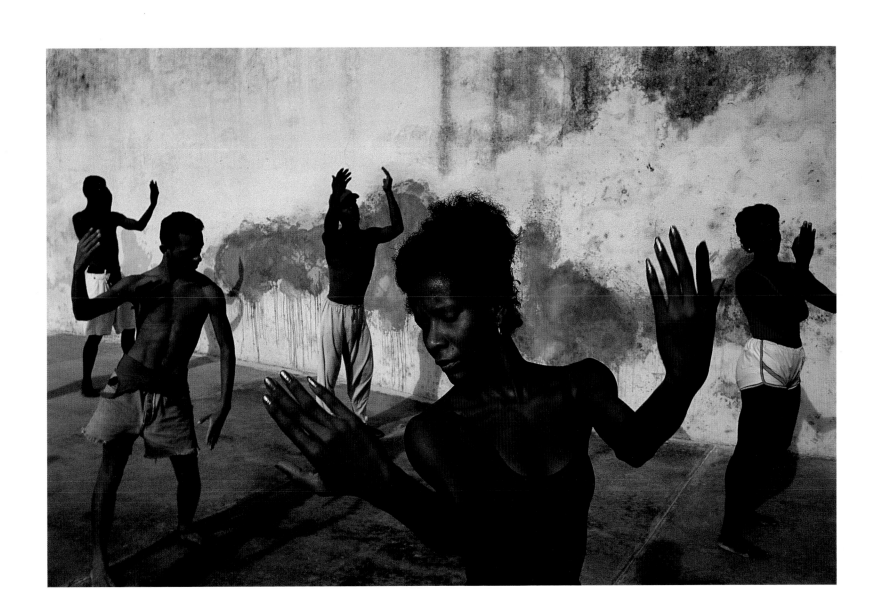

Painted walls lend some life to Trinidad's streets. The town has seen centuries of boom and bust, going from a mere back-water in the 1600s to a plantation center with nearly 6,000 residents by 1755. As the plantations faded, so did Trinidad's fortunes. The railroad didn't reach here until 1919, and a highway not until the 1950s. Isolation preserved the colonial heart of the town, which is now being restored. In 1988, UNESCO named Trinidad a world heritage site.

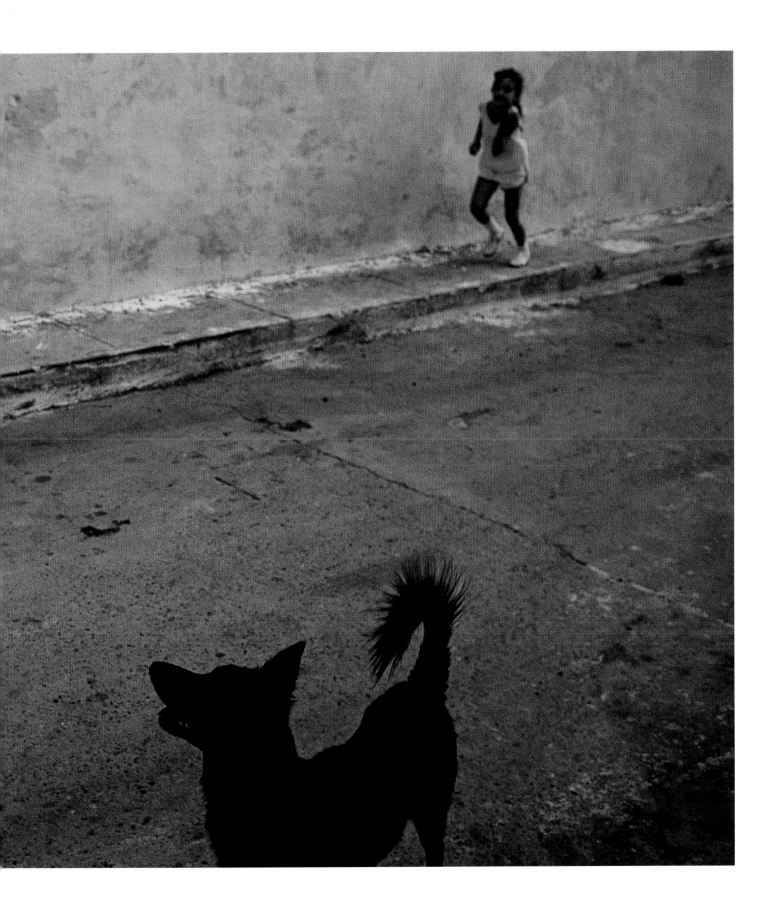

Many of Trinidad's cobble-stone streets have a distinct slope to the center. Most say it's for drainage—others insist an early Trinidad governor's right leg was shorter than his left, and that he had the streets built on a slant so he could walk without a limp.

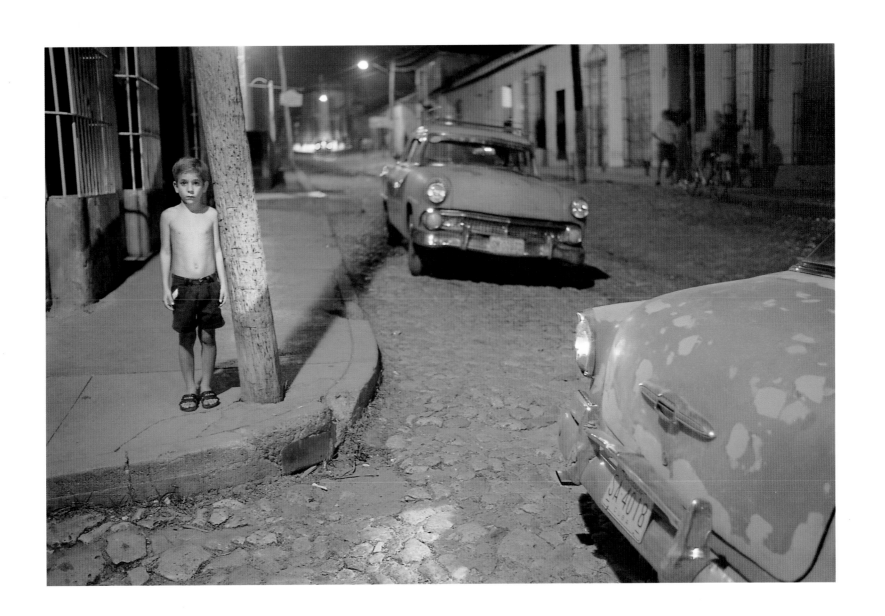

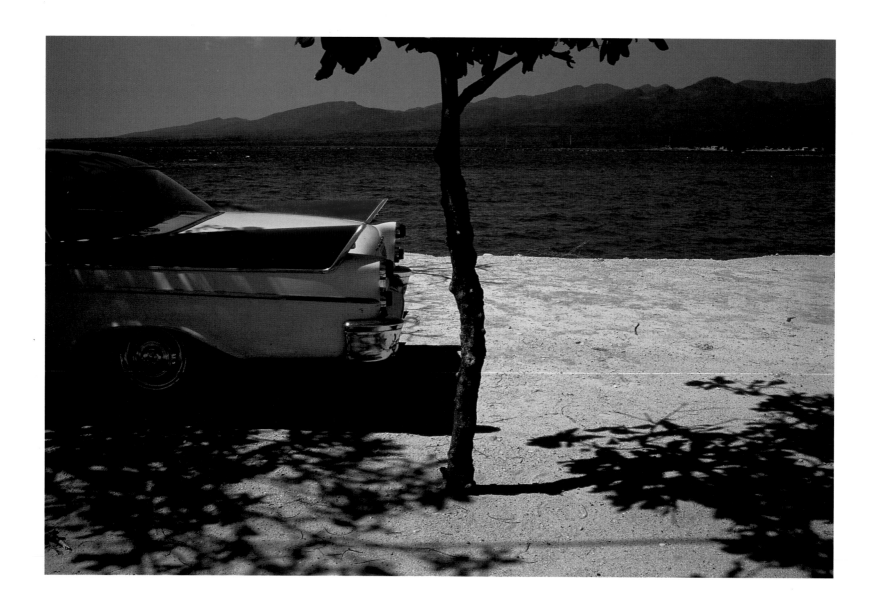

The sea opened Trinidad to the world, bringing in conquistadors, slave and sugar traders, and visitors such as 19th-century German naturalist Alexander von Humboldt. Today's stretches of sand that scallop the Caribbean draw tourists from Europe, Canada, and the rest of Latin America. For locals, getting to the beach is a cinch if you have wheels, sometimes stopping at an ocean-bound stream for a quick clean-up (opposite).

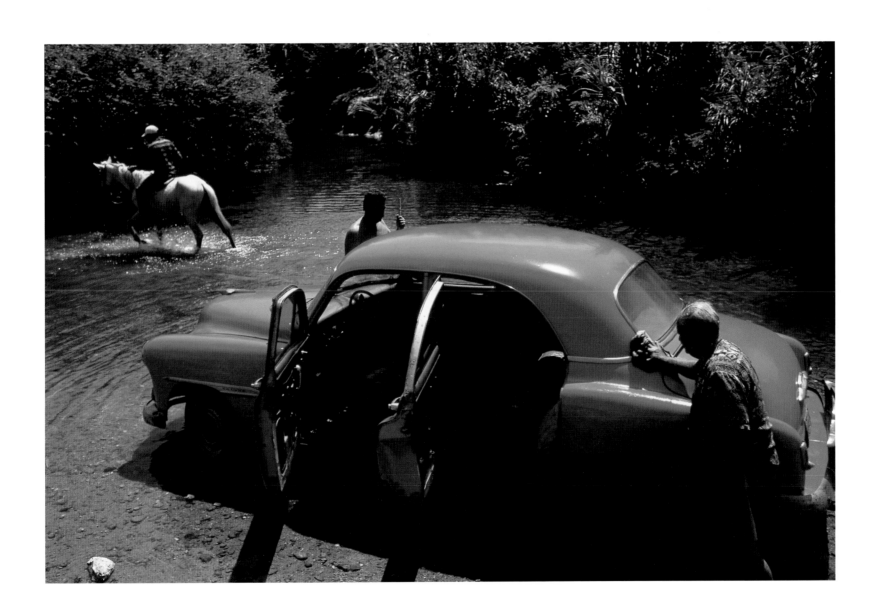

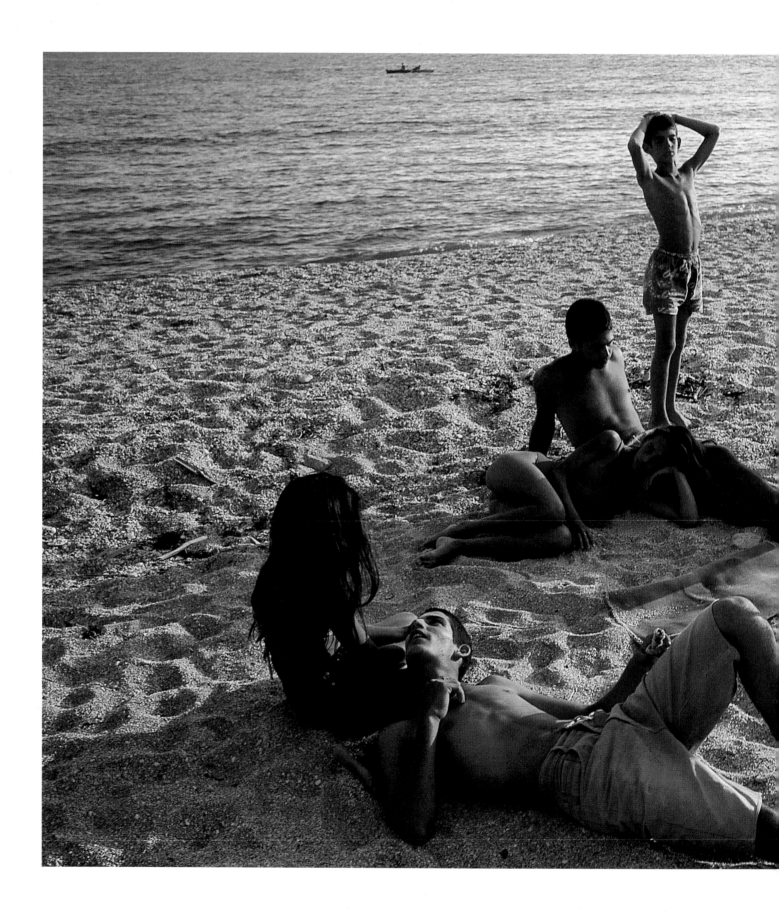

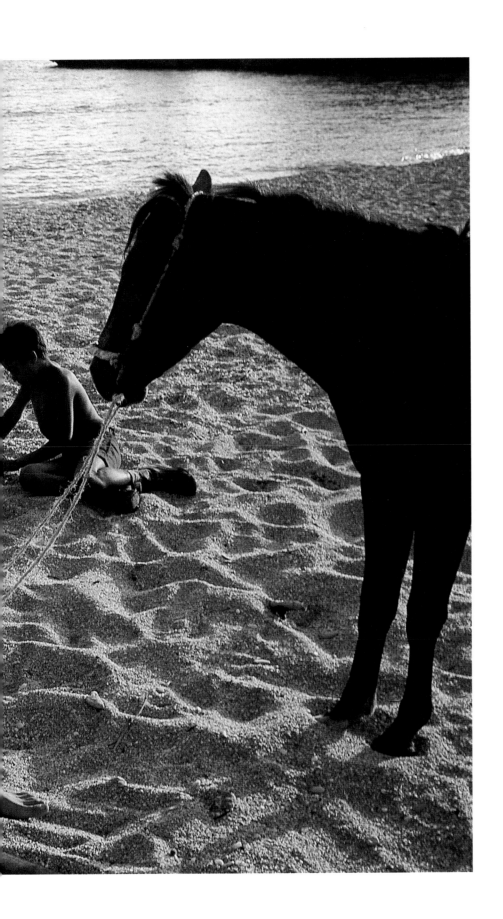

By foot or by horse,
Trinitarios inevitably find
their way to the area's
unspoiled beaches.

 "There is no other place
like it in all of Cuba," says
an elderly resident. "My
wife and I were born here,
and we love it."

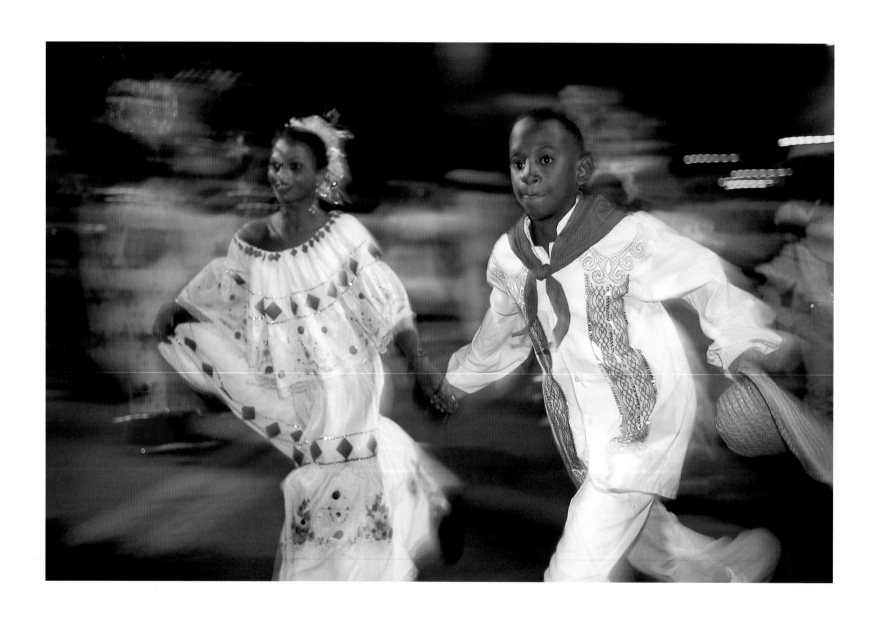

It's 5 a.m. Do you know where your children are? In Santiago de Cuba on the island's east end, if it is late July they are most likely out celebrating Festival del Caribe, the biggest party of the year.

The East End

The drive paralleling the Sierra has stayed with me not because it was especially dreamy but rather because it was ordinary. Hitchhikers were traveling no more than twenty kilometers each, to and from school, family, work. If the country's failings were leaking through irreparable cracks, its strengths were visible through incandescent air. The people of the Oriente had a tempo, steady and unyielding. They were part of their land, fluid enough to fill its contours, slow enough to accommodate its heat.

TOM MILLER, FROM *TRADING WITH THE ENEMY: A YANKEE TRAVELS THROUGH CASTRO'S CUBA*, 1992

Just about as far east as you can go on Cuba spreads a coastal plain and the town of Baracoa, site of Cuba's first settlement, founded by Diego Velásquez in 1512. Once accessible only by boat, it is a lush area of clapboard houses surrounded by cacao and coconut plantations.

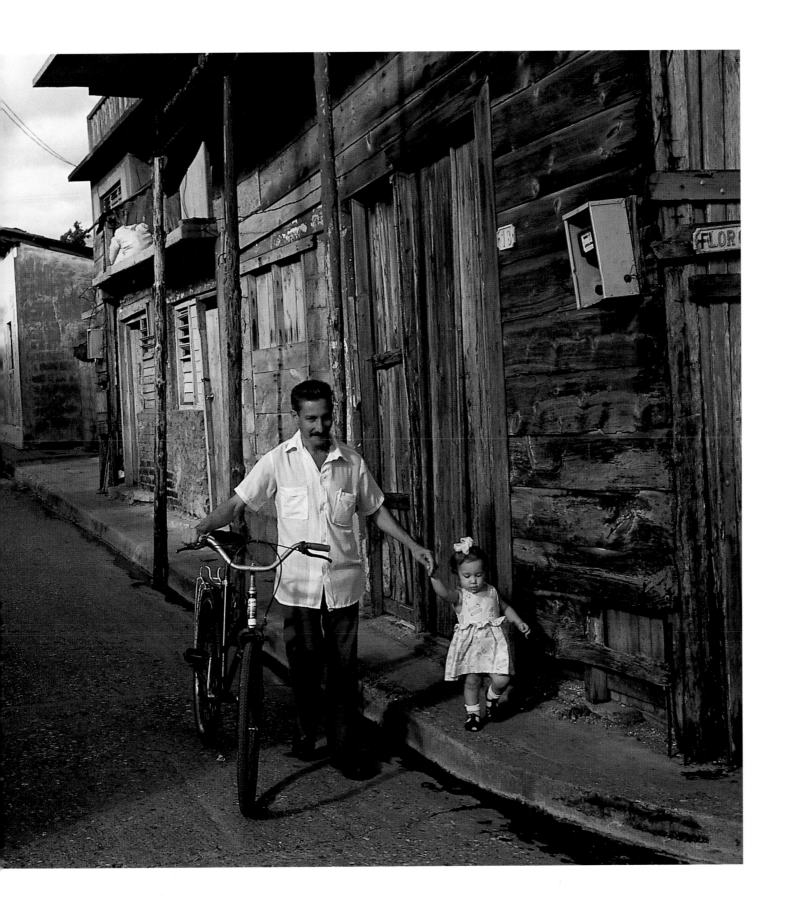

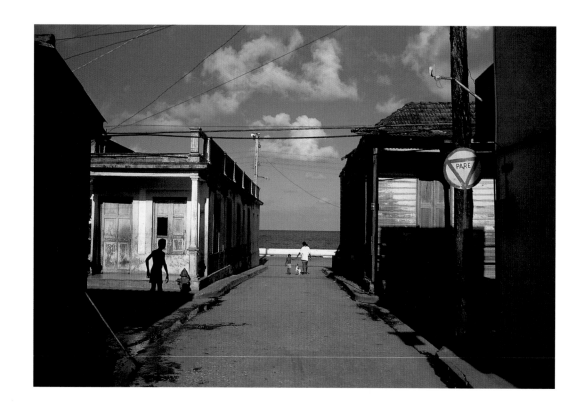

Beyond Baracoa lies the eastern Caribbean, overlooked by old wooden houses and more recent apartment blocks (opposite). Found buried along this shore was a gilt cross, now kept in Baracoa's Catedral Nuestra Señora de la Asunción, built in 1805. Local legend dictates the cross was planted by Christopher Columbus when he visited Cuba; recent scientific tests lend that story some support, dating the wood to the 1400s.

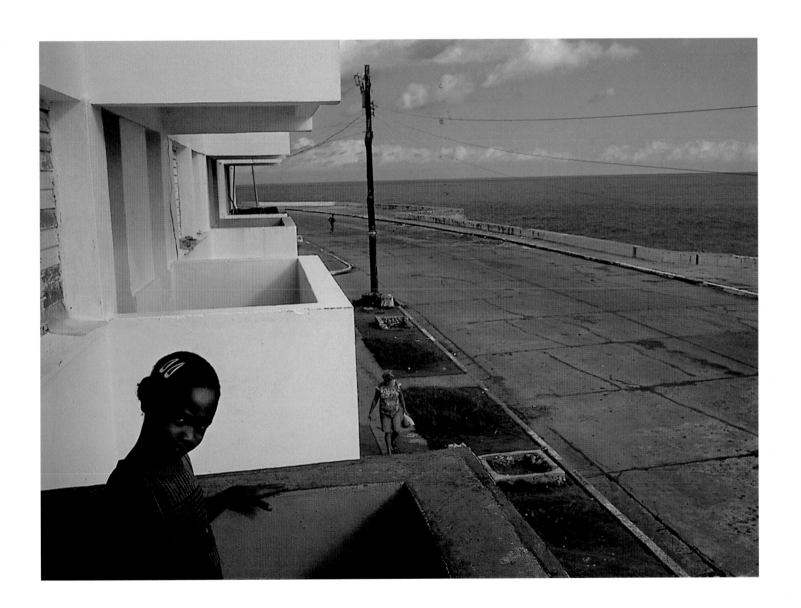

With El Yunque, Baracoa's flat-topped mountain, on the horizon, a young woman poses for another photographer on a hotel terrace. Some guests stay for months at Baracoa's leading hotel, El Castillo, a renovated hilltop fort dating from the 1700s.

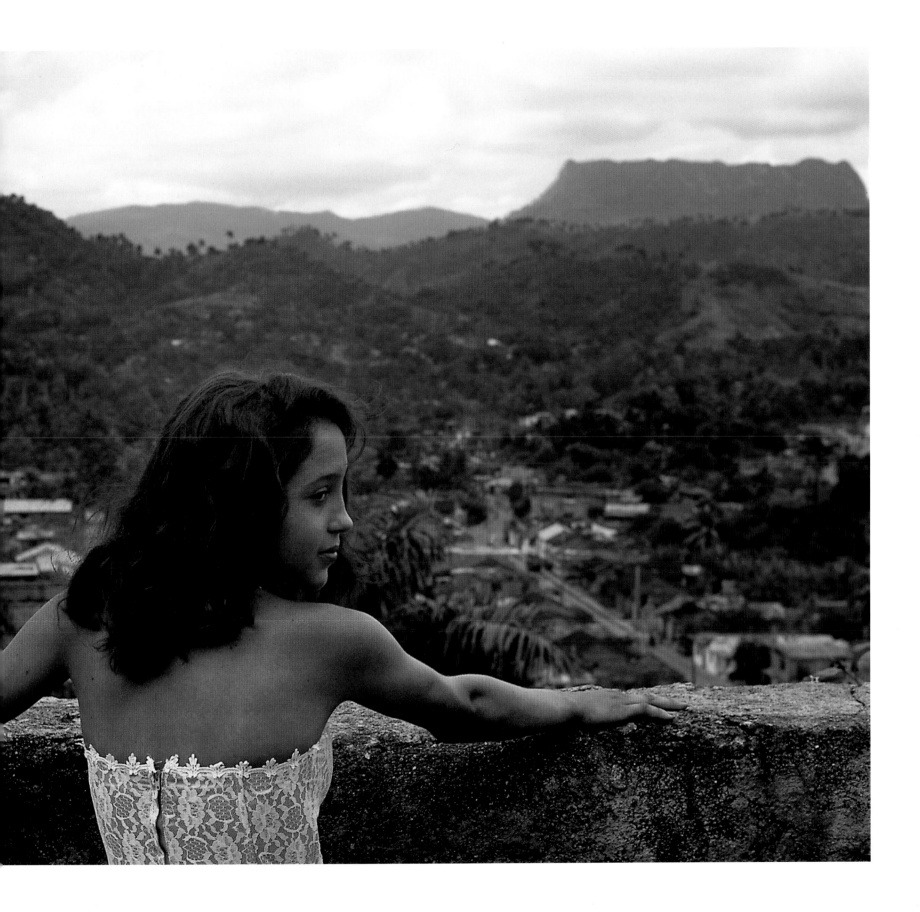

If you want to start a bicycle repair business in motor vehicle-starved Baracoa, virtually all you need do is stand outside your home with a tool kit. Located at the edge of nowhere, the residents traditionally fend for themselves. There's even a local specialty you'll find nowhere else: *cucurucho,* a soft coconut and sugar candy.

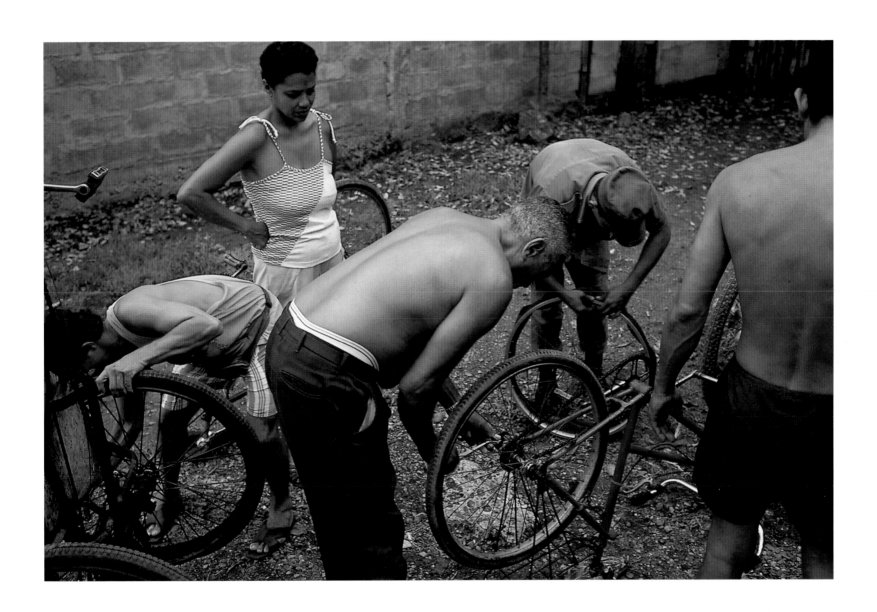

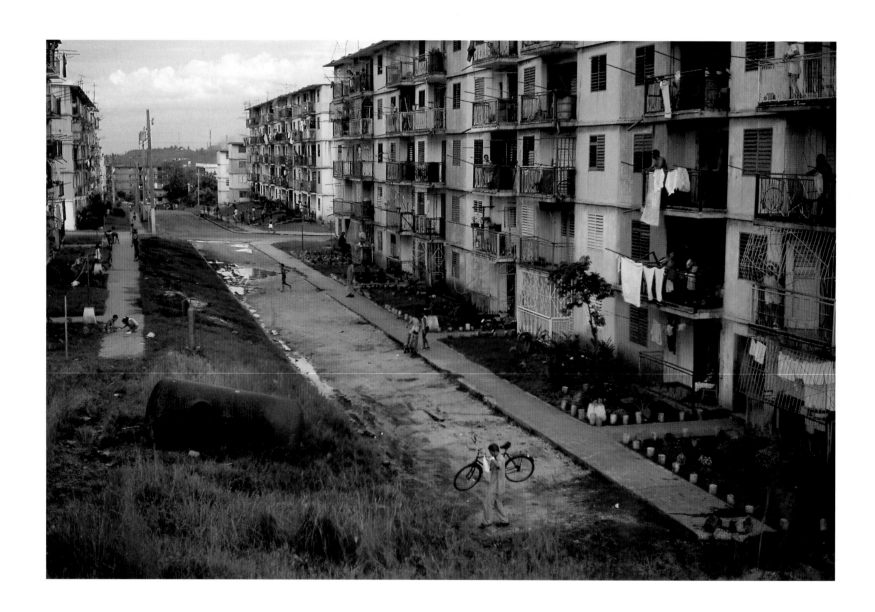

At the heart of Cuba's marginal industrial economy, the town of Moa on the coast northwest of Baracoa has been a mining and export center since before the revolution, when U.S. mining companies began scouring nickel from the earth there. Soviet-inspired prefab housing, built since 1959, adds no beauty to a landscape long blighted by the processing plants. Young workers (opposite) take time out for recreation.

Sporting her Socialist
Pioneer bandanna, a girl
in Baracoa picks up the
day's ration of bread for
her mother and herself:
One roll apiece. "Rationing
is the worst thing about
Cuba these days," says one
of the many women with
no hard currency to buy
extra groceries at the
well-stocked—but U.S.
dollars-only—food stores.

190

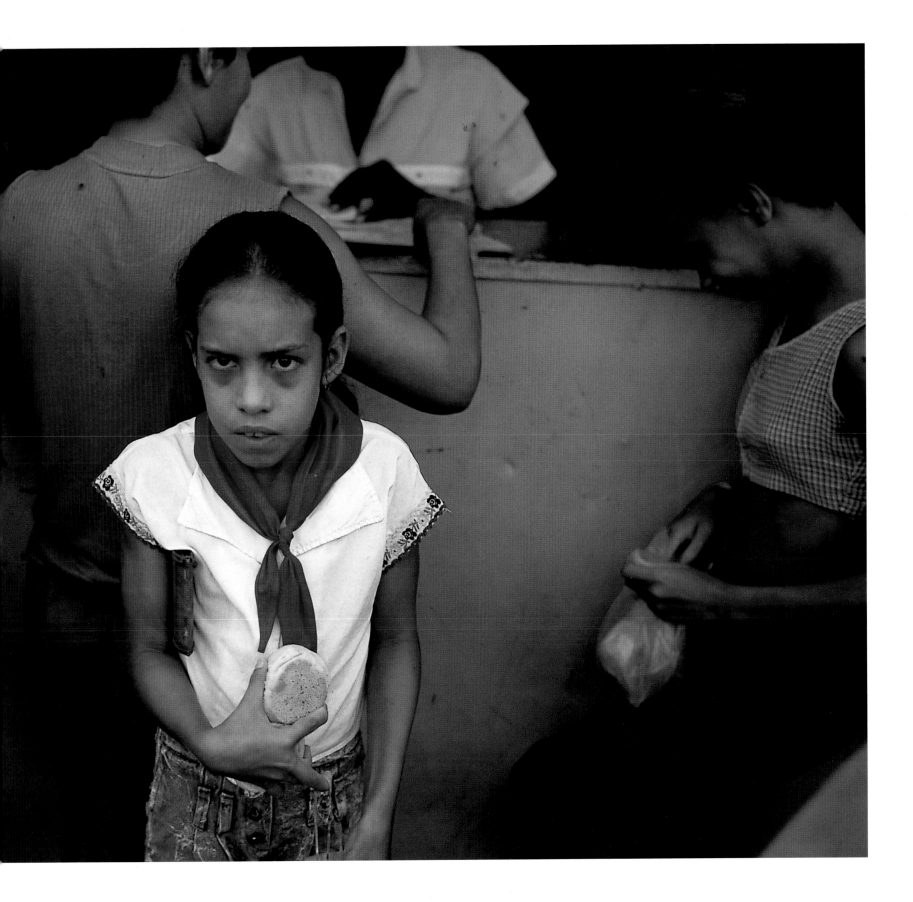

Cuban to the core, the centuries-old custom of cock fighting flourishes, unfazed by decades of Soviet influence. Cock fighting has been illegal in Cuba for years, but the increasing availability of U.S. dollars makes its lure irresistible to many. Police will no sooner shut down one fight site than another will resurface nearby. Before the admiring gaze of a young onlooker, two Baracoa neighbors compare their birds before heading out to the yard for a match.

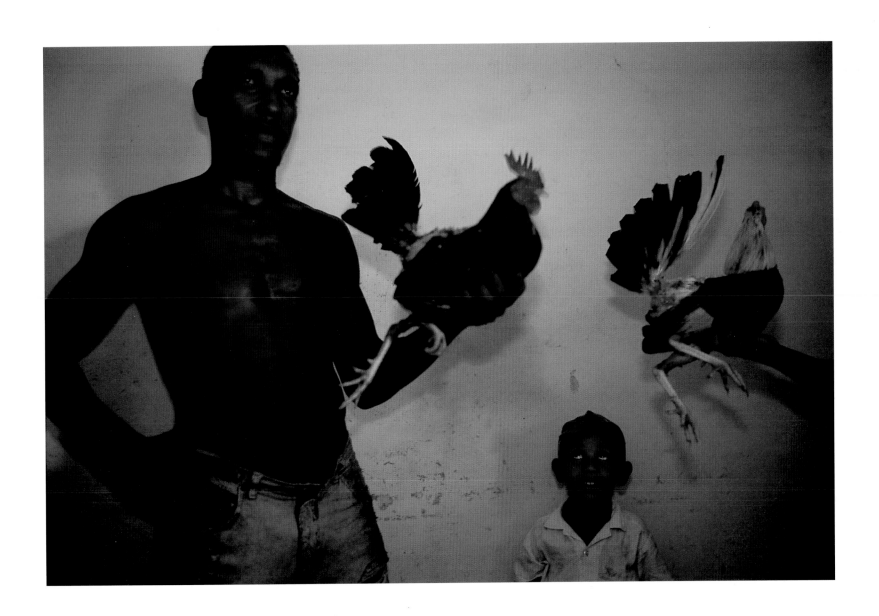

When the lights go out at
night in Baracoa, everyone
heads out to the street,
where only headlamps
from the occasional pass-
ing vehicle pierce the dark-
ness. Weekly blackouts
have become common
throughout Cuba since
subsidized Soviet oil that
once fueled power plants
dried up in the early 1990s.

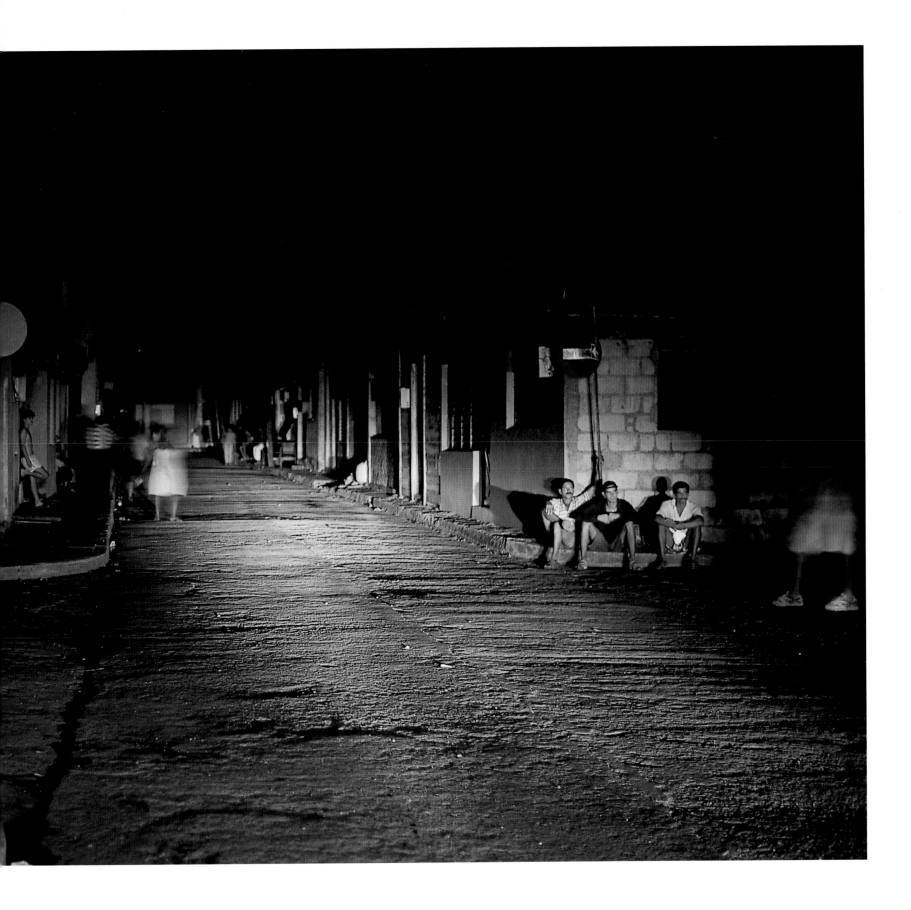

Living icon and tireless
voice of the revolution,
Castro commands atten-
tion in Santiago de Cuba,
where he made his first
speech as the island's new
leader on January 2, 1959.

"Castro will speak for
five hours, and it always
seems to be the same thing,"
says Harvey. "He tells them
the story of the revolution,
of the people's 'glorious
victory over oppression.'

"It's a terrific story, and
I suppose if George
Washington were still alive
today, whenever he told
us the story of crossing
the Delaware, we'd listen
to that, too."

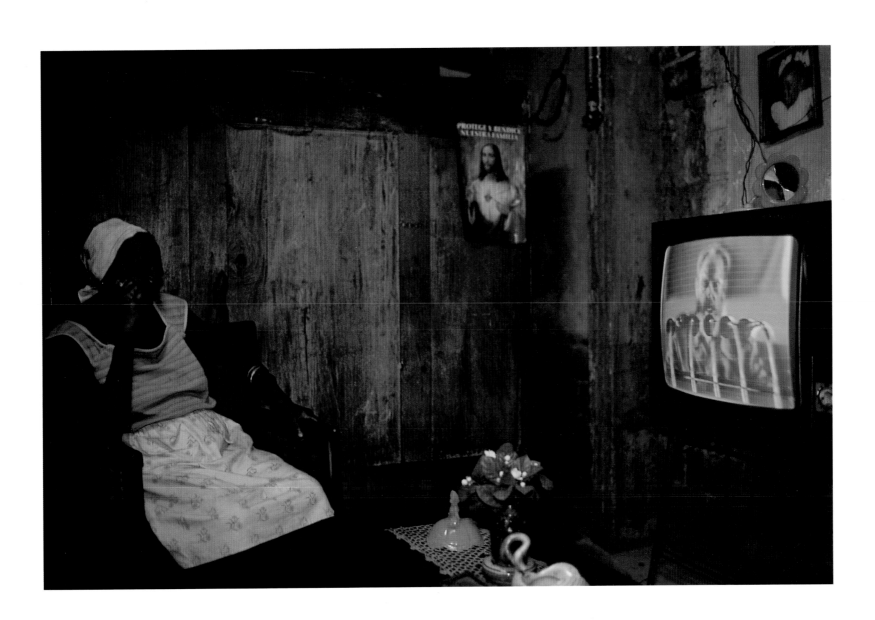

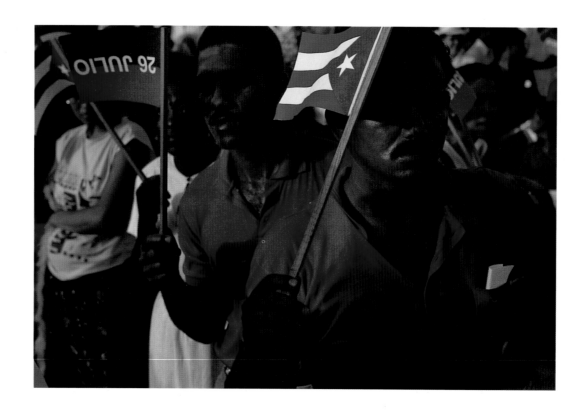

It was during carnival in Santiago de Cuba that Fidel Castro's revolutionaries, in 1953, attacked the Moncada barracks, knowing that the troops of Cuban dictator Fulgencio Batista would be among the drunken celebrants. The raucous celebration also helped drown out the sound of the rebels' gunfire. Many carnival revelers still wear their communist-red outfits, but a banner and oversized shorts are not out of order (opposite).

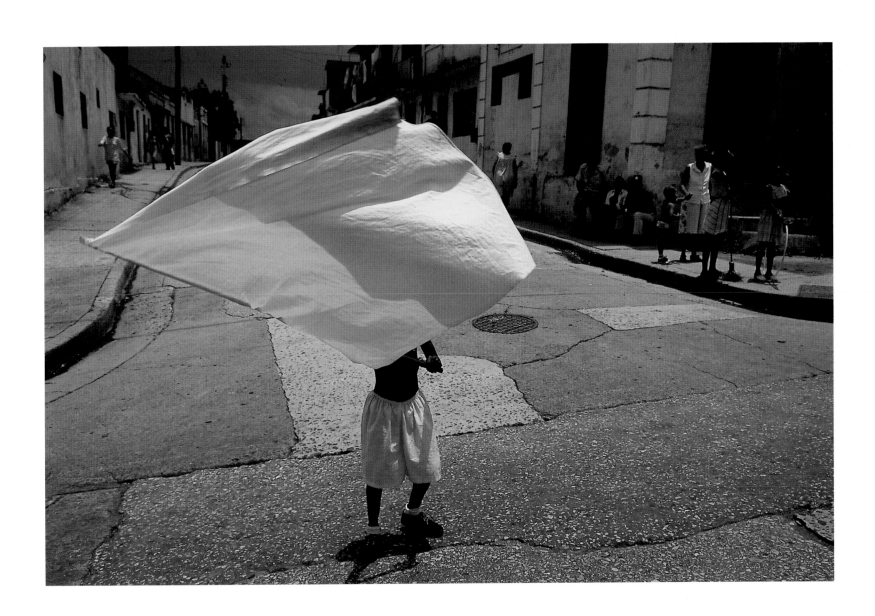

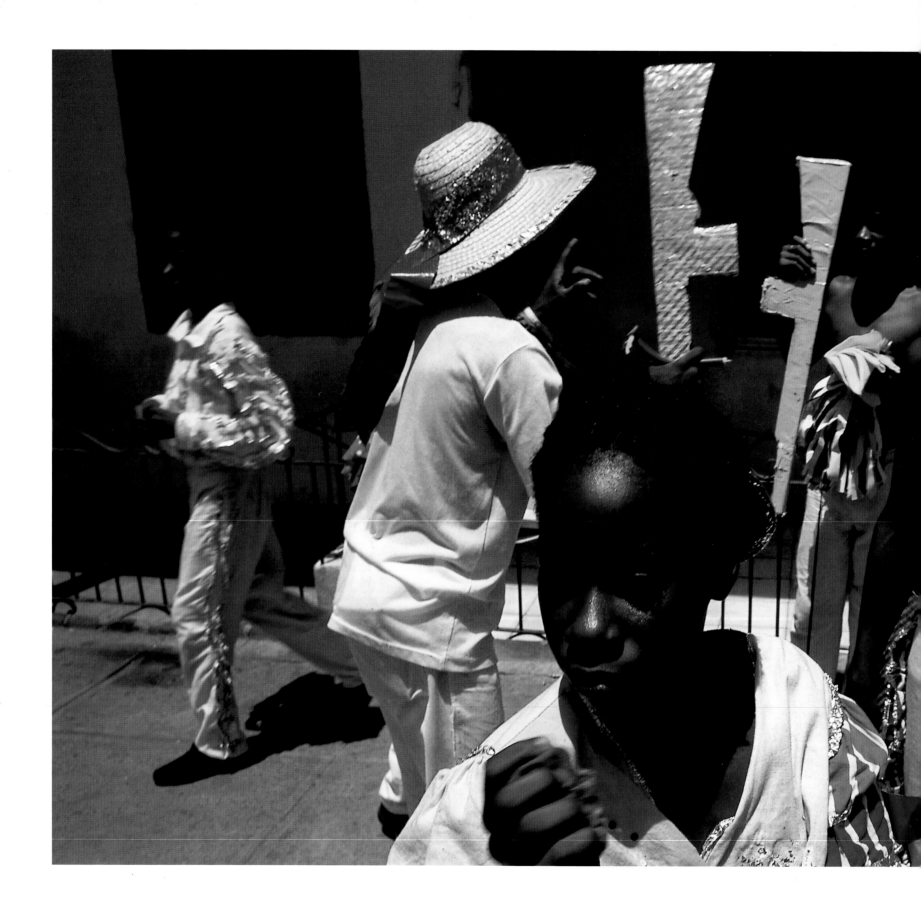

Recreating the rebel's attack on the Batista stronghold in Santiago de Cuba, carnival celebrants wield cardboard cut-out rifles. It's the closest any non-government Cuban can get to carrying a firearm.

"I suppose," says Harvey, "that dealing in drugs and carrying a gun are the two quickest ways to get yourself hauled off in Cuba."

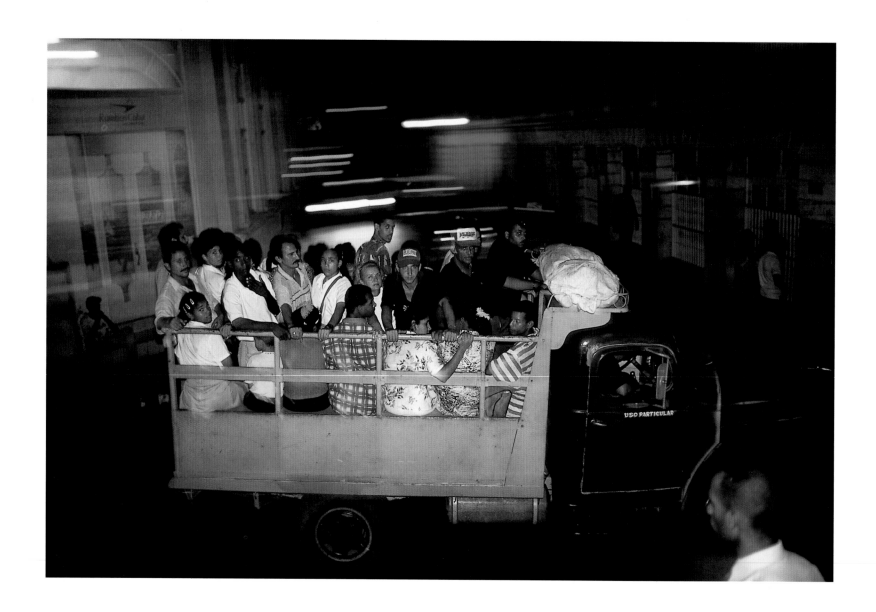

"No es facil—It's not easy" applies to almost everything now in Cuba. With public transportation scarce
even during high-season events like carnival, commuters squeeze into private vehicles like this truck. Still,
at carnival time it seems all of Santiago de Cuba is in a marching mood. Bands trumpet and drum their way
through the streets (opposite) all day and all night, performing to cheering partygoers.

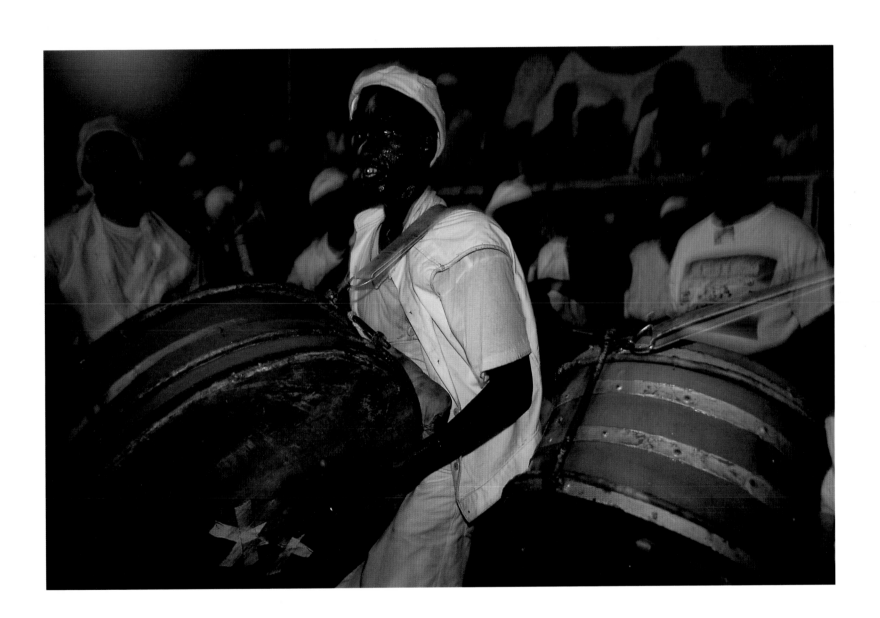

Carnival lights up a Santiago de Cuba street on a sultry July night as a costumed dancer makes her way home. Downtown, other dancers pulse to the syncopated beat of music played on trumpets, conga drums, and cowbells. From the remote corner of a country teetering at the brink of collapse, the sounds of unbridled joy defy the darkness.

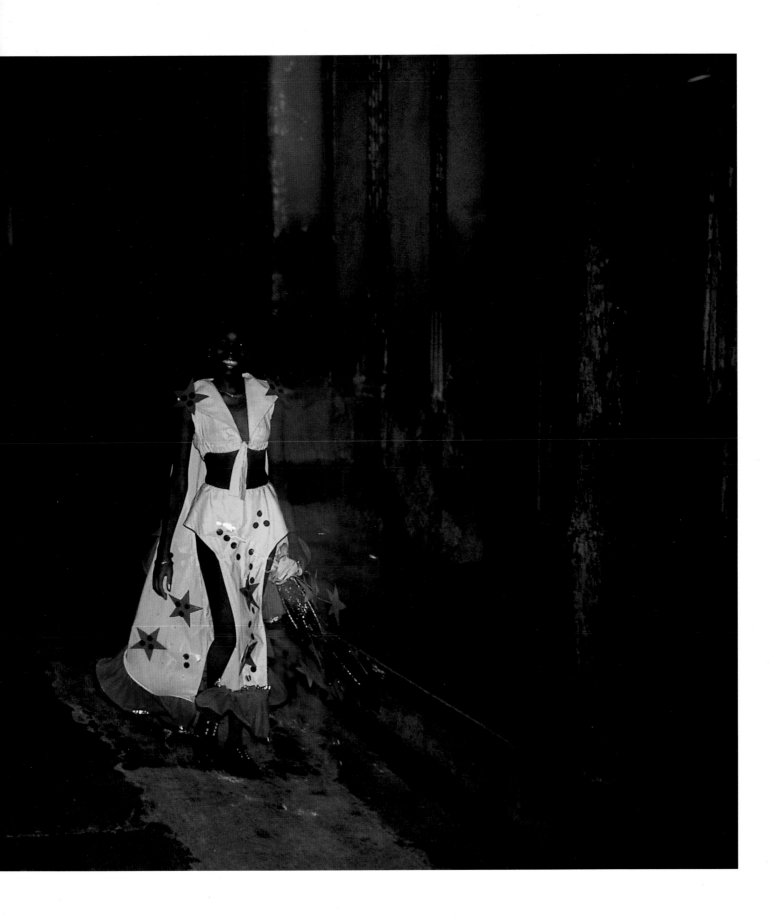

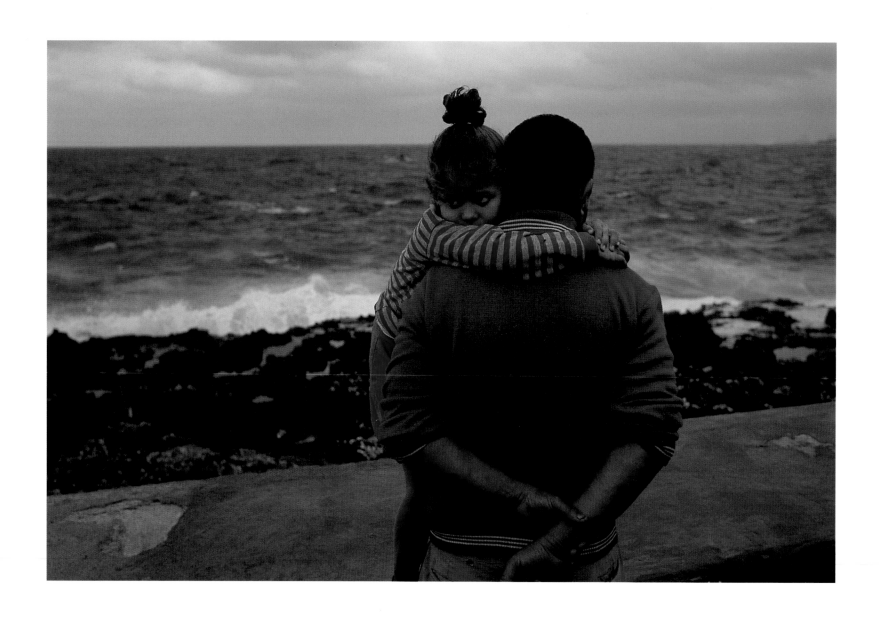

An entire generation has been born and raised in the shadow of Cuban communism. The generation before them lived under corrupt dictators. For centuries before that, Cuba was subject to the whims of an often indifferent empire. As they watch world communism vanish around them, Cubans contemplate the next direction their island nation will take.

Awaiting an Outcome

FOR MUCH OF THIS CENTURY Cuban–American relations have been as entangled as partners in a salsa. Fraught with ambiguity and heavily burdened, the relationship generally served both countries' interests until the late 1950s. While the United States meddled heavy-handedly in Cuban affairs, many Cubans were all too happy to turn over responsibility to the U.S in exchange for material benefits. But soon after the corrupt Batista dictatorship opened the door to revolution, a young opportunist saw in the United States a convenient whipping boy, a role it has filled ever since.

In American hostility Fidel Castro has found a useful means of holding onto power. From the imposition of a far-ranging economic embargo in 1962, through the C.I.A.'s support of the Bay of Pigs invasion and various plots to kill or overthrow Castro, to the passage in 1996 of the Helms–Burton law, which aimed to further weaken the economy and Castro's government by tightening the embargo, the U.S. has given Castro the weapons with which to rally Cuba behind him. And rally he does. U.S. policies are blamed for nearly everything that's gone wrong and are summoned as justification for demands on Cubans for ever more work and sacrifice. "A remarkable new generation of Cubans...is being indoctrinated systematically with the idea that the United States is the embodiment of everything that is narrow, selfish, and evil in the world today," wrote *New York Times* columnist James Reston after a visit in 1967.

You'd think that Cubans—more than 60 percent of whom were born since the revolu-

tion—would hate Americans, or at least the ogre called the United States. The miracle is they do not, far from it. Castro has had no more success turning his countrymen against the U.S. than he has in creating the new socialist man. "When I'm in Mexico, I do everything possible to disguise the fact I'm from the U.S.," says a frequent traveler from Los Angeles. "When I'm in Cuba, I try to make sure everyone knows it." Except for some hard-core *fidelistas*, it is virtually impossible to find a Cuban who does not like Americans and light up on meeting one. A young tobacco farmer near Trinidad, who has rarely encountered anyone from the United States in his lifetime, wants to see the economic blockade end "so that Cubans and Americans can embrace each other like brothers." Part of the explanation is history and geography; the ties are familial, however difficult, and stretch way back. Even in the 1950s the intellectuals' antagonism toward the U.S. did not trickle down to the majority of Cubans.

Also, Cubans have a lot in common with Americans, more than with Spaniards and other Hispanics. Like Americans they are optimistic, practical, and resourceful; they share a relaxed take on life, an understanding, a *simpatía*. A great many Cubans have relatives living in the U.S. and would immediately embark for Miami if they could. (In 1998 a U.S. lottery to select some 15,000 of the 20,000 Cuban immigrant quota drew 541,000 applicants, at some possible risk to themselves.) Young Cubans are obsessed with U.S. culture and brand names. In their feelings about the U.S., mythology plays a large role—the U.S. as promised land, where, as one put it, "You'd kick a rock and money would fall out." This attitude may be common in Third World countries, but to find it so openly expressed in one where official policy and rhetoric are profoundly anti-American is part of the pervasive surrealism. Popular jokes express the sentiment: What are the only two things Cubans like about the U.S.? Answer: The movies and everything else. (Walk through the streets of a Cuban town on Saturday night when the TV shows a U.S. movie, and absolute stillness prevails.) So does the U.S. flag on T-shirts and bandannas—a streetside cache at the relatively astronomical price of three dollars each disappears in minutes.

The bullish feelings toward the U.S. reflect the desperate longing for a way out of the current isolation and hardship. When and how it will come about no one knows, but hardly anyone, except perhaps Fidel Castro himself, doubts that the U.S. is the key. For the island's economy to succeed, the U.S. must buy its products and allow American tourists to visit. Meanwhile, the salsa continues. Today, once again, the status quo serves the mutual interests of the two governments. Castro calls the U.S. embargo "economic genocide," but many

observers believe without it he'd be gone, that thousands of U.S. businessmen and tourists streaming through Cuba would undermine his tight controls and, if not dislodge, at least sideline him. With the embargo in place, the United States helps maintain the illusion that the island's problems are due to outside pressures rather than a severely dysfunctional system. And yet, in another of the situation's endless ironies, the U.S. maintains the embargo mainly to placate the rich and powerful in the Cuban-American community, the very community whose members send up to 800 million dollars a year in remittances to family on the island, helping to keep Castro's government afloat.

And Castro is not unuseful to the U.S. He keeps a lid on migration by sea, which when uncontrolled in 1980 and 1994 seriously strained U.S. resources. Castro also serves as a drug policeman in the Caribbean. Reprising its role of 250 years ago as transshipment point for gold and silver traveling to Spain, today's Cuba, with thousands of islands and keys on which to make drops, is an ideal way station for smuggling modern riches—cocaine—from Colombia to the U.S. and beyond. Castro's tough though greatly underfunded anti-drug program has impressed U.S. drug enforcement officials; they are looking at ways to work more closely with it.

The danger of communist Cuba posing a security threat to the United States or any other country—the major rationale for the embargo—is long gone. But the strong political pressure to hold fast outweighs for now any reasons to give it up. The implacable and shrill opposition of Cuban-Americans to lifting the embargo is what mostly determines U.S. policy; polls in Miami show half oppose even opening talks with Castro's regime. While the feelings of the majority of Cuban-Americans today—those born in the U.S. and those who arrived within the last 20 years and thus lived for a time under Castro—are far less passionate than the 1960s exiles who "lost" their homeland, it is these earlier exiles, still fantasizing about restoring a pre-Castro Cuba, who hold the political ground. "Perhaps they are the only ones interested in occupying it. Perhaps the rest of the exiles have other life priorities," writes Cuban-American sociologist Lisandro Perez. In any case, the situation awaits an outcome—in Cuba, for Castro to die or somehow to fall; in Miami, for a generational shift to moderate the hard-edge conservatism of the 1960s generation.

The small modifications announced by President Clinton in 1999, such as allowing for more people-to-people contacts and the sale of food, seed, and fertilizer to religious groups, private farmers, and family restaurants, as well as for the baseball games between Cuba and the Baltimore Orioles, fell well short of lifting the embargo. There appears to be no immedi-

ate or pressing incentives for the U.S. to do so. With a hard currency foreign debt estimated in 1998 at 11.2 billion dollars and little foreign exchange, Cuba will remain hard pressed for years to buy the American technology, drugs, and other products it needs in quantity. Initially, the money may in large part come from a massive influx of U.S. tourists. What the island does have, mainly sugar, tobacco, and nickel, the U.S. doesn't need. Buying sugar would be hard on the American sugar industry and devastating to other Caribbean countries whose economies depend on selling sugar to the U.S. Still, many American farmers would like to see the Cuban market open, and many companies are keen to take advantage of investment opportunities, now left to Canadians, Europeans, Latin Americans, and others. Though limited, the opportunities offer a toe hold for a future when they may become extremely attractive. One day, a Commerce Department report says, U.S. exports to Cuba could grow to two billion dollars a year, creating some 30,000 new jobs in the U.S.

Rebuilding Cuba post-Castro will be a huge undertaking, requiring outside aid estimated at between 500 million and 2.5 billion dollars a year for several years. But for the long term Cuba has many assets: location, an educated population, important mineral resources, a significant biotechnology industry, and excellent prospects for tourism. Also, if political conditions are right, rich Cuban-Americans may invest heavily in many kinds of projects.

Perhaps the most compelling reasons for lifting the embargo have to do with creating conditions for a peaceful and stable transition to a post-Castro democracy. Former Secretary of State Lawrence Eagleburger, who supported the embargo as long as the Cubans were "a Soviet surrogate and raising hell in Central America," has observed that "if we want to have any influence in a post-Castro Cuba, we have to reposition ourselves. We can't do it 90 miles away with the door locked." The question of whether the transition will be orderly or chaotic has to be a worry to the U.S., if only for the spectre of thousands of small boats headed for the Florida coast. The hatreds rampant on the island—and in Miami—over what's transpired these 40 years could unleash the kinds of bloody reprisals that tormented Cuban politics in the past. Though unlikely, it's possible the U.S. would be forced to intervene, again. A permanent solution calls for Cubans on both sides of the Straits to settle their differences—end their civil war—so that the Miamians can support the islanders in shaping a uniquely Cuban future, one combining freedom and justice with social reforms.

For now Cuba struggles to keep its economy growing. After showing some improvement to 1996 following the crushing loss of Soviet aid and markets, the gross domestic product increased by only 1.2 percent in 1998. Sugar production in 1998 was down to its lowest

He rarely appears out of army fatigues, but even President Fidel Castro donned suit and tie to attend Pope John Paul II's Havana Mass. Defying all predictions, Castro has served as Cuba's supreme ruler for more than 40 years, longer than any head of state alive. Now in his 70s, he vows his revolution will continue, with or without him.

level in 50 years. Still, the government feels it is slowly making headway, and with all its problems Cuba has less poverty and illiteracy than most other Latin American countries. Tourism, not sugar, is now the island's economic engine, growing at nearly 20 percent a year. In 1998, 1.4 million tourists visited Cuba, staying in hotels and resorts built by Canadians and Spanish, among others, in joint ventures with the government. The vast, gleaming, modernistic airport terminal, built by the Canadians in 1997, reflects the ambitious expectations for the future. With two million tourists planned for 2000, the island is once again becoming a major tourist destination, only this time without Americans. (Although many do go, both legally and illegally, the numbers are relatively minuscule.) Sex tourism—one of the big draws of the fifties—had come back too, but Cubans are trying hard to clamp down on prostitution in favor of "family tourism."

Though remaining adamantly against privatization ("*Lo nuestro es nuestro*—what's ours is ours," a billboard in Havana proclaims), the Cuban government has cautiously embraced

foreign investment. While deploring the budding capitalists among the self-employed, the regime wholeheartedly favors state capitalism; by the end of 1998 it had signed some 350 joint ventures and deals with foreign companies. Aside from hotels and other projects related to tourism, however, the majority of deals so far are reported to be small and hard to come by. Laws on the books since the mid-1990s establish free-trade zones on the island, but in practice little has happened. One problem is that Cubans insist on doing the hiring and firing of workers—and paying them in pesos, while charging the foreign company dollars. "Most people, when they are confronted with the terms of the joint venture, say 'wouldn't time and energy be better spent elsewhere?'" a European banker is quoted as saying. Still, foreign investment appears here to stay: Large, high-price condominiums for foreigners are being built—and an elite beach-and-tennis club that catered to foreigners (and rich Cubans) in the pre-Castro era and spent the intervening years as an athletic training center has recently reopened as...an elite beach-and-tennis club catering to foreigners.

Meanwhile, Castro's controls on personal freedoms show no signs of loosening. Even longtime trading partner Canada, which strongly opposes the U.S. embargo, has been reexamining its ties since Castro sentenced four leading political dissidents to prison terms in 1999 for publicly advocating democracy. At the same time, he threatened tough new punishments for political opponents. "The harrassment against dissidents, human rights activists or anyone else attempting to exercise the most basic rights of association and expression continues exactly the same," a director of Human Rights Watch is quoted as saying.

"I am often asked what Castro's future will be," famed, exile Cuban author Guillermo Cabrera Infante wrote in 1992. "I always answer that he has none: He spent it all on his urge to keep himself in power." It is clear that Castro will do little that risks sacrificing control. The least traumatic transition for Cuba would be one he himself initiated, starting with opening up market forces to build the economy—but that he refuses to do. "He's just like an airplane hijacker with 11 million people on board," a prominent Cuban dissident laments. "He'd sooner blow us all up than compromise his revolutionary principles." Though he's named his brother, Raul, as successor, many Cuba watchers believe a collaborative government would soon follow. People at all levels of Castro's government recognize that a profound transformation must occur. But "No one has the courage to say, 'No, *Now* is the time for change,'" says a European diplomat. Meanwhile, defying decades of predictions, Castro lurches on, a man who, in the words of his 40th-anniversary speech, "dresses the same, who thinks the same, who dreams the same" as the day he came down from the Sierra Maestra. ∎

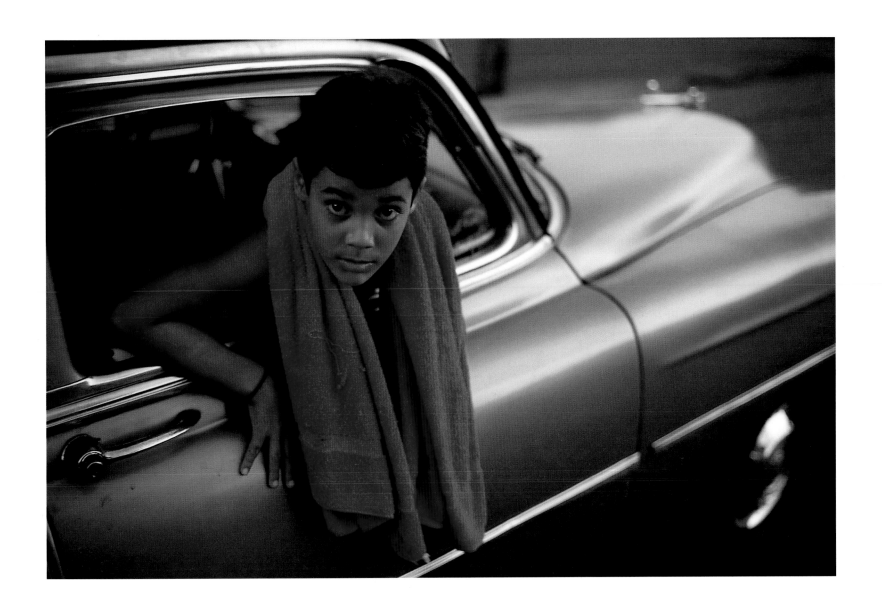

Cruising in a 1953 Chevrolet, a boy rides home after his ninth birthday party at a hotel swimming pool in Camagüey. As the revolution loses its swagger and its youth, Cuba is on the verge of inevitable but incalculable change. Its 11 million people await the next page in the island's tumultuous history.

Acknowledgments

My photographs of Cuba represent the most collaborative effort of my career. This is the "short list" of the people who made this book possible.

My first trip to Cuba in 1996 was financed with an assignment secured by David Strettell at Magnum. Subsequent photography in 1997 and 1999 was funded in part by Magnum as well.

Late in 1997 John Echave, senior assistant editor for NATIONAL GEOGRAPHIC magazine, submitted a proposal to Editor William L. Allen for a story on Cuba. Most of the work presented here was from three GEOGRAPHIC assignments: Cuba, Old Havana, and Trinidad. Echave became my mentor in Cuba. We made two Cuba trips together, and John was instrumental in setting up permissions for photographing around the island. Bill Allen assigned this most important project of my career. Thank you, John and Bill.

I credit National Geographic President and CEO John Fahey for insights into the future that made it possible for this kind of photography book to be published by the Society. John spent three days with me in Cuba, and my instincts tell me that new and creative things for the future are more likely to happen because of his leadership.

Associate Editor Robert M. Poole and Managing Editor Robert L. Booth, my colleagues at the magazine, edited my Foreword.

Longtime friend, art director David Griffin, created the elegant layout for Cuba. David's sense of white space, typography, and picture sequencing turned transparencies on a light table into a real book.

Lisa Lytton and Leah Bendavid-Val, both of whom know what it takes to make a good book, served as my creative advisors.

Thanks go to Nina Hoffman, Will Gray, Kevin Mulroy, and Elizabeth Newhouse of National Geographic Books. Nina gave the green light on this book and allowed us our creative freedom. Will lent encouragement and support. Kevin Mulroy, director of adult trade publishing, creatively juggled photography, writing, production, and finance to make this book a reality. Elizabeth Newhouse wrote the insightful and informative text that gives balance to the book.

George White and Chris Brown, in charge of manufacturing and quality control, went out of their way to make Cuba production values first class.

Cuban officials from MINREX: Roberto de Armas, Edgardo Valdez López, and Luis Fernández gave me visas and permission to roam Cuba freely. Thank you, gentlemen.

Eusebio Leal, historian of the city of Havana and personal friend, is a key to our cultural interchange with Cuba.

To Cuban friends Pepe, Jorge, and Gustavo, I give a very special thanks for helping me with the photographs.

My Magnum colleagues are always a driving force in my career. James Nachtwey, Larry Towell, Alex Webb, Inge Morath, Stuart Franklin, Dennis Stock, Steve McCurry, and Paul Fusco all advised me on this book.

Career-long friends at NATIONAL GEOGRAPHIC: Jodi Cobb, William Albert Allard, Michael Nichols, Chris Johns, and Sam Abell, who have all done major photography books, inspired me to do this one. Special thanks to director of photography Kent Kobersteen and associate director Susan Smith, whose general support of photographers is appreciated by everyone in the business.

Personal thanks go to lifetime friends Medford Taylor, Jon Schneeberger, and Ira Block who have put up with my idiosyncrasies and have given me nothing but encouragement and moral support.

My special friend, Christina Cachie, who has suffered my mood swings, helped edit pictures, and worked on location in Cuba, deserves extra credit for dealing with me on a day-to-day basis. Thank you, Christina, for your love and support.

The Harvey family is my greatest asset. Brothers Gary and Craig, sister Patricia, and their families continue to be there for me. My talented filmmaker sons, Bryan and Erin, make me proud every day of my life. My parents, Alan and Maryanna Harvey, built darkrooms for me when I was a child, talked me out of racing motorcycles as a teenager, understood me when no one else did, and always made me feel I was doing the right thing. For them, I reserve my highest thanks, respect, and love.

— David Alan Harvey

The editors gratefully acknowledge the assistance of National Geographic staff researchers and of contributing editor Martha C. Christian.

AUTHOR'S NOTE: Most of the names in Chapter Two, "Illusion and Reality," have been changed to protect identities. In preparing the historical material, particularly for "Six Landings," a number of published works were drawn on, most heavily Hugh Thomas's masterful *Cuba or the Pursuit of Freedom*, updated edition, 1998, the single comprehensive source on the subject. The author dedicates her text to her parents, Edward and Betsy Landreth, who passed on their love for Cuba.

DAVID ALAN HARVEY has photographed extensively in Latin America for more than 20 years, most often for NATIONAL GEOGRAPHIC. He has been a member of the photographers cooperative Magnum since 1993.

ELIZABETH NEWHOUSE has been thinking about Cuba ever since she lived there as a young person in the 1950s. She began her career in Latin American affairs with the Peace Corps and then turned to editing and writing, which she has done for National Geographic for the past 20 years.

Cuba

Photographs by David Alan Harvey
Essays by Elizabeth Newhouse

Published by the National Geographic Society
John M. Fahey, Jr. *President and Chief Executive Officer*
Gilbert M. Grosvenor *Chairman of the Board*
Nina D. Hoffman *Senior Vice President*

Prepared by the Book Division
William R. Gray *Vice President and Director*
Charles Kogod *Assistant Director*
Barbara A. Payne *Editorial Director and Managing Editor*
David Griffin *Design Director*

Staff for this book
Kevin Mulroy *Editor*
David Griffin *Art Director*
William R. Newcott *Legends Writer*
Kevin G. Craig *Assistant Editor*
R. Gary Colbert *Production Director*
Richard S. Wain *Production Project Manager*
Janet Dustin, Margaret Callahan *Illustrations Assistants*
Peggy Candore *Assistant to the Director*
Dale-Marie Herring *Staff Assistant*

Manufacturing and Quality Control
George V. White *Director*
John T. Dunn *Associate Director*
Clifton M. Brown *Manager*
James J. Sorensen *Budget Analyst*

The world's largest non-profit scientific and educational organization, the National Geographic Society was founded in 1888 "for the increase and diffusion of geographic knowledge." Since then it has supported scientific exploration and spread information to its more than nine million members worldwide.

The National Geographic Society educates and inspires millions every day through magazines, books, television programs, videos, maps and atlases, research grants, the National Geography Bee, teacher workshops, and innovative classroom materials.

The Society is supported through membership dues and income from the sale of its educational products. Members receive NATIONAL GEOGRAPHIC magazine—the Society's official journal—discounts on Society products, and other benefits.

For more information about the National Geographic Society and its educational programs and publications, please call 1-800-NGS-LINE (647-5463), or write to the following address:

National Geographic Society
1145 17th Street N.W.
Washington, D.C.
20036-4688 U.S.A.

Visit the Society's Web site at www.national geographic.com.